Georges Braque

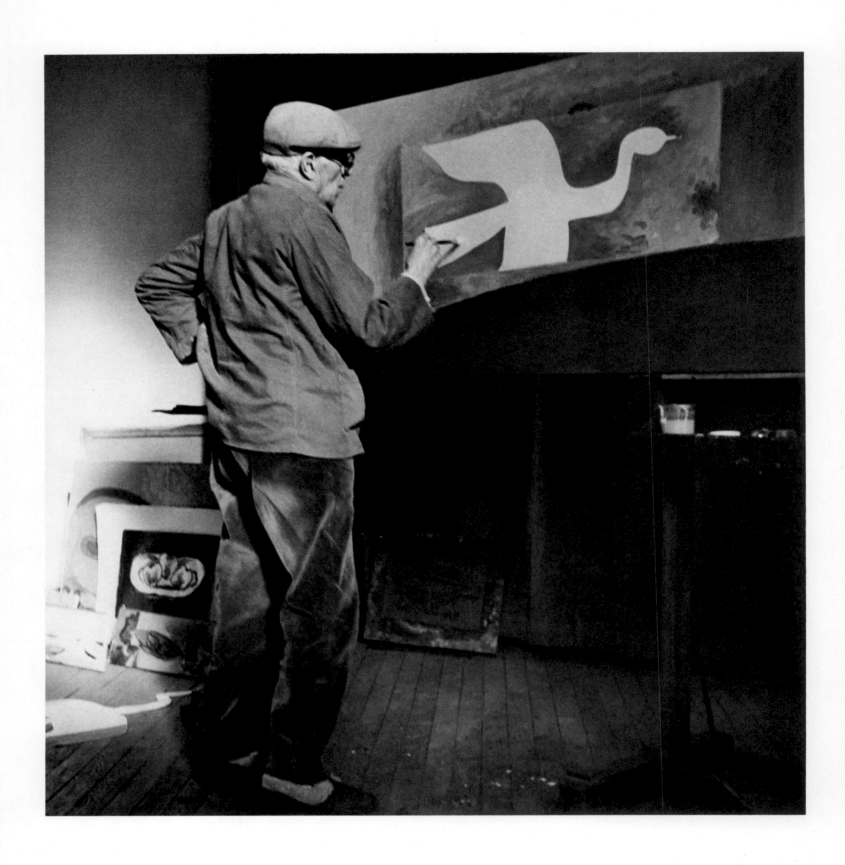

GEORGES
BRAQUE

Text by
RAYMOND COGNIAT

Translated from the French by
I. Mark Paris

THE LIBRARY OF GREAT PAINTERS

HARRY N. ABRAMS, INC., PUBLISHERS, NEW YORK

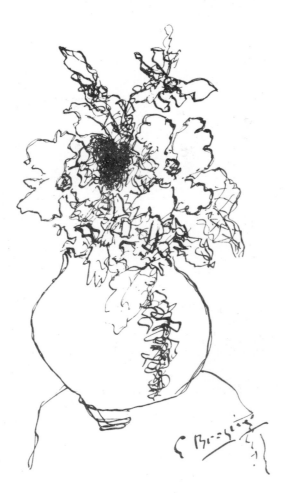

Editor: Joanne Greenspun

FRONTISPIECE. Georges Braque. Photograph, c. 1954

Library of Congress Cataloging in Publication Data

Cogniat, Raymond, 1896-
 Georges Braque.

 (The Library of great painters)
 Translation of G. Braque.
 Bibliography: p.
 Includes index.
 1. Braque, George, 1882-1963. 2. Artists—France—
Biography.
N6853.B7C6213 709'.2'4 78-13640
ISBN 0-8109-0703-8

Library of Congress Catalogue Card Number: 78-13640

Printed in Japan

Contents

Writings and Thoughts of Georges Braque 60

Georges Braque and the Critics 61

Biographical Outline 62

Comparative Illustrations to the Colorplates 63

COLORPLATES

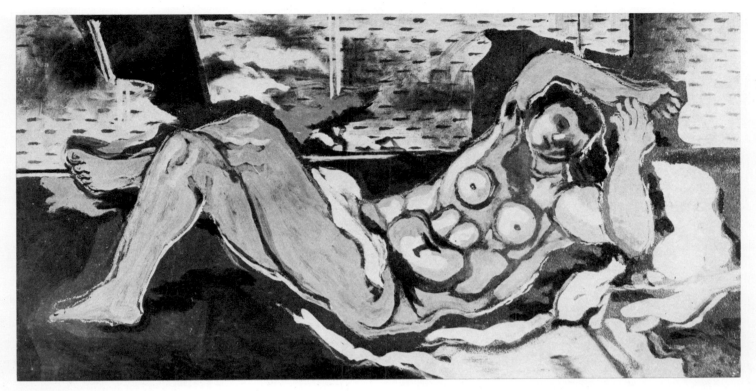

1. *Reclining Nude*. 1924. Oil on canvas,
11 7/8 × 23 3/4″. Bührle Foundation, Zurich

GEORGES BRAQUE

PRELIMINARY YEARS
(1882–1907)

THE ERA

Let us set the stage. After the defeat of the French
army in 1871, France, in the last quarter of the
nineteenth century, was receptive to all sorts
of new ideas. It called impatiently for the most
radical changes but did not yet know what forms
to give them. This desire for change lacked a fixed
goal.

When Impressionism burst on the scene in
1874, its opponents considered it a chaotic ne-
gation of the rules. But those who, shortly after,
were to claim it as a forebear—the Neo-Impres-
sionists or the Symbolists—hastened to establish
new disciplines; a few of them were even tempted,
politically speaking, by anarchist theories. Thus,
everyday events witnessed a succession of highly

contradictory impulses. Even as the most con-
ventional kind of middle class gained power, its
members saw their children become involved with
reckless theories. There was no end to the con-
flicts—indeed, the contradictions—that arose in
both the political and private sectors between an
order established by a generation coming to
power and that fondly hoped-for freedom sought
by the younger members of society.

However, this notion of liberty did not exclude
the principles of discipline. After Impressionism's
initial explosion of independence and individu-
alism, the new adherents grouped together and
decreed precise rules. Of course, they all clamored
for the freedom to break away from what their
elders had done; but each of them then had to
rediscover principles by which he could gain self-
identity. As a result, it was the second generation,
together with their friends and admirers, that was
to forge reaction. Van Gogh and Gauguin did not
believe that a desire to go beyond their Impres-

9

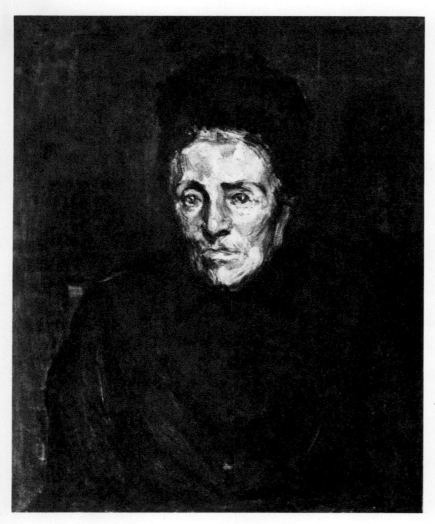

2. *The Grandmother of a Friend.* c. 1900.
Oil on canvas, 24 × 19 5/8″. Private collection

sionist colleagues would lead them to reject the enthusiastic impulses of their younger days. Nonetheless, beginning in 1888–90, it is their work that gave rise to Fauvism, just as that of Seurat— also closely linked to Impressionism—later helped the theoreticians defend Cubism.

Before culminating in the positive results that were to take shape between 1905 and 1910, these ideas were still undergoing a disorganized gestation period: even at the end of the nineteenth century, one could not foresee the triumphs about to occur. At best, one could well imagine that a climate fraught with such restlessness, while favorable to those young men endowed with genuine individuality, was disconcerting for the more undecided among them. Consequently, it was not long before a nearly automatic process of selection took place, separating the ones who would emerge the strongest (even if it meant scandal) from those who approached this era of inquiry solely with prudence and uncertainty.

This sorting phenomenon explains how and

why, in a few years' time, groups made up almost exclusively of the best elements would take shape, a process seemingly determined by nothing more than the whims of chance. In the years to come, those elements would, as individuals, take on increasing importance.

BEGINNINGS (1882–1901)

Georges Braque was born on May 13, 1882, in Argenteuil, in the heart of that region from which the Impressionists drew their inspiration. It was in this Parisian suburb by the Seine that he spent his first years. Although the Braque family moved to Le Havre in 1890, the atmosphere and light so dear to the Impressionists remained the same.

In 1893, he entered the local secondary school. He could hardly be credited with scholastic prowess: he eschewed book learning for physical exercise that helped him blossom into a strong, tall young man. The comfortable financial circumstances of his family enabled him to pursue his studies until the age of eighteen. Beginning in 1897, he attended evening classes at the École des Beaux-Arts in Le Havre, where Émile-Othon Friesz (b. 1879) and Raoul Dufy (b. 1877) had studied a few years earlier. Everything progressed normally, without family troubles. As a matter of fact, his father, a house-painting contractor by trade, who was an amateur painter in his free time, unhesitatingly permitted his son to follow the same path and even acquire knowledge over and above the technical skills required of the craftsman. It was in this spirit of enlightened workmanship that Braque joined his father's business in 1899, after which he was apprenticed in Roney's firm of more highly specialized decorative painters. In the following year, he went to Paris to continue his apprenticeship under the painter-decorator Laberthe, a former employee of his father. At the same time, he attended drawing classes under Quignolot at the Cours Municipal des Batignolles.

Even if Braque was not exactly swept away by an irresistible calling, at least he did not have to overcome middle-class reservations. In perfect harmony with his family, he adopted his father's and grandfather's trade, studying the required lessons so that he could practice it under the best possible conditions. Jean Leymarie, one of his most meticulous biographers, points out that by completing his apprenticeship with Laberthe, Braque hoped "to obtain the house-painter's

3. *Cousin Johanet.* 1900–1901. ▶
Oil on canvas, 24 × 19 5/8″.
Private collection

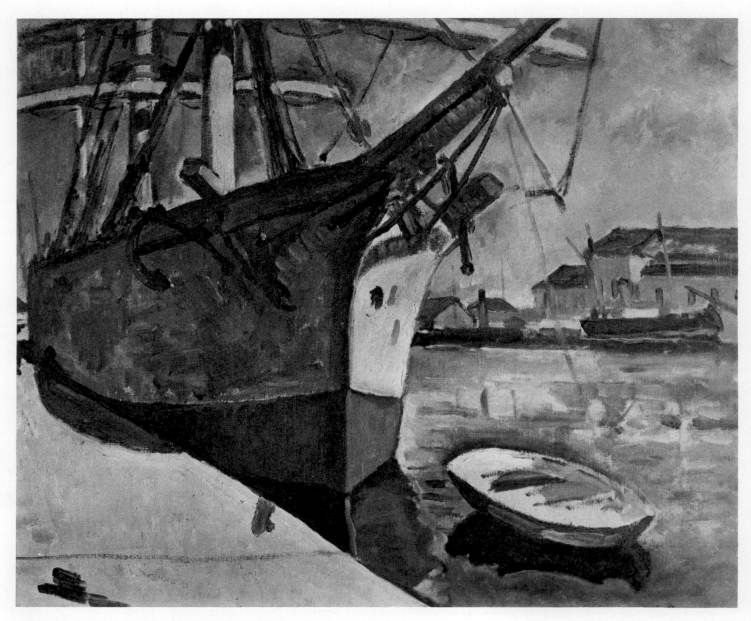

4. *Ship in the Harbor, Le Havre*. 1905. Oil on canvas,
21 1/4 × 25 5/8". Private collection, New York

diploma that would reduce his period of military service from three years to one." In October of 1901, he left Paris to serve in the 129th Infantry Regiment stationed near Le Havre.

Upon his return a year later, changes were already taking place. No longer a craftsman ready to resume his career, Braque had by now reached the higher plateau of a young painter wanting to go beyond mere knowledge of materials. The singular nature of his formation, so different from customary initiations into painting, should be emphasized; through it he acquired the techniques of the artisan. It was only later that the fine arts made their somewhat supplementary (though by no means secondary) contribution to this background. One must bear in mind this specialized vocational input especially with respect to

Braque's future experimentation, in which craftsmanship would play the major role of placing its resources at the disposal of highly innovative artistic formulas.

BEFORE FAUVISM (1902–5)

Although Braque henceforth took his "bearings" on a different level, he reached that level with the same instinct, the same naturalness, that had served him so well until then. He settled in Montmartre, first in Rue Lepic; later, in 1904, he moved to Rue d'Orsel. He visited the Louvre now more than ever; lingered over the works of Corot; discovered the Impressionists of the Caillebotte collection in the Musée du Luxembourg; and visited the Durand-Ruel and Vollard galleries. In ad-

dition to a brief stint in the studio of Bonnat at the École des Beaux-Arts, he went regularly to the Académie Humbert on the Boulevard Rochechouart, where he met other young artists, including Marie Laurencin and Francis Picabia.

All these events came together in the simplest possible way: "I never had the idea of becoming a painter," he said one day to Dora Vallier, "any more than I had the idea of breathing. . . . I liked painting and I worked a lot."

Few works from the years 1902-4 remain. The ones that do survive reveal a true painter's temperament, a meticulous attentiveness and seriousness in his use of the medium, and an obvious austerity when it came to expressing feeling. For all that, they are tinged with a certain heaviness. The gem was still enveloped in surrounding material, awaiting the liberation that would come with maturity.

In 1905, Braque began to overcome his hesitancy by displaying greater boldness in the positioning of details and greater freedom in his choice of colors. He spent the summer at Honfleur and Le Havre. He could now interpret more faithfully the diaphanous quality of the air; and, daring to simplify forms, he attempted to determine what had to be kept. The youthful vigor of this liberation paved the way for the explosive changes that were about to take place. Quite naturally, his new language was akin to that of Dufy and Friesz, the old Le Havre acquaintances whom he had once again met in Paris.

5. *The Port of Antwerp*. 1906. Oil on canvas, 19 7/8 × 24 1/4″. Kunstmuseum, Basel

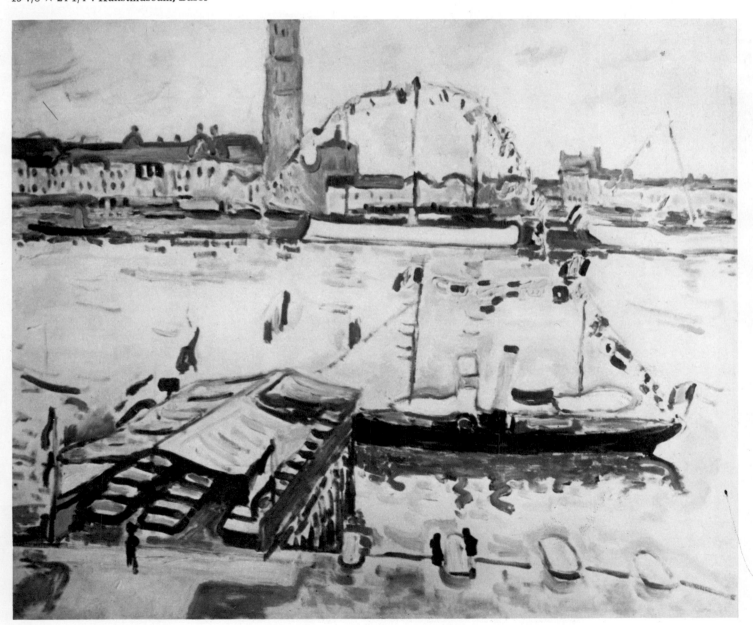

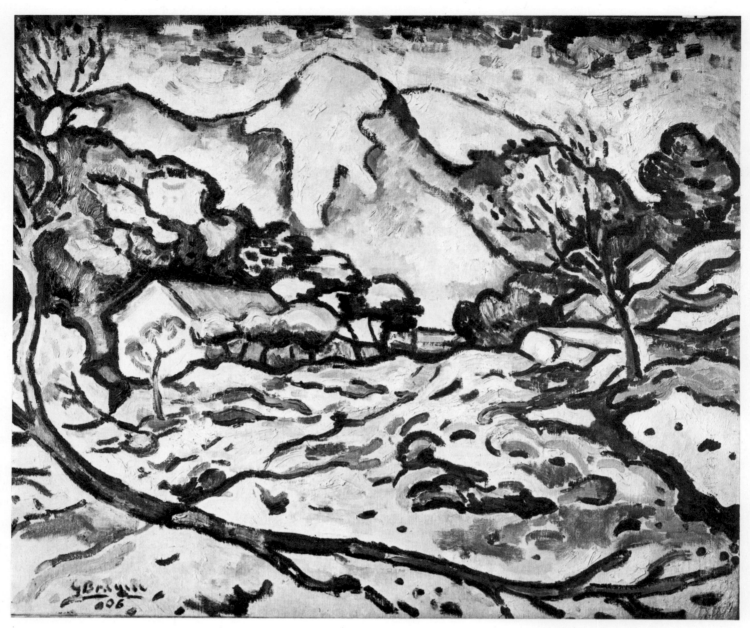

6. *Landscape at La Ciotat.* 1906.
Oil on canvas, 19 5/8 × 24″. Private collection

Like him, they made the landscapes of every-day life their theme and concentrated on inter-preting not only the fluidity of the air and water of ports along the Seine estuary (Le Havre and Honfleur), but also the nuances of light as it played upon the houses lining the embankments and was reflected in the dock basins. Although, like the Impressionists, theirs was primarily a painting of air, reflections, and changing water surfaces, they went beyond the Impressionists in their glorifica-tion of color. However spontaneous this vision may appear to be, it was actually the logical result of Braque's personal evolution as well as the out-growth of exchanges of ideas with artists of the same generation. From 1904 on, when he decided to turn his back on the traditional teachings of the schools and academies, Braque felt that he had within himself enough resources to expect more of his art than academic restraint.

The new friendships and the interaction with people of his own generation contributed to this awakening. We have already seen him rubbing elbows with Friesz and Dufy and, later on, with Marie Laurencin and Francis Picabia at the Aca-démie Humbert. In 1905, he met the Spanish sculp-tor Manolo and the man who, a few years later, was to become the historian of the Cubist move-ment, Maurice Raynal. As one might well imagine, such eager youthfulness could hardly remain indifferent to the issues of the day.

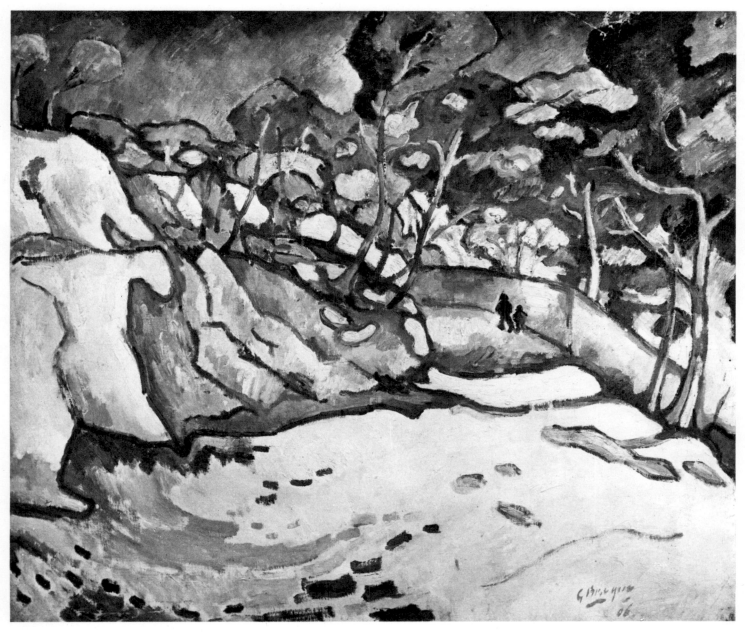

7. *L'Estaque.* 1906. Oil on canvas,
23 1/4 × 28 3/8″. Private collection, Paris

FAUVISM (1906–7)

Georges Braque was only twenty-four when, in 1906, he began to lean toward more assertive displays of daring; and he found that his sympathies lay with Fauvism, the movement of the scandalous Salon d'Automne of 1905. The changes in style and color were immediate and unmistakable. Like Dufy and Friesz, both of whom were subject to the same influences, he painted landscapes that took on new resonance and more exuberant coloring.

In the summer of 1906, he went to Antwerp with Friesz; it is probably here that the great change took place. A few months earlier, in 1905, the Salon d'Automne's celebrated room of the Fauves had stirred up violent debates. In that same year the Salon des Indépendants had held Seurat and Van Gogh retrospectives that made a strong impression on young painters. Braque contributed seven paintings to the Salon des Indépendants of 1906. Although none of these has survived, we may surmise that they were works of transition, less ponderous and more highly colored than his first paintings, yet still rather traditional if we bear in mind the 1905 canvases so reminiscent of his relationship with Dufy at that time.

Thus, we now see that the years 1906–7 marked the point at which Braque, reaffirming his strong-willed sense of renewal, embarked on what is called his Fauve period.

With the dozen or so paintings executed at Antwerp in 1906, he broke through an important barrier along the road to emancipation. Living and working side by side with Friesz—they even treated the same subjects—he put his new vocabulary to the test. Though interaction between them was inevitable, their mutual boldness took on certain personal touches that underscored each one's individuality.

Braque was still relatively reserved. True, the echoes of Impressionism sounded in his work, but they were undergoing a transformation whose impassioned outcome was greater freedom of imagination. Moreover, relying in part on divisionist techniques (albeit in a less systematic, more spontaneous way), he exploited the scintillating radiance to be derived from small, isolated brushstrokes.

In October he settled at L'Estaque, near Marseilles, where he executed paintings whose incandescence confirmed the new orientation. The time had come for the challenge of pure painting as exemplified in the work of Matisse, Derain, and Vlaminck.

For the new painters, the south of France was usurping the supremacy of the Seine Valley so dear to the Impressionists. They preferred the hard, steady brilliance of the Mediterranean sun to the subtle, ever-changing light of the Île-de-France. Cézanne had just died and his influence was continuing to grow. People were beginning to understand that his work could lead to paths that moved away from Impressionism and its evocation of the instantaneous point in time.

CUBISM (1908–18)

PRE-CUBISM (1906–7)

On his arrival in Paris in February, 1907, Braque exhibited six new paintings at the Salon des Indépendants and sold them all. He returned to L'Estaque and La Ciotat for the summer. This year witnessed a shift even more fundamental than the preceding one in terms of the artist's execution and, above all, conception of painting. The picture was no longer a mere representation of nature: it became an act in itself, willed and structured by its creator. With their pure, bright Fauve colors, broken brushstrokes, and transpar-

ent atmosphere, the 1906 works had begun to move toward a purely pictorial arrangement, but one whose inspiration from nature remained the logical outgrowth of a largely Impressionist framework. Suddenly, the very terms of creation changed, probably at some point during his stay at La Ciotat. Instead of dividing surfaces into sparkling strokes of fresh color, Braque now arranged his pictures with more clearly delineated forms whose contours were filled with colors of greater density and stability. The artist set out on a quest for an architecture suitable for painting. Even though the initial landscape was still a governing factor, he now sought to emphasize its essential structure rather than the shifting light emanating from it.

There had been a large Gauguin retrospective at the Salon d'Automne of 1906; and, in all likelihood, Braque had been influenced by it to some degree. The technique of delineating forms with weighty strokes as well as the tendency to reduce landscapes to a few broad, violently colored surfaces were hallmarks of the Gauguin legacy. Other Fauve painters had followed Gauguin's example in their experiments. About the same time, Braque was inclined to stress vertical superposition of landscape elements that nearly block out the sky, instead of trying to suggest space opening out into the distance.

After returning to Paris in October, 1907, Braque met Guillaume Apollinaire through Daniel-Henry Kahnweiler, to whom he was now bound by contract. Apollinaire, in turn, introduced him to Picasso and thereby afforded him the opportunity of being one of the first to see the Spaniard's just-completed *Demoiselles d'Avignon*, that famous composition which was no sooner displayed than its insolence gave rise to the most impassioned and highly divergent opinions.

The meeting of the two artists was an event of capital importance, for their friendship would soon give birth to Cubism. The deep impression made on Braque by *Les Demoiselles d'Avignon* served as a springboard for his resolution to blaze entirely new trails.

At the same time, alluring examples of Cézanne's work were being exhibited at the Salon d'Automne and the Bernheim-Jeune gallery. Thus, 1907 was for Braque a year that marked the confluence or succession of a great many possibilities.

On the one hand, his views of the port and bay of La Ciotat reveal a continuing use of reso-

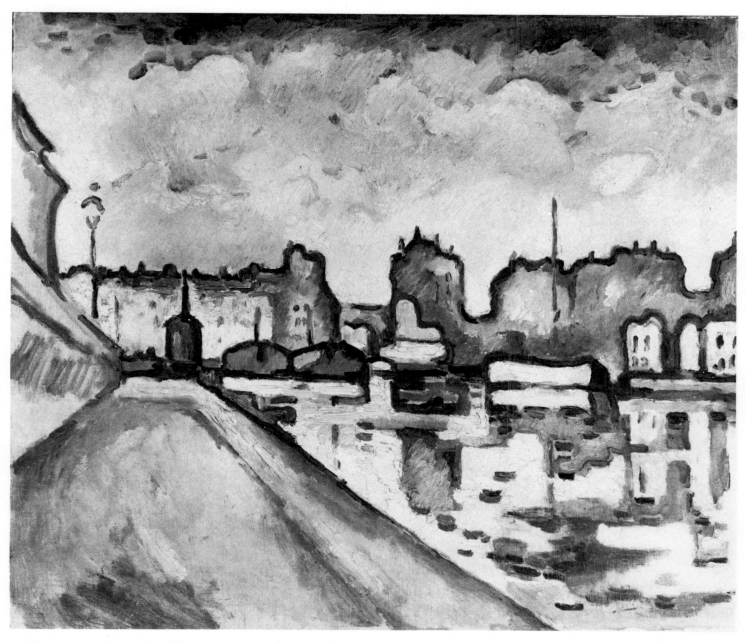

8. *The Canal St. Martin.* 1906. Oil on canvas,
19 5/8 × 24 3/8". Private collection, New York

nant tones akin to those of transparent water-
colors. The modulated areas of intense color take
on added vibrancy thanks to detached, shimmering
strokes whose brilliance evokes the shifting air
or water. Actually, all of this was a continuation
of the experiments of 1906. But at the same time,
we can see him trying his hand at a different solu-
tion, one whose structured landscapes, composed
of strongly outlined, homogeneous forms, begin
to show the influence of Cézanne as well as, per-
haps, Derain.

This evolution asserted itself even more
conclusively in the course of the same year. It
took the shape of two nudes treated with uncom-

promising and, indeed, totally unexpected bold-
ness.

The process of formal simplification, seen in
the Fauve works, that had led to broad surfaces
now gave way to volumetric combinations con-
ceived as masses. This effect was further enlivened
by high relief or simplified shading. Such a concept
of volume, with its overwhelming rhythmic pat-
terns, together with the choice of color and stroke,
signaled a repudiation of Impressionism. Instead
of subdividing surfaces into reflections of light, the
brushstrokes now fashioned a unity based on large
monochromatic areas. Surfaces were no longer
modulated by means of juxtaposed areas of shim-

mering color but by broadly drawn spaces achieved by an economy of means. The austere character of this new path is underscored by the choice of dominant browns and reddish-browns over more captivating blends of color.

A comparison of these compositions with previous landscapes reveals immediately just how far the artist had come. As a source of inspiration, Impressionism had run dry; Braque's commitment to creativity was now total. The world could no longer be reduced to a statement of mere optical sensations. It now became the pretext for a structure that was *thought* rather than felt. The amazing thing is that Braque's already highly intellectual concept of art did not stifle the sensitivity that continued to infuse life into this nascent geometry.

CÉZANNIAN CUBISM (1908–9)

During the year 1908, the transformation of Braque's attitude toward reality entered its final stages. The concept of volume that had asserted itself in the later 1907 landscapes as well as the earliest nudes was now coupled with a budding geometrization antithetical to the suppleness of the Fauve period.

The details of the landscapes he was now painting at L'Estaque were subjected to maximum simplification and piled up to form a densely packed universe. It was these landscapes that prompted Louis Vauxcelles's use of the word "cubes": and so the terms "cubist" and "cubism" came into being. And, indeed, the houses had been reduced to doorless, windowless, flat-surfaced parallelepipeds; the trees were now sleek tubes crisscrossing one another as they climb into space. His palette hardly strayed beyond shades of green and ocher occasionally accented with gray. So vertically oriented were these landscapes that, more often than not, there was no room left for the sky. His work was becoming more and more a closed world, a process that marked the definitive break with what had gone before.

More than just the development of a new style, Braque's renewal of the landscape and discovery of the nude were accompanied by the exploitation of a subject hitherto kept completely in the background—the still life. It would soon become a theme of paramount importance.

The influence of Cézanne is patent, but in Braque's hands it is a Cézanne grown much more intransigent than ever before. There was something in the latter's landscapes, in the way the air circulated about them and carried one off into the distance, that was reminiscent of the lightness of Impressionism. Nothing of the sort is to be found in the lessons that Braque drew from Cézanne. His was an uncompromising austerity.

Artists were then discovering the provocative words of Cézanne's famous statement made in a letter to Émile Bernard, which had just been published in *Mercure de France*: "Treat nature in terms of the cylinder, the sphere, and the cone." Now governed by the will of the painter, subject matter was cut up into overlapping planes—a solution which entailed a redistribution of light. Whereas light rules supreme in every corner of Impressionist pictures and continues to permeate the atmosphere of Braque's earlier landscapes, his first Cubist experiments take light and break it up in a way that illuminates each plane differently and breathes life into the entire arrangement.

The works of this period reveal two distinct lines of endeavor: on the one hand, an extreme simplification of volumes reduced to their essentials and, on the other, a proliferation of planes resulting in lively multifaceted surfaces. The seemingly contradictory aspects of this twofold quest were soon to become united. Braque's was an unsettling vision: most of the works sent to the Salon d'Automne of 1908 were rejected, and the artist refused to allow the rest to be exhibited. Subsequently, the young dealer whom he had met the previous year, Daniel-Henry Kahnweiler, arranged a one-man show in Rue Vignon (November 9–28, 1908) for twenty-seven of Braque's works; accompanying the show was a catalogue with a preface written by Guillaume Apollinaire.

The following year, he went to La Roche-Guyon and then to Carrières-Saint-Denis. The landscapes painted there, though less sober than those executed in Provence, confirm yet again the path he had decided to follow. While showing a desire to limit his palette to only a few colors, they also reveal a landscape architecture accentuated to the point of geometric severity. Now more than ever the canvas is filled with densely packed yet evenly distributed objects arranged along a strictly vertical axis.

THE CLIMATE OF REVOLUTION (1909)

Thus was Cubism born, and along with it an utterly new way of looking at the world and depicting it. We feel it necessary to stress this

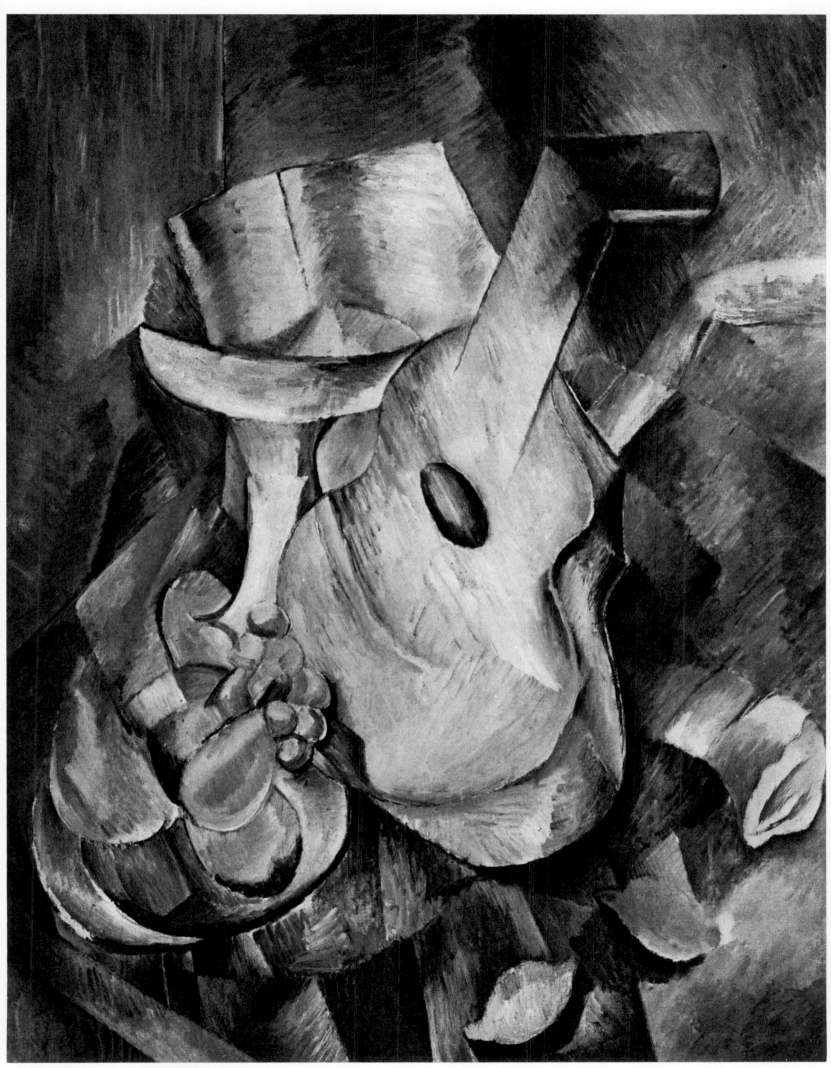

9. *Guitar and Compotier.* 1909. Oil on canvas,
28 3/4 × 23 5/8″. Kunstmuseum, Bern

point in order to take an accurate stock of events. The Cubist aesthetic is today so deeply engrained in our tastes and habits that we find it difficult to realize just how thoroughly aggressive—indeed, revolutionary—a creation it was in its own day. The public at that time saw it for what it was and reacted immediately and vigorously with nearly unanimous hostility. It could not have been otherwise since nothing had prepared them for this unprecedented vision. There had been only some vague feelings of anticipation coupled with the knowledge that previous modes of expression had been exploited to the saturation point.

Beginning with the first days of Impressionism in 1874, one innovative offering followed another at an ever-faster pace. Divisionism, the Nabis, Symbolism—these were all accepted and digested, thereby leaving the air of expectancy ungratified. The very success of Impressionism, by then a thoroughly acknowledged fact of life, robbed it of all stimulative value in the eyes of the young. The so-called modern style adopted by the fashion world yielded nothing more than surface peculiarities. Aroused rather than assuaged by these passing temptations, the public's thirst for something unprecedented continued unabated. The result was that a need was felt for innovation at any cost. The growing power of workers' movements and the conflicts between church and state created social crises that bore out the violent opposition between a past doing its best to survive and a future struggling to find a voice. Unrest and war in the Balkans added nationalistic yearnings to the scenario, not to mention significant changes to the map of Europe. These were the birth pangs of a new era.

The art world was particularly sensitive to these stimuli; youth was being goaded on by the promise of discovering the unknown. To their expectations Cubism brought a sudden, clear-cut answer that blossomed in the unsettled atmosphere it so actively nourished. Everything about it was antithetical to what had preceded it; one might even say there was something of the *agent provocateur* about it. Here is how Jean Cassou sums up this feature: "To be sure," he writes, "there was something ironic, insolent, and capricious about the genius of several [of Cubism's] champions, something in an Apollinaire or a Picasso that was like a playful feast of unbounded imagination."

Note that Braque's name does not appear in the above quote. In other words, as far as that artist was concerned, the idea of playfulness did not enter into the picture as much as a technical and intellectual process of experimentation in keeping with his upbringing and his feeling for creative, spiritually oriented craftsmanship.

In order to get a better understanding of early Cubism, we must bear in mind what made it fundamentally opposed to Impressionism, in terms of the picture's essential structure, composition, and subject as well as its technical devices, organization, and spirit.

To Impressionism's improvisation on nature, Cubism countered with conscious structuring. To its unforeseen contingencies, reasoning. To its instantaneousness, permanence. To its joyous polychromatic radiance, a harsh palette reduced to the most sober colors. Color was glorified by the Impressionists and worshiped by those who followed, up to and including the Fauves; Cubism turned its back on color in order to retain the interaction of form and volume.

No less significant was the choice of subject matter. Whereas Impressionism set out to explore and unveil nature in all her litheness and lightness, Cubism was obsessed with the geometric intricacies of the mechanical world. It preferred the static arrangements of the still life to the landscapes of the Seine Valley and its play of shifting light.

Space itself was now different: while it had been remote for the Impressionists, it became close, fairly palpable for the Cubists. A Monet or Sisley encourages the mind to imagine the view stretching out to the right and left; a Braque still life, beginning in 1908 and even more so in subsequent years, is a closed world, the result of the artist's deliberate effort to prevent its extension. How, in a world already seething with excitement and pulled by numerous contradictory offerings, could so fundamental a change emerge without catalyzing impassioned movements? From today's vantage point, it would appear that Cubism clearly asserted itself in a way that sums them all up.

In fact, events did not unfold quite so neatly. First of all, what we subsume under the label of Cubism evolved bit by bit over the course of the years that followed. It took various forms—each one marking a new stage, a new resolve to discover—and always threw into question previously acquired elements, thereby fostering opportunities for scandal in a climate already fraught with revolution.

Furthermore, despite the fact that today we

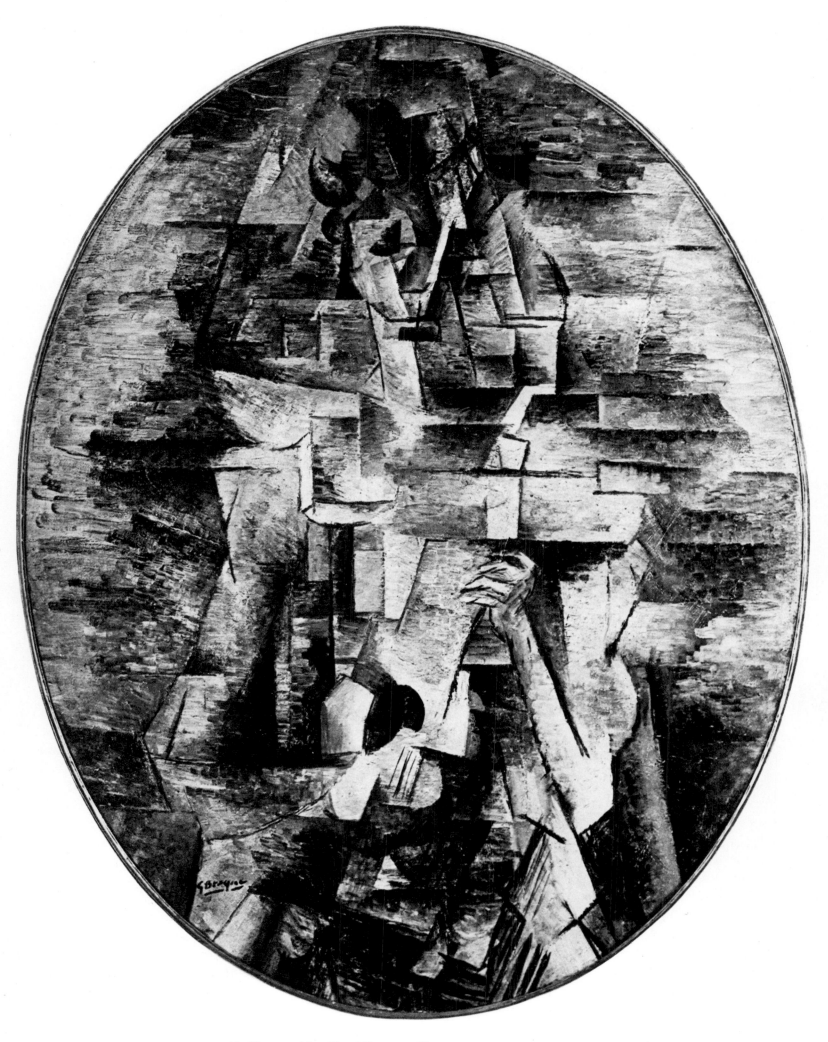

10. *Woman with a Mandolin.* 1910. Oil on canvas,
36 1/4 × 28 3/4″. Bayerische Staatsgemäldesammlungen, Munich

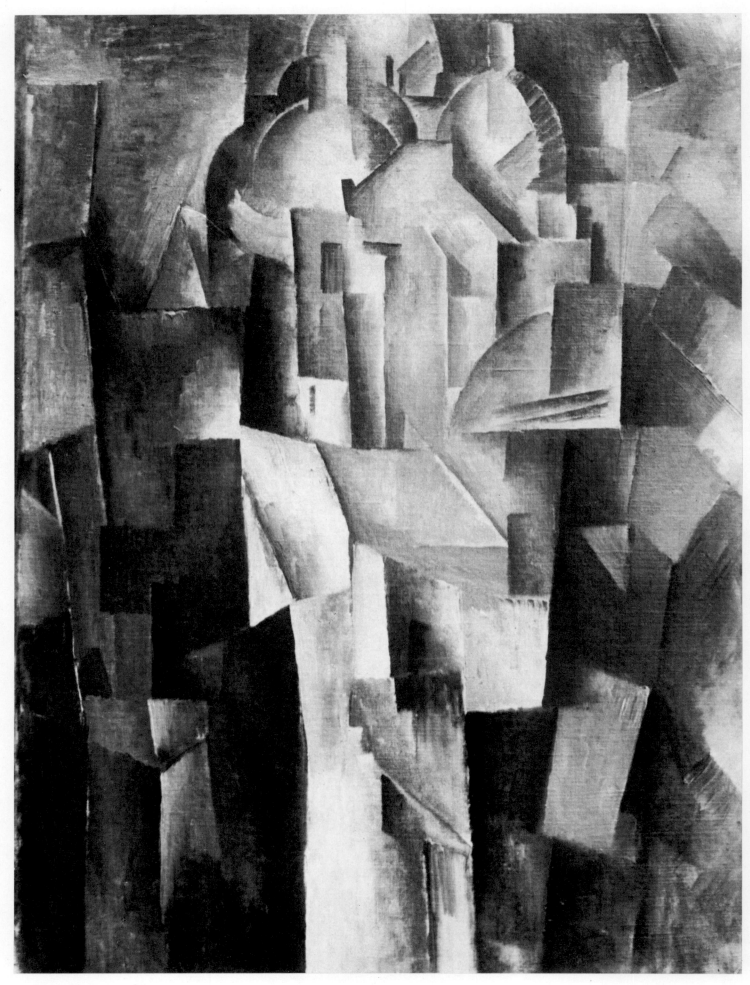

11. *Sacré-Coeur*. 1910. Oil on canvas,
21 5/8 × 16 1/8″. Private collection, Paris

distinguish three great currents during this era (Fauvism, Expressionism, and Cubism), things at the time did not sort themselves out in quite so orderly a fashion. Collective exhibitions threw together artists whose different leanings in no way precluded mutual influences, not to mention others who, in spite of their independence—or perhaps because of it—were linked to this climate and contributed to its chaotic turbulence.

ANALYTICAL CUBISM (1909–12)

Even though some of Braque's 1909 works—especially the landscapes painted at La Roche-Guyon and ports in Normandy—are clearly indebted to Cézanne, other pictures betray a desire to experiment along a more personal path. This was the beginning of Analytical Cubism, so labeled because space and form were now subjected to an essential process of analysis that destroyed the object's appearance. It is a world created and controlled exclusively by the will of the painter. Distancing himself further and further from a representation of reality, the artist first breaks objects into facets viewed from different angles, then regroups them to form oppositions and rhythms that are but a vague suggestion of the real world.

It may be relevant here to point out that Braque was fond of music and is even said to have been a fairly accomplished accordionist. This leads one to believe that there is some link between his taste for music and the frequent occurrence of musical instruments or scores in his still-life compositions. In a more subtle way, one is reminded of the relationship between music and the system of notation he was then in the process of inventing: consider the fact that his arrangements are dominated by certain repeated signs and by broad rhythms stretching vertically or obliquely, decomposing the object to better integrate it into an overall harmony that takes shape as the eye passes from one plane to another.

The emphasis now shifted from the representation of a given object in order to create an illusion to the destruction of its "real" appearance and the application of its fragments so that they contributed to a whole. The object was now to be recorded in its totality in a way that would avoid any possible misinterpretation. Later, this tendency was given added stress: reading a picture grew to be more and more of a challenge and wound up becoming an exercise in hermetics.

The titles that were affixed to paintings were not particularly helpful in this respect. However, this was of little consequence for the aim was not to recognize a woman, a Portuguese, or a violin, but to be seduced by a spatial organization whose hitherto untapped resources produced an astounding poetry of shuddering immobility.

Now and then, an almost realistic detail—a glass, a bottle, a nail—is inserted into the play of glistening facets as if to assert its connection, not to the world of optical illusion, but to a shared plastic reality. Such details are placed there to stimulate the imagination, much as an intelligible word amidst a collection of gibberish serves as a point of reference by which we feel we can decipher the rest.

This procedure evolved to the point of creating an abstract space stocked with often incomprehensible forms and planes interspersed not only with object silhouettes and fragments of the kind just described, but also with other graphic signs such as numbers, type, and newspaper titles. Looming out from the surrounding proliferation, they assure the survival of some measure of objective reality.

In transfiguring commonplace objects, this disarticulated vision of the material world chose as its training ground the still life above all other themes, doubtless because it lent itself so effortlessly to the freest sorts of transpositions and could thereby adapt itself to the conception of the individual artist. The process of bringing everything to the foreground gave the picture an immediacy that might well be called tactile space.

Later on, a more precise definition of this notion could be found in the artist's writings. Witness the following passage from Braque's *Cahier*, published by Maeght in 1948: "Visual space," he writes, "separates objects from one another. Tactile space separates us from objects." In the same publication we find a statement of capital importance: "In creative art there is no effect without distortion of truth." Such thoughts attest to an awareness that was the fruit of long years of creative experimentation.

In 1909, while Braque was working on his Cézannian landscapes at L'Estaque, in Normandy, and at La Roche-Guyon, Picasso was plunging into similar experiments at Horta de Ebro, in Spain. Their relationship became so intimate that they agreed not to sign their pictures, and it is now difficult to tell for certain which works produced

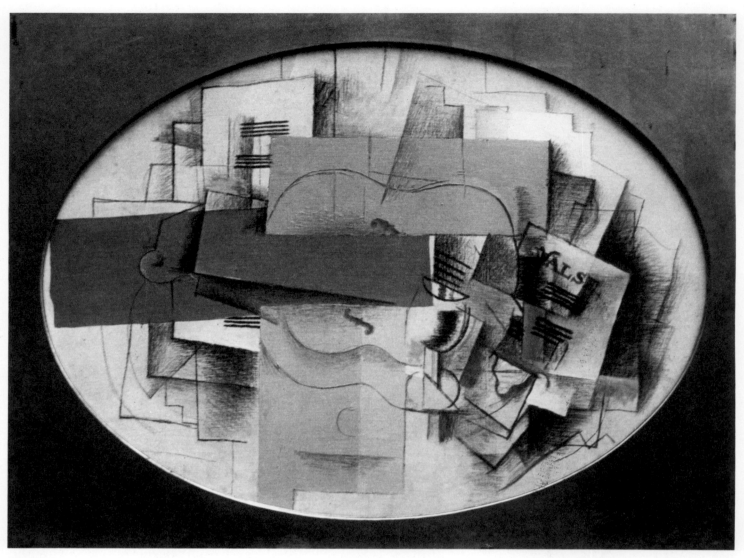

12. *Still Life with Glass, Violin, and Sheet Music.* 1913.
Oil and charcoal on canvas, 25 3/8 × 36″. Wallraf-Richartz Museum, Cologne

during this period belong to which artist.

The bond of friendship between Picasso and Braque grew stronger in the next few years. They both spent the summer of 1911 at Céret, and the following year found them together again at Sorgues, near Avignon. Many of the works executed at this time by the two artists reveal unmistakable similarities.

The metamorphosis of simple volumes into fragmented planes transformed the structure of the picture into a scintillating surface, as if brought to life by musical waves or vibrations that disintegrate its forms. That is, forms were reduced to mere suggestions activated by some characteristic detail (the base of a glass, the strings of a mandolin, a violin scroll), resulting in a gleaming austerity that one could almost call Cubist Impressionism.

The Cubists invented a special kind of light

in the process. No longer emanating from the depicted object nor illuminating the object, light grew out of the picture itself and accentuated its rhythms. That is, it played a part in depersonalizing the object. This fragmentation formed a transparent grid that structured itself more and more into a broader geometric pattern, one that reorganized the surfaces into larger, fairly rigid, more readable arrangements that heralded Synthetic Cubism.

Thus, there was no clear-cut break: Analytical Cubism was to persist for some time to come. In Braque's case, one can often come across surviving traces of this phase; and it was not uncommon for him to go back to work on a picture without seeking to destroy its original character or style. He refused to disavow what was previously acquired but, whatever the changes, he remained true to himself.

MODIFICATIONS IN CUBISM: THE *PAPIERS COLLÉS* (1912-14)

While one can detect the beginnings of Cubism in the 1908 landscapes of L'Estaque, followed by its flowering in the still lifes of 1910, it was not long before the new language developed into a hermeticism whose spirit presaged the kinds of experiments that would soon lead to abstract art.

However, the trend toward reduced readability was counterbalanced by a subsequent breakdown of the barriers between reality and abstraction, by ruthlessly imposing bits of that otherwise rejected reality. Braque's trade skills were now pressed into serving this illusion: he blended false marbling and false wood-graining techniques into the intellectualized play of plane surfaces. To these simulations, which bordered on *trompe l'oeil*, Braque, like other Cubists, added materials from real life—bits of wallpaper, cigarette packs, newspaper headlines, playing cards—

traces of everyday banality inserted into the magical world of metamorphosis.

The interplay of unconventional materials incorporated into the pictorial substance resulted in arrangements so startling and effects so captivating that, used as an expedient to reintroduce color, these materials very nearly supplanted paint altogether. In September, 1912, this new way of thinking led Braque to compose the first *papier collé* (literally, "pasted paper"), which proved to be the starting point for an important series of works that continued until 1914.

Analytical Cubism was being replaced by Synthetic Cubism. Marking the transition between the two orders were the paintings of 1912 and 1913. In addition, they brought into play highly innovative effects based on the use of sand, sawdust, and iron filings, all of which bear witness to a renewed interest in the very stuff of construction, more or less shunned or scoffed at in preceding years.

13. *Guitar and Glass.* 1917. Oil on canvas,
23 5/8 × 36 1/4". Rijksmuseum Kröller-Müller, Otterlo

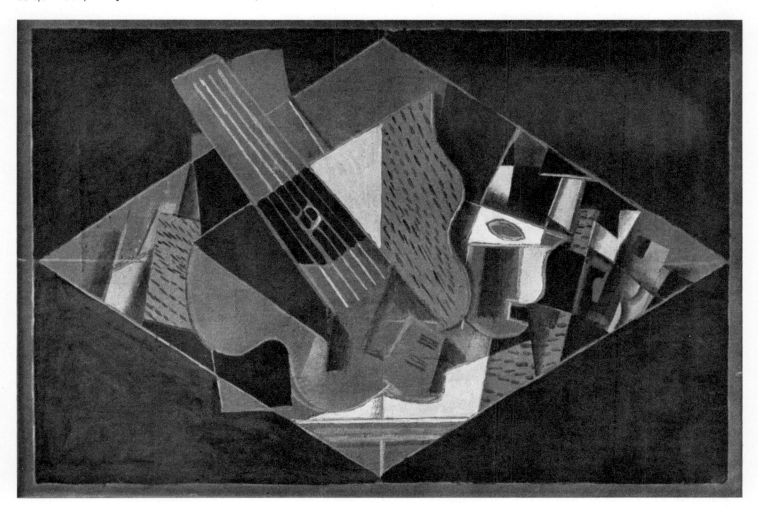

25

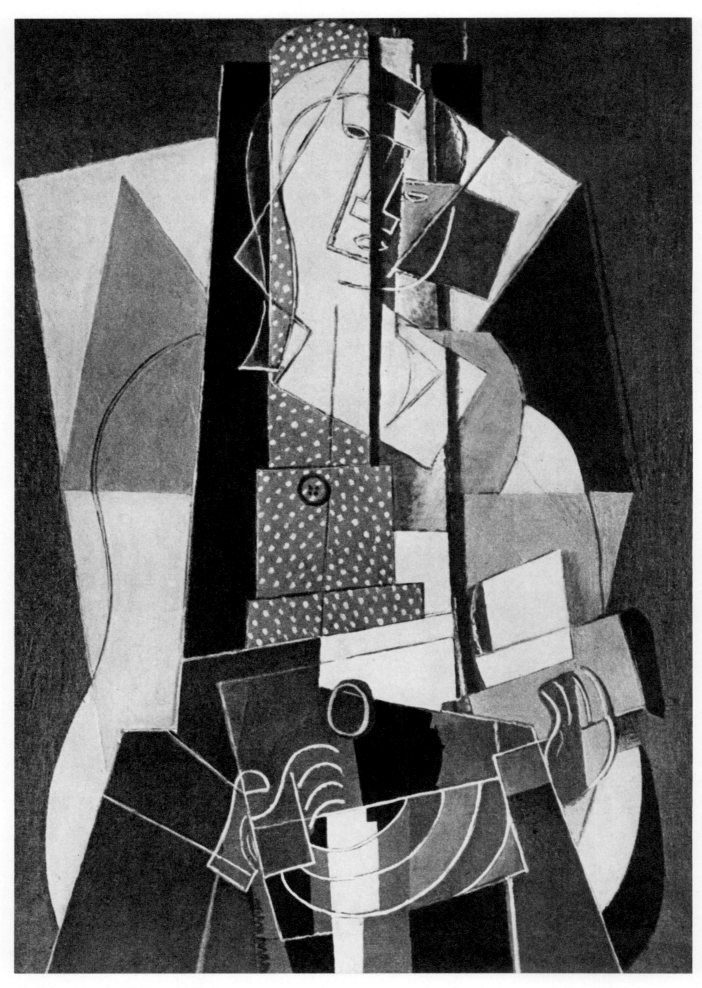

14. *Woman with Mandolin.* 1917. Oil on canvas,
36 1/4 × 28 3/4″. Private collection, Paris

Up to the time of Braque's first *papier collé*, the introduction of unusual materials worked hand in hand with the paint, either blending or contrasting with it, but never to the point of fully eliminating it. However, the artist henceforth pushed this line of experimentation to the extreme. Paint was eliminated completely. His arrangements, invariably large still lifes, were now composed of pieces of paper of various shapes and kinds; and the objects in question—pipes, bottles, musical instruments—were indicated by nothing more than stark superimposed outlines. The results were indeed surprising. Combining such modest, even meager, resources with a sense of exacting purity, Braque created works whose stylistic severity and extreme elegance hark back to Classicism at its most unyielding. Never would he surpass the point of equilibrium attained in this series.

Perhaps without its being fully realized at the time, his innovation, in fact, lay just as much in the restoration of materials as in the discordant notes sounded by unusual juxtapositions. Actually, the elements that make up the works as they appear today have changed considerably: the bits of newspaper, in particular, have yellowed, and the colors and papers have faded somewhat. Nevertheless, these compositions have lost none of their noble beauty, which indicates that their original colors played a less important role than the arrangement of their forms and materials.

The invention of the *papiers collés* was a major event. It marked the first stage in a process of regrouping of elements which, over the course of the preceding years, had been scattered in a desire to analyze objects and their space.

SYNTHETIC CUBISM (1912–18)

With Analytical Cubism, objects had lost their usual characteristics and had reverted to essential, rudimentary forms. Transfigured into a language of poetic plasticity, this disintegration of everyday reality was realized perfectly in the *papiers collés*. They marked both a beginning and an end; for the subject matter, formerly stripped of all reference to reality, could now begin to be reshaped into an ideal form. So complete had the revolution been that it no longer felt the need to play the role of agent of destruction. On the contrary, it left its past triumphs behind and set out on the path of reconstruction. Since the first step had been analysis and its resulting hermeticism,

it was only logical that the second should involve a synthesis that could serve as the basis for a new version of reality.

The austerity of the *papier collé* allowed, in large measure, for a return to color and a certain degree of readability by conquering the object anew, but this time avoiding the kind of destructive scattering typical of previous efforts. Form and color would now be treated as two distinct systems of expression; the very act of dissociating them enhanced each one's expressive potential.

Combined with the use of multiple, imaginary points of view, this concept doubtless had a hand in undermining old habits. Since the artist henceforth painted what he thought instead of what he saw, his pictures took on a wholly new appearance. At the same time, he adopted a new set of guidelines just as strict as those laid down by realistic representation, if not more so. So conscious was Braque of these unavoidable yet enriching constraints that he occasionally established rules governing materials and fashioned unconventional formats. By encasing his still lifes in diamond-or oval-shaped frameworks that turn the subject in on itself, he dispelled any illusion of the picture spilling over its physical boundaries.

The era of synthesis had arrived. Its aim was to exploit the stock of acquired materials and reaffirm the autonomy and independence of form. Granted, a certain degree of fragmentation remained; but it became more orderly, less unstable, and arranged itself into rhythmic parallel zones. The reinstated order was dubbed Synthetic Cubism: the final stage, the final transformation in an evolution which, for all the vehement criticism it encountered, revolutionized the way everyone— even the most ignorant and unrefined sectors of the public—looked at the world.

In fact, the movement was so effective that, after only a few years, dissident voices began to make themselves heard. The same spirit of newfound freedom to create anything and everything now spawned the very forces that had opposed it. (Impressionism had undergone the same process, but not so swiftly.) The most dynamic and vigorous offshoot was the movement of Italian artists who published Marinetti's Futurist manifesto (1909) in both Paris and Italy and, in 1912, exhibited an important collection of paintings at the Bernheim-Jeune gallery. Although their writings obviously owe a great deal to Cubism, their purpose was quite different from, even antithetical to, that of the preceding movement. Whereas their stated goal

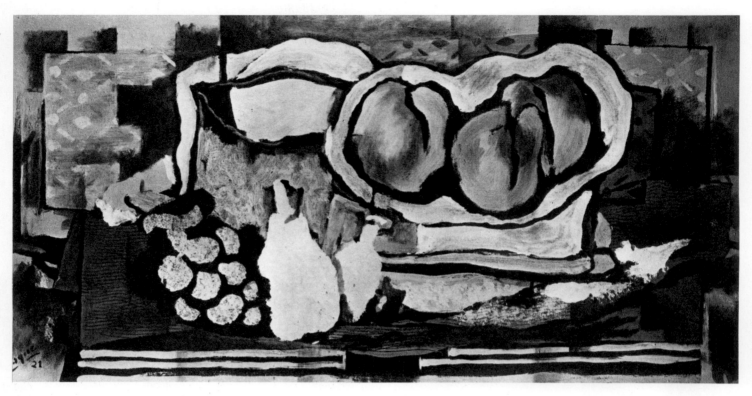

15. *Compotier and Fruit.* 1921. Oil on canvas,
12 1/4 × 25 5/8". Private collection, Paris

was to depict motion radiating outward, the Cubists sought a stability that impelled the eye inward.

The other current of major importance to emerge (c. 1912) was the one that included Kandinsky, Delaunay, and Mondrian, among others. From them sprang abstract art. It, too, had its roots in Cubism.

BETWEEN YESTERDAY AND TOMORROW (1914–18)

The declaration of war in August, 1914, found Braque at Sorgues, where he had stayed on several occasions since 1912. It caught the artist in the midst of his work. Once mobilized, he entered the 223rd Infantry Regiment with the rank of sergeant, was later promoted to lieutenant, and received two citations. Then, on May 11, 1915, he sustained a serious head wound at Carency and had to be trepanned. Following a long convalescence, he was invalided and demobilized in 1916. After his subsequent return to Sorgues, his condition improved slowly; and on January 15, 1917, a banquet was held in his honor in Paris to celebrate his return and recovery.

In all likelihood, his period of convalescence led him to meditate on the means and goals of his art: now his ideas began to gel. In fact, the pic-

ture-filled *Cahier* previously mentioned is dated 1917–47. (Curiously enough, it begins and ends with postwar eras.) Choosing to bypass any references whatsoever to political issues, it is a distilled collection of the painter's observations.

Braque began to work again. Interrupted in the middle of his Synthetic Cubist phase, he continued along the path of greater simplicity and total reintegration of color. A more straightforward geometric pattern emerged from large, unbroken surfaces whose overlappings in no way interfered with their complete unity. The composition now did not constitute the transparent space of previous stages, but was a collection of opaque planes no longer shattered into glistening facets. These large, simplified, well-defined zones may be compared to Picasso's highly linear arrangements. But they also bring to mind those of Juan Gris, not to mention the architectural bas-reliefs of Henri Laurens. In fact, it was in 1917 that the relationship between Braque and both these artists grew closer and more secure.

Light, too, took on a different character. As we have already pointed out, the first experiments of the analytical phase fashioned light out of shattered reflections. From now on, however, light belonged to each particular form: it *was* the form. The elements of Analytical Cubist shapes seem to dissolve in space with nearly Impressionistic mo-

bility. With *papier collé*, forms were built up anew and, thanks to the nature of the materials used, helped effect a paradoxical reconciliation of transparency with a new density. In the synthetic phase of Cubism, forms were restructured into large plane surfaces that yielded linear patterns devoid of spatial perspective. As Cubism progressed from one stage to the next, it brought about a transformation of material reality into a plastic statement. This explains not only the analytical phase's initial disintegration of people and objects into facets but even more clearly the subsequent introduction of letters, numbers, and *papiers collés*. In essence, familiar shapes and objects that we are physically aware of are incorporated harmoniously into a strictly *pictorial* whole. In this manner, we accord them a new expressive value without sacrificing their material appearance.

The picture became an end in itself, with its own modes of color, space, and perspective. We have already witnessed its quest for a light of its own. Not some Caravaggesque light drawn from an external source to orchestrate a dramatized scene; not Rembrandt's light emanating or radiating from people or things—but a fixed light that belongs to the picture itself, to its every detail.

The triumph over color was achieved more slowly and with greater difficulty. Limited at first to a spare two or three shades in the L'Estaque landscapes, the artist's palette, beginning with the analytical phase, became neutral, almost monochromatic: it was a period during which one could more properly speak of reflections than bona fide colors. However, color—albeit still quite subdued—did begin to reappear with the *papiers collés* and their special role vis-à-vis material reality. Finally, Synthetic Cubism reinstated color as a fully active participant. It reasserted itself even more forcefully than before, not only as uninterrupted surface (enlivened by the sand that Braque occasionally mixed in with his pigments), but also, beginning in 1914, in stippled areas that contrast with smoother surrounding surfaces.

No less crucial was the part played by space and perspective. Never before had the problem of translating the three-dimensional real world into the two dimensions of the picture been handled with such lucidity, nor solved with such freedom and flexibility. Instead of the mechanical, geometric system proposed by the Renaissance and echoed in photographic perspective, Cubism

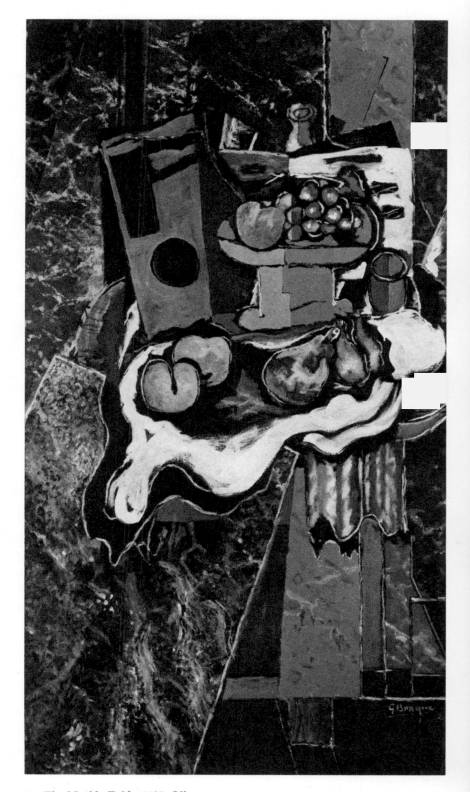

16. *The Marble Table*. 1925. Oil on canvas, 51 1/4 × 29 1/8″. Musée National d'Art Moderne, Paris

sought a point of view that would be multiple, shifting, palpable. In order to transpose three dimensions onto two, it began by flattening out successive planes along a vertical instead of a horizontal axis. However, this expedient did not resolve the question in all its complexity. After all, points of view change according to the relationships between objects as well as between the objects and the painter or observer.

This multiplicity, which explains the perplexing reasons behind Analytical Cubism, saw in

29

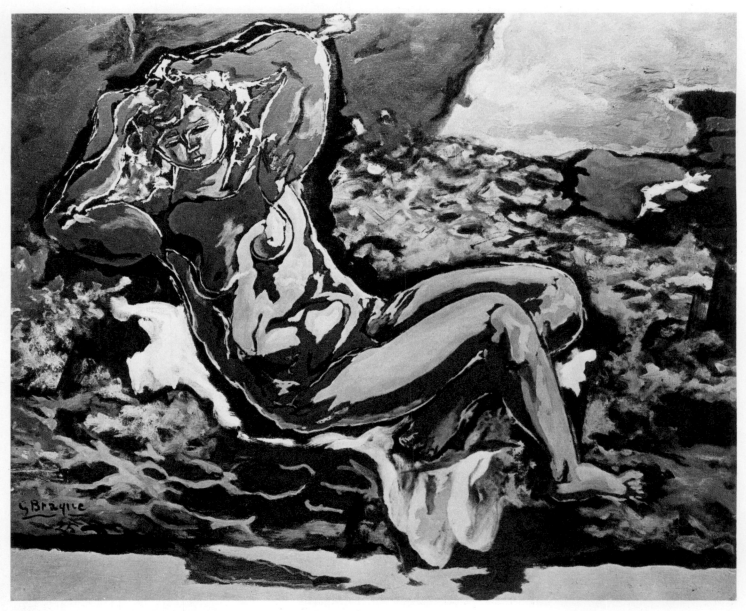

17. *Reclining Nude.* 1925. Oil on canvas,
19 3/4 × 24″. Private collection

Synthetic Cubism a chance for simplification. It was at this point that Braque's art opened up to the promise of new decorative effects, together with hints (from 1917 on) of a frank sensuality which had been shunned, or so it seemed, over the past decade.

EXPERIMENTS (1918–63)

STILL LIFES (1918–22)

For all its revolutionary explosiveness, Cubism ultimately generated its own submission to a dis-cipline just as rigorous as that of Classicism. Now that the movement had spent some ten years experimenting with newly discovered resources, its founders looked toward reclaiming their freedom before they found themselves in the grip of what could turn into neo-academism. Having put forward innovative techniques and procedures, they now turned to other ways of exploring, exploiting, and evoking reality. The time had come for individual artists to tap their ideas and the knowledge they had acquired.

Cubism ceased to exist as a collective movement after 1918, for each of its contributors became involved with his own pursuits. This spirit of independence notwithstanding, their works continued to evoke the Cubist aesthetic. Curiously

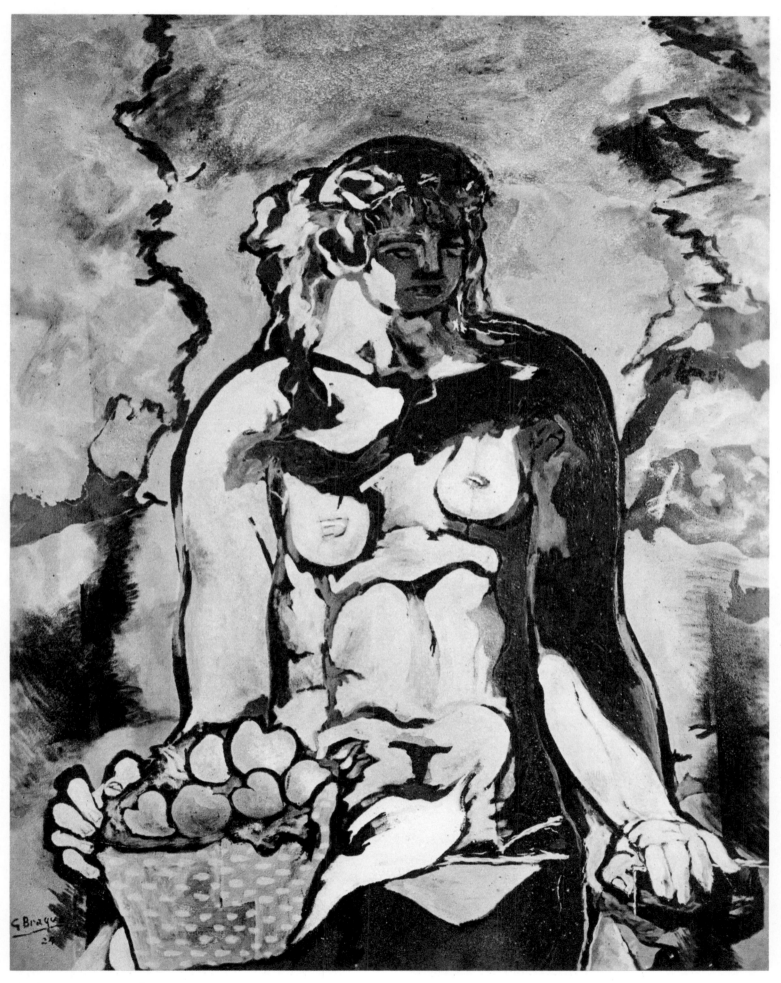

18. *Nude with Basket of Fruit.* 1925. Oil on canvas,
36 1/4 × 28 3/4″. Private collection

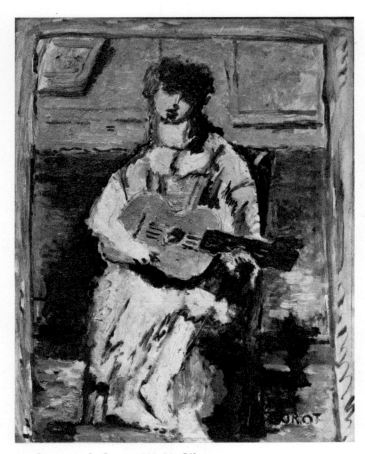

19. *Souvenir de Corot.* 1922–23. Oil on canvas,
16 1/8 × 13″. Musée National d'Art Moderne, Paris

enough, Cubism as a collective enterprise had utilized to the utmost and even championed individuality. But it is equally obvious that those same individuals were open to outside suggestion and exchange. For example, certain commentators have claimed that African art (probably discovered by Derain) exerted no influence whatever on the initial stages of Picasso's Cubism. Yet the relationship between the faces in *Les Demoiselles d'Avignon* and African masks is self-evident. It is inconceivable that such a link was mere coincidence. Braque's work, on the other hand, does not bear any trace of African art. Yet his connection to Picasso is undeniable, in spite of the fact that it is often difficult to tell exactly which one influenced the other.

The two artists had lived side by side both in Paris and the provinces. They had pushed their self-effacing partnership to the point of leaving their works unsigned or, at most, signing only the back of the canvas. Now they gradually reasserted their independence. Even though something of their bond could still be detected in the *papiers collés*, Synthetic Cubism and perhaps the war as well helped restore their autonomy.

From now on, Braque's work developed along lines that were less clear-cut than ever before. Since his production, for all its diversity, no longer follows a strict chronological route, its evolution needs to be examined as a set of thematic entities. Therefore, it should be understood that the dates used in subsequent chapters to delineate periods serve as nothing more than indications of a general, even arbitrary, nature. We shall find that different trends often intermingle and sometimes overlap, spanning several years without limiting themselves to neatly dated blocks of time.

Typical of this kind of stylistic commingling is the cycle of works executed over the years 1917 and 1918. At the same time that Synthetic Cubism was making its final appearance, there was a simultaneous reawakening of a poetics of color and sensuality. One could see it in the less rigid forms, the more supple lines, the more dynamic use of the medium. It was an explosion, yes, but one still confined to a rigid, oval- or diamond-shaped framework.

These still lifes incorporate not only everyday objects (pipes, bottles, or musical instruments) already so familiar to us from previous works, but quite often pieces of fruit as well. We can fairly touch, even taste, their living substance. What emerges from the overall composition is a kind of vibration, a physical satisfaction scarcely to be derived from the rigors of Cubism. In addition, forms were now set off with curved or undulating lines thickly applied in a way that would soon shake the straight lines out of their rigidity altogether.

However, Braque's decision to dominate his palette with dark grays and blacks points to a continuing inclination toward austerity. The presence of fruit—the palpable nature of its substance, its poetry, the vitalizing spirit emanating from it—has often caused people to draw a parallel to the works of Chardin. Likewise, the name of Cézanne could be mentioned here, even if Braque's objects now had a less direct, less immediate appearance than in the pre-Cubist landscapes of L'Estaque. Think of Cézanne's concentrated still lifes, the way he grouped his apples so that the center of his compositions took on a powerful density. In the same manner, Braque, using his own technical means, created an authoritative presence involving a similar ability to simplify and harmonize volumes—an ability, in short, to transform the material into the pictorial.

THE TEMPTATION OF THE BAROQUE: THE *CANEPHORAE* (1922–27)

Whereas Cubism has been interpreted as a renewed yearning for order, a return to a kind of Neoclassicism, Braque's new manner could be seen as a reincarnation of the Baroque spirit. A process of humanization soon led to a renewed emphasis on figures that now completely shed the mechanical appearance forced on them during the various stages of Cubism.

Picasso had for several years found himself drawn to bathers, dance scenes, and mythological groups. This marked a desire to revert to a kind of traditionalism, as exemplified by his contributions to Diaghilev's Ballet Russe. Likewise captivated by the heroes of antiquity, Braque worked around the theme of the *canephorae*, or women bearing baskets filled with votive offerings. The large female nudes of this period blossom in serene yet impressive majesty.

By comparing Braque and Picasso during this era, we not only get at the heart of their individual pursuits, but we realize that the degree of communion that they had known in their Cubist days would never be reached again. To be sure, something of that bond could still be detected, even if it was only in occasional thematic similarities. It is as if, by means of ceaseless confrontation, each one more or less consciously used the other as a point of reference in order to take stock of the moment—not as a source of inspiration, but as a way of monitoring oneself. It is of little consequence to know which one influenced or overtook

20. *Still Life: Le Jour.* 1929. Oil on canvas, 45 1/4 × 57 3/4″. National Gallery of Art, Washington, D.C. Chester Dale Collection

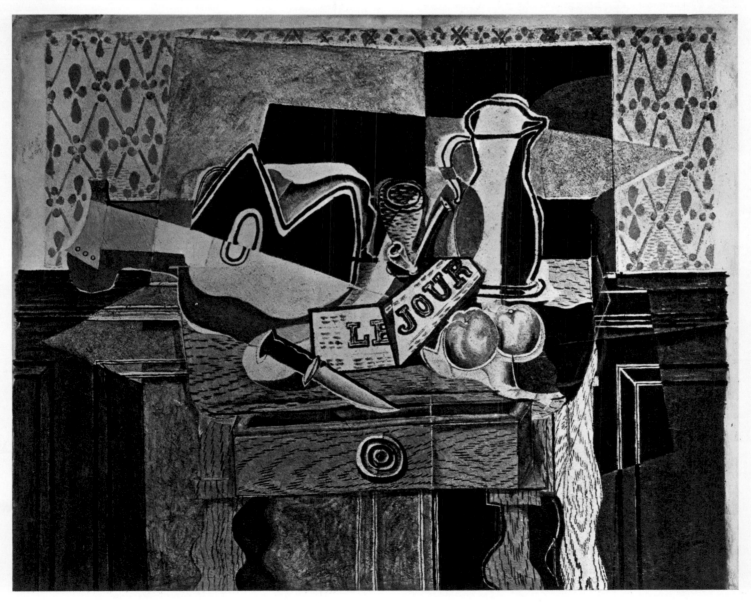

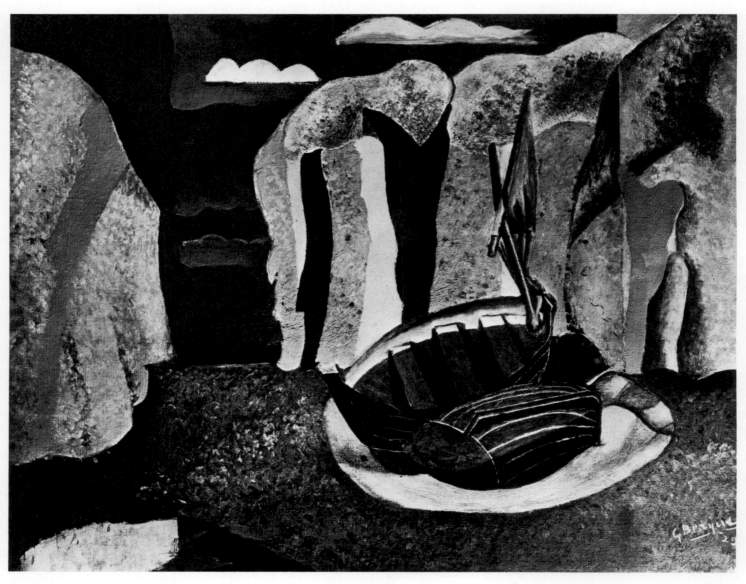

21. *Cliffs*. 1929. Oil on canvas,
19 3/4 × 25 5/8″. Private collection

the other. The results always transcend the comparisons and attest all the more forcefully to each one's individuality. The monumental style achieved in Braque's series of nudes and *Canephorae* marks one of the zeniths of his artistic career. Geometric stiffness has been totally replaced by sinuous lines drawn with extreme suppleness. The surfaces are modeled by curious contrasts of light and shadow through which line gives meaning to color but refrains from strictly delineating it.

The same flowering of both a calm, healthy sensuality and a sense of monumentality can be seen in the still lifes as well. Whether a piece of fruit, a basket, or a cup, the object has now regained its self-identity without having to submit to the rules of verisimilitude. Gone is angular stiffness: the shapes are now curved.

Another important aspect of the works pro-

duced during this period is the role of color as a physical element. The combinations and blendings typical of the *papiers collés* lead one to believe that Braque could not keep his back turned to the resources that his materials had to offer and that the austerity of his early Cubist days was only a temporary constraint. It is doubtless the pulpiness of Braque's fruit—their tactile presence surpasses mere physical resemblance—that makes one want to put them on an equal footing with those painted by Chardin.

FRUIT DISHES AND *GUÉRIDONS* (1927–30)

Braque continued to tap the resources of the still life, which from now on was stamped with a kind of realism and a striking alliance of physical sensation, classical transposition, and intellectual structure. What are the hallmarks of this artistic

34

vision? First and foremost, it was the culmination of all previous efforts and of what they had to teach about the stimulation of one's feelings.

The lyrical style that emerged from the objects grouped atop mantelpieces or pedestal tables (*guéridons*) was grounded in organization as disciplined as that found in the strict, geometric patterns of previous years. Moreover, Braque continued to subject his works to physical constraints of the most limiting sort. We have already noted his tendency to enclose his compositions in circles, diamonds, and ovals to prevent the eye from wandering. To these he now added formats elongated in height or width, and their unusual proportions called for special kinds of arrangements.

In the case of the new cycle—the mantelpieces that began to appear about 1921 and especially the *guéridons*, whose tops support and embrace the complete repertory of still-life elements—it is the shape of the furniture that surrounds the objects with an enclosing framework. The exuberant profusion of the upper part of the canvas serves as a counterpoint to the simplicity and relative calm of the table legs, which create their own distinct sense of space.

Objects were no longer reduced to the schematized geometry of the Cubist period, although even then they had something that set them above the mere representation of reality. In spite of their density, they became signs or symbols in themselves. Their abstract reality is inscribed with a free, sinuous line, like a kind of spontaneous writing. True, the wood of the furniture and the marble of the mantelpieces do indeed recall the use of simulated materials in the *papiers collés*. This time, however, the techniques of false marbling and false wood graining were exploited by using actual paint, resulting in a more thorough integration. What we see now is not whimsical *trompe l'oeil*, but an amalgamation of materials into a plastic poem, a harmonious pictorial medley in which paint and outline are one and the same, applied with a thick, robust impasto that molds volumes into undulating surfaces.

Braque attained this high degree of virtuosity with resources which, though apparently simple, prove to be, on closer inspection, highly complex. The artist had now learned to manipulate contrast as well as reconcile its oppositions. For instance, we see lines changing color as they travel from one area to another, or as they appear against various backgrounds. We also see light abruptly cutting objects in two without the benefit of shading to make the transition from one zone to the next.

Objects were now contoured by a thick, curving line into which the artist would occasionally implant a thin, differently colored line that would both lighten and reinforce the former. By means of an ingenious, magisterial alchemy, he transmuted objects heaped atop pedestal tables into disarrayed sumptuousness. The densely packed arrangements of 1928 marked the full blossoming of this style: the artist managed to bring out different elements without abandoning the Cubist concept of two-dimensional space and its vertical alignment of background planes.

It was also about 1928 that his palette underwent a change. Shunning the darker area of the spectrum, he turned to a much lighter color balance (for example, as a means of suggesting those parts of an object hidden in shadow). We should note here, as we have in reference to other periods, that these modifications did not come about either by sudden, definitive breaks or via transitional byways, but by unabashed changes in viewpoint. For instance, a picture conceived according to a new, experimental formula might stand out in the middle of an ongoing series of works. Or the recent past would reecho in the appearance of a canvas bearing traces of previous efforts. Thus, we see that acts of repudiation did not enter into Braque's passage from one system to another.

During the years 1928–30, however, he was to take up other themes in accordance with an interpretive approach that ran counter to the one utilized in the still lifes.

LANDSCAPES AND HUMAN FIGURES (1928–38)

Beginning in 1928, and especially in 1929, Braque returned to the long-forgotten theme of landscape. This time, however, the artist revealed a technique and a frame of mind quite different from what had governed either the Fauve landscapes of previous years or the still lifes he was working on concurrently. The tiny, trembling strokes of Fauvist divisionism and the organized clutter of the more recent still lifes now gave way to the broad, simplified volumes of sea cliffs. In 1927 and 1929, he traveled to Dieppe and, in 1930, set up a studio in a house built for him at Varengeville. Braque often journeyed to this spot and continued to work there until the end of his career.

The return to landscapes was more than just a change in theme: it marked a new approach to organizing space. Unlike the vertically arranged scenes painted in 1908–9 in Normandy and the

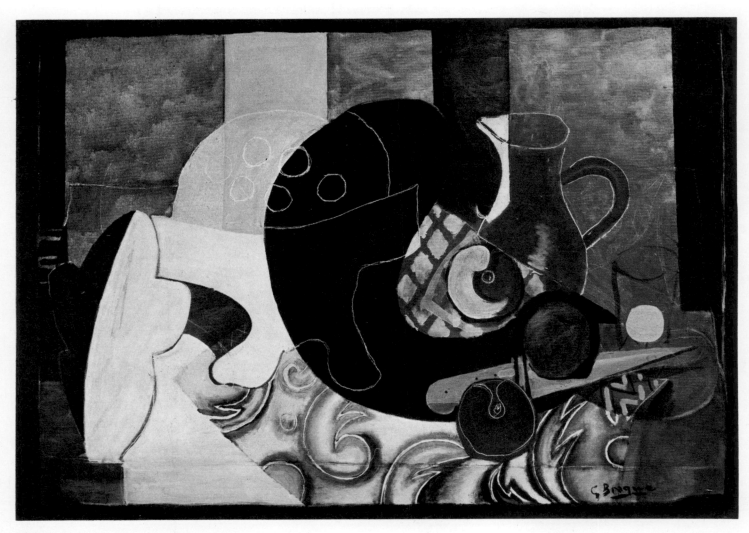

22. *Still Life with Pitcher.* 1932. Oil on canvas,
23 5/8 × 28 3/4″. Private collection

south of France, these seascapes revert to a horizontal disposition in which the visual planes recede into the distance. Despite this, the result is not a lightened space: the sky, now restored, rises like an opaque wall, shutting the arrangement in even more severely than the trees and houses that scaled the earlier landscape canvases. Furthermore, the disposition of elements is counter to that of the still lifes. In the latter, everything is concentrated in a centrally located grouping surrounded by relatively empty space; in the landscapes the volumes and masses are evenly distributed around an uncluttered central point of focus.

In fact, Braque's landscapes look like stage sets. Large vertical motifs frame the scene to the right and left; the foreground is more or less open however important the subject located there; and the sky hangs like a backdrop and envelops the setting in an undefined but opaque space. Several years later, Braque took up this theme again and

gave it the same characteristics. We see here, perhaps more clearly than anywhere else, the permanence of his ideas even as they underwent change. From 1928 to 1933, he painted four or five seascapes a year and did more in the same style during 1937–38. In all likelihood, his experience with the real stage was not totally unrelated to this concept of space. In 1923, he had been commissioned by Serge Diaghilev to design the costumes and sets for his ballet *Les Fâcheux*, and in 1924 by Count Étienne de Beaumont for his Soirées de Paris production of *Salade*. The following year, he was asked to do the same for Diaghilev's *Zéphyre et Flore*.

Here again, a particular interpretation of space is the key. For most painters, the still life constitutes a closed space; the landscape, an open one. The theater, however, is a special case: it involves a closed space (the stage) containing a space that is sometimes open (the set). Indeed, Braque's decor for *Les Fâcheux* offers a telling

example of this twofold restraint. The later land-scapes apparently tried to resolve the difficulties that arose from this problem by transforming a closed space into an open one.

In his Fauve landscapes, Braque had clearly decided in favor of the openness typical of the Impressionists, whose subjects seem to extend to the right and left. His efforts at L'Estaque or at La Roche-Guyon and the Normandy harbors sig-naled a repudiation of such expansion. By com-bining these two impulses, the artist arrived at a solution which, though seemingly alien to Cubism, in fact subjects the picture to the same type of rigorously structured limitations. In addition, the various elements situated in the foreground (boats, ropes, etc.) are quite independent of one another, like so many stage props ready to greet the characters of a play. In Braque's theater, how-ever, there is no movement: it remains static, like a place awaiting activity in an atmosphere of solitude.

Braque once again turned to the human presence that he had treated in the *Canephorae* and other nudes. First there were a number of almost classical *Heads* (1928–29), realistic in appearance despite their being composed of broadly drawn areas. But then—doubtless as a reaction against the charms of such splendid tranquility—the same theme was treated, about 1930, in a more aggressively stylized way, with superimposed outlines closer in keeping with Cubist principles.

Concurrently, in 1928–29, he embarked on an even more unlikely venture that was continued in several paintings up to 1931 and then in a *Reclin-ing Nude* (1935). It was a path of experimentation quite alien to what he was painting at the time as well as to what he had done previously. Perhaps

23. *Tennis Players.* 1932. Pen and wash, 5 7/8 × 8 1/4". Private collection

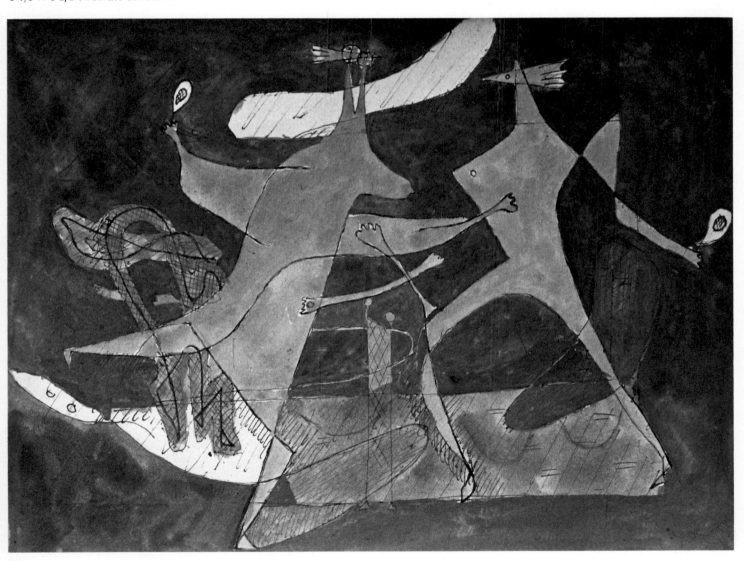

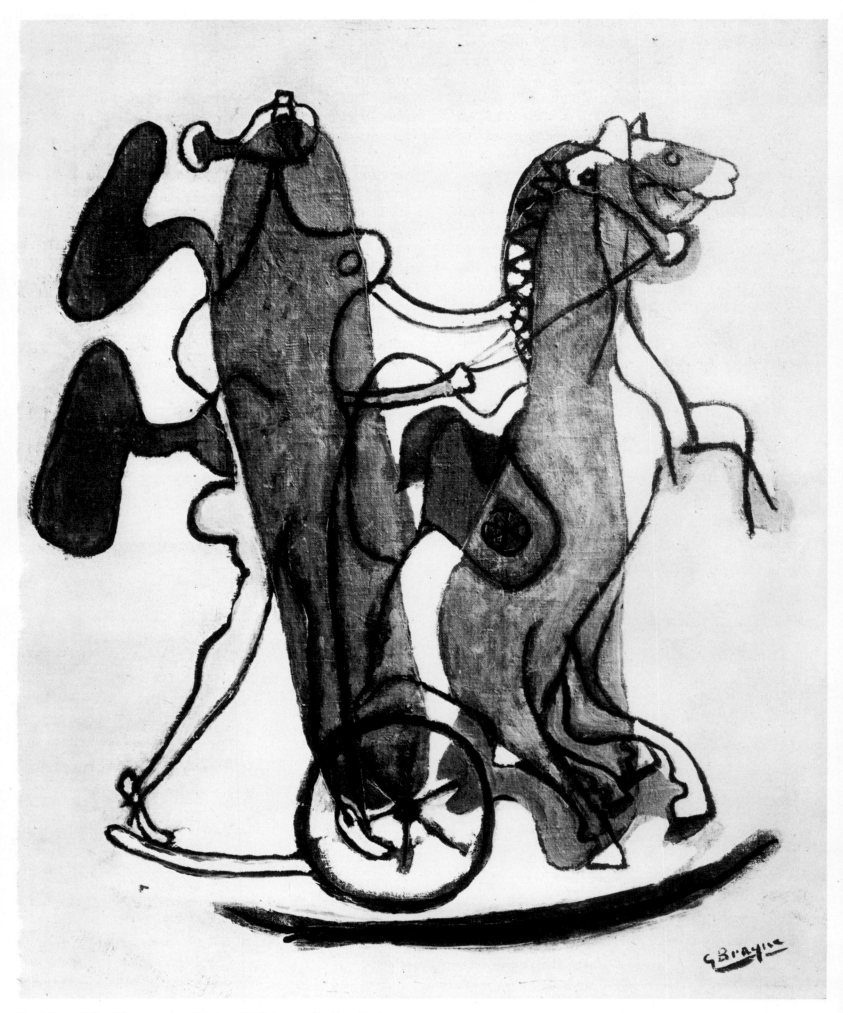

24. *Athena.* 1931. Oil on canvas, 15 3/8 × 13″. Private collection, Paris

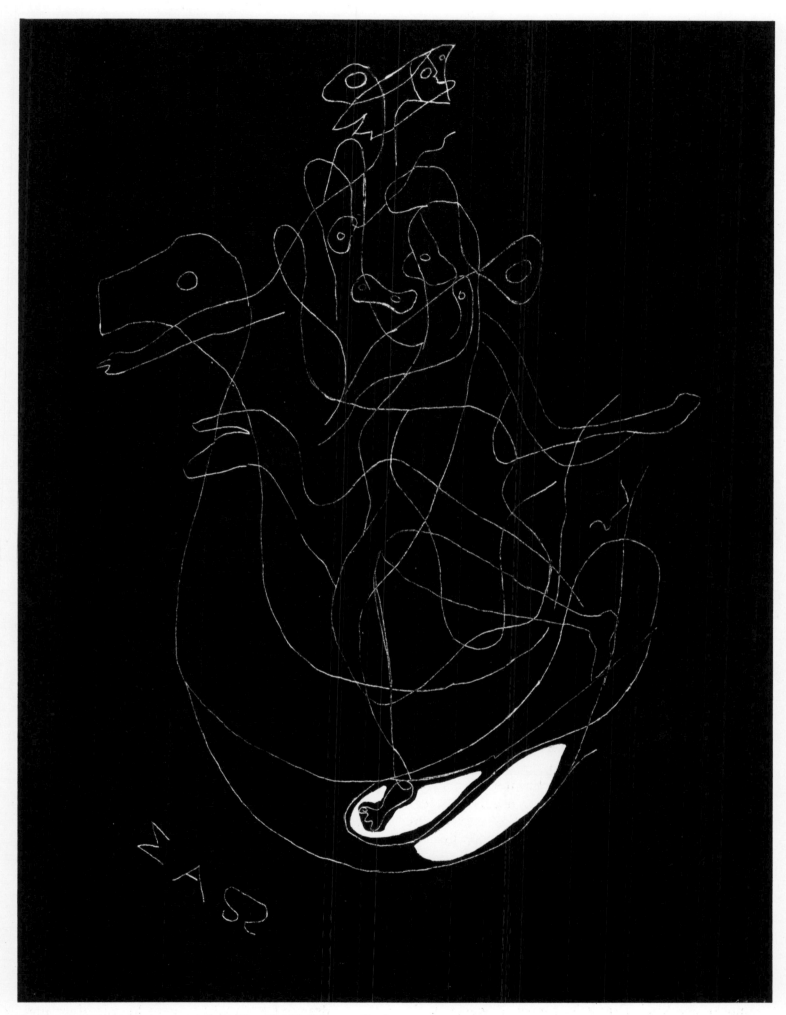

25. *Zao*. 1931. Black plaster, engraved, 73 1/4 × 51 1/8″. Private collection

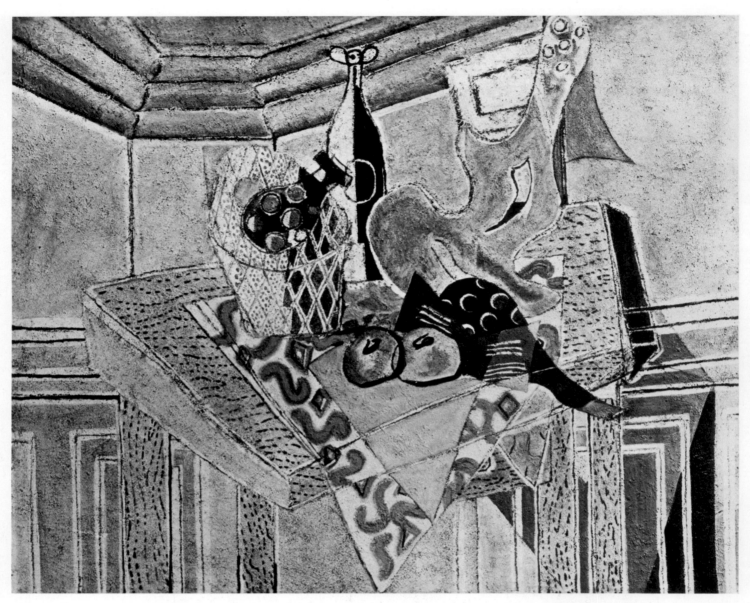

26. *The Yellow Tablecloth.* 1935. Oil and sand on canvas,
44 7/8 × 57 1/8″. Private collection

the series of *Bathers* he now began was a reply of sorts to the contemporaneous pictures executed by Picasso at Dinard—those emaciated, disjointed, strangely gesticulating silhouettes whose tension, even contortion, borders on caricature in a fit of assertive exasperation.

Did these excesses make Braque more aware of what was, by comparison, the nearly classical equilibrium he had reached in the *Guéridon* still lifes? Was he afraid of finding himself forever trapped in that perfection? Was it a reply he was seeking, or a kind of self-denial? In any event, there can be no doubt that the *Bathers* of this era bring to mind certain aspects of the same subjects painted by Picasso. Witness the small heads supported by long necks, the emaciated arms, and the generally provocative form and movement that transform a woman into a puppet of a slightly monstrous kind. Braque's women, however, lack

the aggressiveness of Picasso's: even in their outlandish appearance they retain a certain gracefulness, if only in their arabesque-like movement and the lack of reserve in their postures.

COLOR AND FORM (1930–32)

The nudes of this period, more than the still lifes, mark an obvious attempt to simplify, an effort already visible in the landscapes but now a good deal more complex in nature. Bodies were reduced to large monochromatic areas that made up the center of the picture, surrounded by two or three elements also composed of broad, colored surfaces. The forms may seem a bit overblown, but this is counterbalanced by an elegance whose satisfying harmony and equilibrium hark back to a kind of order that one is tempted to call classical.

Braque then applied the technique of arrang-

ing areas into large expanses of color to a new series of still lifes. This time, however, the colored areas are not made to fit the contours of the objects; they are merely suggested by a threadlike outline which, though drawn upon the surface, remains independent of it. What we see here is a reemergence of dissociated form and color, now freely superimposed. The isolated objects are simply hinted at; they become nothing more than symbols whose shape is outlined but whose surfaces remain unmodeled. With these compositions, Braque achieved a purity, a serenity, comparable to the *papiers collés* at their most splendid, but this time utilizing a more flexible and readable system of representation.

This series is also marked by the virtual elimination of straight lines (except for the table edges that, now more than ever, serve as a kind of framework). The replacement of orthogonal patterns by compounded, interconnected circles and curves endows the forms with a high degree of pliability while totally avoiding the feeling of dullness that might be expected from such a procedure.

Occasionally, this new spirit of simplicity endeavored to join forces with the previous scheme of *guéridons* laden with geometrically arranged piles of objects. Yet these cannot be considered transitional works; we see that from their dates of completion. They represent instead a skillful, captivating assimilation of two seemingly irreconcilable systems, a solution that yielded highly distinctive creations.

A number of very lovely works were to emerge from this new phase, but its basic form was the simplified still life. With the solemn elegance and spirit of rigor that constantly reappear in the work of Braque, this phase offered a special sense of rhythm that governed a picture's overall architecture—a rhythm of masses undulating like waves coiled in on themselves, evoking once again their resemblance to music.

MYTHOLOGY: INCISED PLASTERS (1931–32)

Other series of works have already made us feel we were touching the field of music, that there was some link between the two, as much by Braque's assured rhythmic precision as by the lyric quality enveloping and emanating from his forms or his interplay of colors.

This kinship, this harmony between two dis-

ciplines, reasserted itself about 1930 in a new, strictly graphic technique for depicting mythological figures. The largest of these engraved plaster panels were commissioned as decorations for an apartment in Paris. The sharply cut line runs over the black-coated surface like a white thread, unwinding itself to wherever the artist's mind may take it. We delight in accompanying him along this fanciful, unpredictable road, this curving thread of Ariadne whose path the reader must be willing to follow if he is to savor fully its details. These figures and their wiry outlines are to be found again in the etchings that Braque was then beginning to execute as illustrations for Hesiod's *Theogony*, commissioned by Vollard but not completed until their publication by Maeght in 1955. To the spontaneous act of visual perception inherent in drawing and painting was now added a curious sensation of movement through time. Perhaps this is why the deciphering process we see here is felt to have something in common with the interconnected series of perceptions that more properly belong to the domain of music. Thus Braque opened his art to territory that he had yet to explore, using that particularly effective ability of his to treat a subject under the twofold yet simultaneous influence of instinct and intellect, that is, spontaneity and reflection.

We have already seen this double viewpoint at work, beginning with the earliest displays of boldness of the Analytical Cubist period. There the disintegration of the subject into facets gave one the impression of a process of creation that is both premeditated and improvised. The same is true of the incised plasters: only the means are different. In both cases, each detail considered separately does not in itself seem to carry much weight. Rather, it is the position it assumes relative to its surroundings that gives it meaning and, conversely, enables it to give meaning to the whole. The unbroken line does not circumscribe the form or pin it down. It roams about in the void, and its winding paths link up to form a comprehensible shape that is silhouette and movement in one, beaming with life and spiritual truth without in any way borrowing from the imitation of reality.

Extraordinarily animated despite their utter lack of density, these transparent forms loom out from an emptiness devoid of perspective. Braque retained their graphic quality even when he would occasionally make use of them in paintings, that is to say, when he utilized a medium that was more substantial than a traced outline.

THE "DECORATIVE" STILL LIFES (1933–36)

In preceding sections, we have presented the works of Braque as running in distinct, well-ordered cycles. Although this tendency does continue, it becomes increasingly difficult to confine his work to precise dates. Thanks to an awareness of what he wanted, combined with a mastery of what he did, Braque achieved a maturity and freedom that allowed him to embark on a wide range of experiments, laying them aside or returning to them without ever showing signs of weakness or redundancy.

Just as the landscapes of 1938 were to echo those of 1928–30, so the still lifes of 1933–35 (and even beyond) were cast in the mold of those executed during the years 1928–30. Once again we come across a centrally positioned jumble of objects heaped atop a table. Now, however, the overall atmosphere is different; it has become fresher, less ponderous, generally characterized by light backgrounds. Black has been almost completely eliminated. Colors have realigned themselves to fit within the boundaries of the objects, a far cry from the dissociation of form and color seen in the broad synthesized areas of the recent 1932 series.

By virtue of their brilliance, the feeling of tranquility that flows from them, and the elegance of their arabesque-like rhythms, these still lifes have been dubbed "decorative" in order to distinguish them from those of other periods.

Generally speaking, the background, now more closely related to the scene, serves as a frame that sets off the group of objects. At the same time, it suggests a space which, after opening out to the right and left, finds itself severely cut off by a wall to the rear that often comes alive with the winding patterns of false marbling. The paintings of this phase are perhaps the most sophisticated works that Braque ever created. Their polished quality could almost be termed precious, without attributing to that adjective any hint of limitation or the slightest trace of flimsiness.

It is indeed a refined approach that blends the objects filling the central area (that is, a zone made up of rounded contours) with the surrounding table and walls, whose paneling constitutes a zone governed solely by straight lines. In other words, the central mass, its lines in motion, is enveloped, framed in a stiff, orthogonal network that, here again, results in an exceptional kind of space. Its slanted lines suggest a receding movement, but this does not engender a break between the foreground and the rear.

The outstanding feature of the *Guéridons* or the *Mantelpieces* of 1925 or 1928–30 is the bulky forcefulness and austerity created by the denseness of the materials used and the powerful contrasts of predominantly dark colors. Even harsher and more static are the still lifes of 1931–32. But those of 1933–35 shine with a brilliance, a lightness, that borders on transparency; and they come closer to giving a feeling of movement.

Perhaps all this reflected a particularly favorable period in Braque's life. Ever since he had had Auguste Perret build his Paris residence in 1925 and had set up shop in Varengeville in 1930, there seemed to be no end to his string of successes. His shows grew in number and importance, and, in 1933, the Basel Kunsthalle organized the first major retrospective of his work. So obvious was the blossoming of Braque's art that one of the still lifes in this series, *The Yellow Tablecloth* of 1935, won for the artist the first prize of the Carnegie Foundation in 1937.

INTERIORS WITH FIGURES (1936–39)

The experiments that Braque had worked on starting in the postwar era culminated in or were contradicted by a new series depicting interiors, with or without human figures. They are imbued with a poetry and mystery that spring from their ability to close in on reality and transfigure it.

From now on, the principle of accumulated objects already utilized in the still lifes was extended to include the entire picture, the entire space of the room depicted. That is, Braque rejected the notion of a concentrated, centrally located grouping set off by a neutral space. Instead of drawing in on itself, as in previous stages, the picture drifted toward expansion. Vertically juxtaposed planes—a bit reminiscent of the order imposed by Synthetic Cubism in 1917–18—form a relatively calm background area, decorated now and again with ornamental motifs that reinforce the busy climate of what lies in front.

To avoid a break between the foreground and the more remote areas, the intricate patterns of the wallpaper were made to blend in with those of the furniture, vases, and flowers. In this manner, rounded contours and rigid orthogonals become interwoven in an overall rhythm; the various areas or motifs are overlapped or superimposed to create a lively mosaic. Thus, people and objects

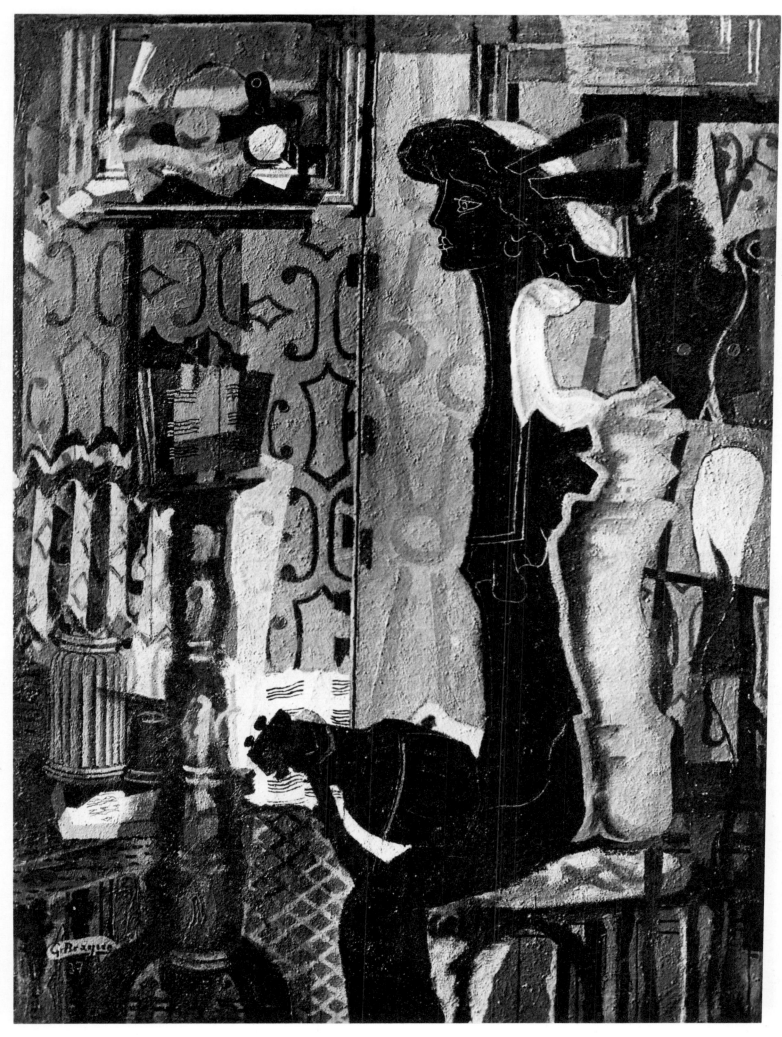

27. *Woman with a Mandolin.* 1937. Oil on canvas, 51 1/4 × 38 1/4″.
The Museum of Modern Art, New York City. Mrs. Simon Guggenheim Fund

28. *Head of a Woman*. 1940.
Bronze, height 10 1/4″

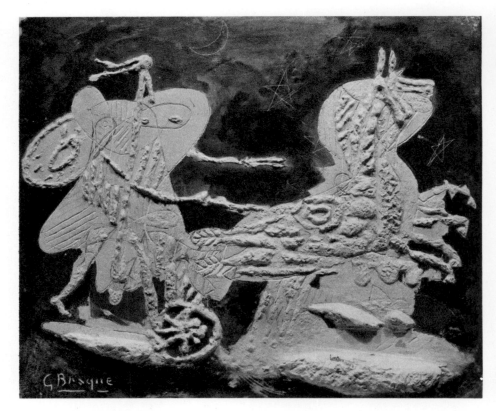

29. *The Chariot of the Sun*. 1952.
Plaster relief

30. *Standing Woman*. 1920.
Plaster, height 7 7/8″

31. *The Pony*. 1939. Bronze, height 7 1/8″

32. *Io, or the Chariot of the Sun.* 1935.
Plaster relief, 8 5/8 × 10 7/8″

33. *Greek Head.* 1941–42.
Bronze, height 9 7/8″

34. *Head of a Horse.* 1943.
Bronze, height 15 3/4″

35. *Hymen.* 1939. Stone

function simultaneously as independent elements and as close allies, thanks to color and to the fine white or lightly colored thread that often delineates the design and in the process enhances the transparency of resulting outlined forms.

This gossamer denseness is even more palpable in that each element, inserted into the whole like a piece of a jigsaw puzzle, glows without any assistance from projected shadows. This is not to say that there is no shadow at all; only now it exists solely as the object's surface, to suggest its volume. Alternating light and shadow are juxtaposed vertically; they complement one another to re-create the various features of those volumes.

True, this technique had already been exploited for several years as a means of modeling the surfaces of objects in the still lifes. But by adapting it to human figures placed in front of a window, and by taking advantage of the powerful effects of backlighting, the procedure took on a richer meaning. To combine the front and profile of a face is to suggest a visual simultaneity more complete than that proposed by Cubism; it is a way of depicting the multiple surfaces of the model. Certain commentators would like to see in this binary system of representation a kind of symbolic reference to such things as the dual nature of being —with the intimate light/shadow relationship corresponding to the opposing emotions that make up the individual—or even the conflict/unity of body and soul, life and death.

We feel that such ideas go beyond those of the painter. Not that Braque is incapable of investing his paintings with meaning and infusing them with a kind of poetry; his writings attest to that. In his case, however, spirituality and poetry are to be found not in some symbolic language, but in the work itself, in what it expresses directly and in what flows from it. All the elements that contribute to one of his pictures do so with absolute neutrality, be they forms and colors or figures as anonymous, as impersonal, as vases or pieces of fruit. The odd thing is that this neutrality fosters an air of mystery and a feeling of static vitality, of silent intensity fraught with secrets. This pervasive atmosphere imparts an animation to the otherwise fixed objects or figures. The picture becomes a pageant that is deciphered bit by bit as one deciphers the details. To read it is to enter a highly complex world; and though it may not seem so on the surface, it is a world as unorthodox and as rich with discovery as that of his Cubist works,

except that the former is more deeply imbued with human feeling.

In order to respond to those critics who are intent on interpreting certain scenes along symbolic lines, we must emphasize the fact that human figures do begin to appear. Unlike the role played by mere props, their very presence injects an active element into a stationary universe. It is no longer enough simply to take diverse kinds of plastic values and note their internal conflict or harmony. Now one must add to this the conflict or harmony between those features and spiritual values. Through this presence, the picture seems to want to tell a story, to appeal to our imagination. Its poetry comes alive through potential activity: the evocation of forms leads to the evocation of dreams.

Here again, Braque's thought cannot be limited to precise dates. In the course of future stages of his career, we shall encounter works akin to those just examined that hark back to the same procedures and similar feelings. We have stated that these interiors seem to bring previous lines of experimentation to a close. But they also serve as a point of departure for achievements of a different order; and we shall be tracking their development in future works.

SCULPTURE (1939–40)

As a sculptor, Braque produced very few pieces, but each is important because it carries so much meaning. In general, they do not duplicate his paintings or even present other versions of the same themes, but instead constitute a separate sphere of activity that stands apart like a rest stop between two periods of painting.

At least this seems to be the case for those years (1939–40) that witnessed the greatest number of such works. Since the war made it relatively difficult to obtain colors, the artist tried his hand at the stones and pebbles of Varengeville.

His earliest-known sculpture dates from about 1920, a female form in plaster whose body is made up of superimposed lozenges enveloped in curving shapes. Perhaps it embodies Braque's passage from the last of the postwar Cubist paintings to the suppler, almost Baroque manner of the still lifes. Jean Leymarie points out an even earlier exercise that also took place during a period of transition: "In 1912," he writes, "when Cubism reached a turning point, he made some paper reliefs which were not without influence on the

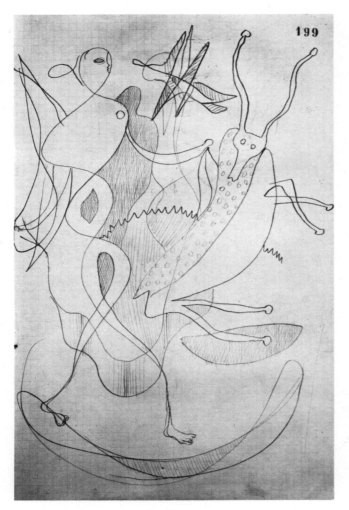

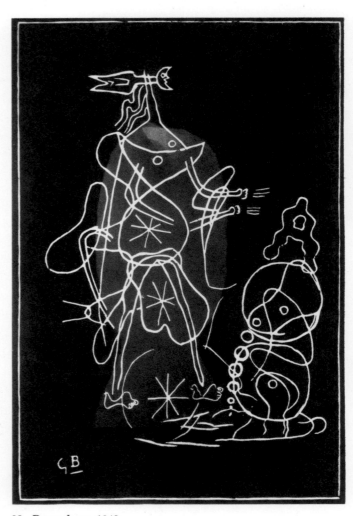

37. *Diana.* 1932.
Pencil, 12 1/4 × 8 1/2″

38. *Persephone.* 1948.
Color woodcut, 22 1/2 × 16 1/8″

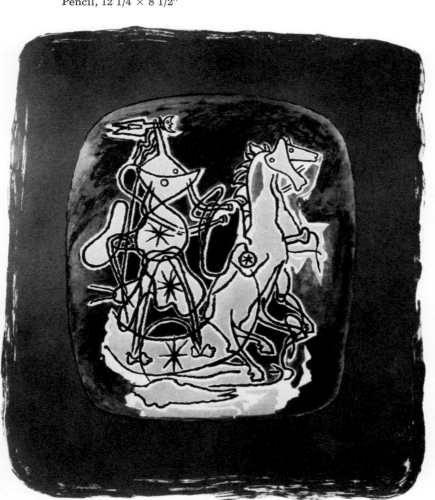

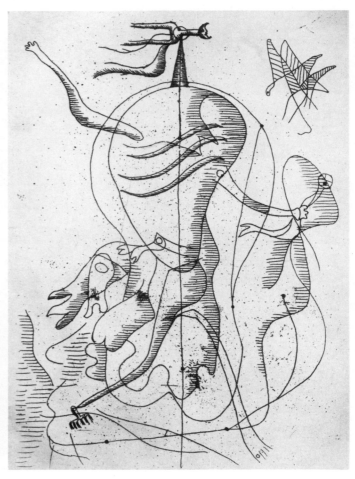

39. *Hera.* 1948.
Color lithograph, 25 5/8 × 19 3/4″

40. *Theogony.* 1955.
Etching, 11 3/4 × 8 1/4″

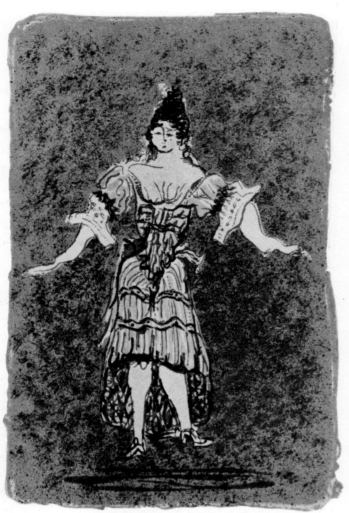

41, 42. *Les Fâcheux,* Extracts from "Regard sur Paris." 1963.
Color lithographs

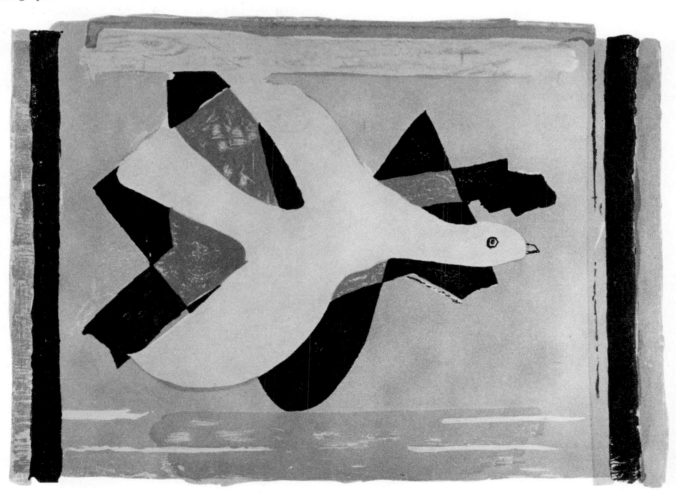

43. *The Bird and Its Shadow.* 1959.
Color lithograph, 23 1/4 × 33 1/2"

'constructions' of his friend Henri Laurens."

Thus his first steps in this direction were taken during an intermediate phase, and they attest to Braque's desire to cease limiting himself exclusively to painting as a medium of expression. The paper reliefs probably paved the way for the celebrated *papiers collés* (in September of the same year). By throwing into question the very nature of the materials used, the "pasted papers" constituted a step of paramount importance in the history of Cubism and of modern art in general.

One could also link the artist's excursion into sculpture to the 1931 engravings on black plaster, not only because they marked a technique newly adapted to unconventional materials, but because the system of graphic representation used by Braque to depict mythological figures was to reappear (with the exception of a few isolated cases) in the 1939 series of sculptures and not in the paintings.

The 1939 cycle was by far the most important, occurring during a period of change. In a sense, the approaching war signaled a halt to the preceding series of experiments before his painting could set out again on new paths.

At Varengeville he picked up and assembled pebbles and bones—simple, pristine forms molded

and polished by time—and carved profiles into them. He would also join them face to face, as in the case of that immediately famous grouping entitled *Hymen*, a bizarre dialogue of shapes in an abstract space.

By undergoing this metamorphosis, inert matter was transformed into austerity and anonymity incarnate, like the heads on Easter Island, also carved from stone. Heeding no material reality other than that belonging to his hands guided by his mind, Braque took nature and added to it his own shapes, the progeny of those hands and their will to create.

A striking throwback to antiquity, this serene, haunting magic was stressed even more in the 1942–43 series of profiles of women, horses, harnessed plows, birds, and fish. Although stone now gave way to bronze, there was no change in the spirit of these forms, these self-sufficient objects. They are autonomous, and their only function is to be themselves, not the imitation of something.

Even more than his paintings, Braque's sculptures are signs, amulets, sacred in content. True, the incised plasters already carried the weight of mythic images. But with his symbolic animals and their emblematic structures, Braque created talismans. Later on, such simplified images recurred in designs for jewelry (executed by Heger de Löwenfeld), thus bringing to these fascinating, magical shapes the spirited opulence of gold and precious stones.

FRUITFUL SOLITUDE: STILL LIFES, FISH, WINDOWS (1939–43)

Braque now had to face the ordeal of war. When the Germans invaded France in May, 1940, he left Varengeville and took refuge in the Limousin, then in the Pyrenees. He returned to Paris in the fall and remained there until 1944, when he went back to Varengeville.

Could it have been a sign of the times that his work took a turn toward greater austerity? The lyricism of the happy still lifes and the throbbing intimacy of the interiors gave way to harsher variations on more or less analogous themes. One might almost see this symbolized in the occasional occurrence of a skull and crucifix were it not for the fact that Braque was not given to revealing himself in this way. Nonetheless, we should bear in mind that several of these compositions are entitled *Vanitas* or *Hamlet* and thus a meaning is clearly implied.

44. *Head of a Girl*. 1951.
Color lithograph, 8 7/8 × 6 3/4"

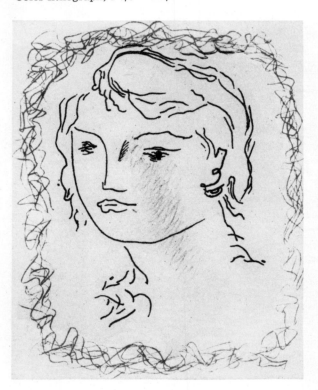

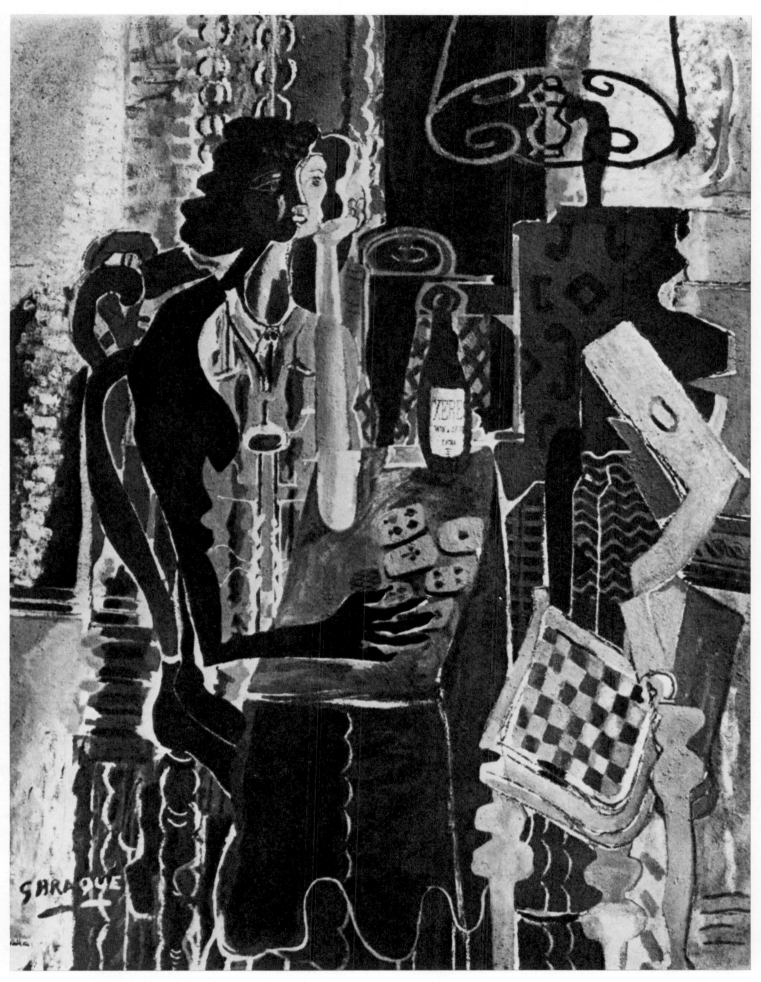

45. *Patience.* 1942. Oil on canvas,
57 1/2 × 44 7/8″. Private collection, Lausanne

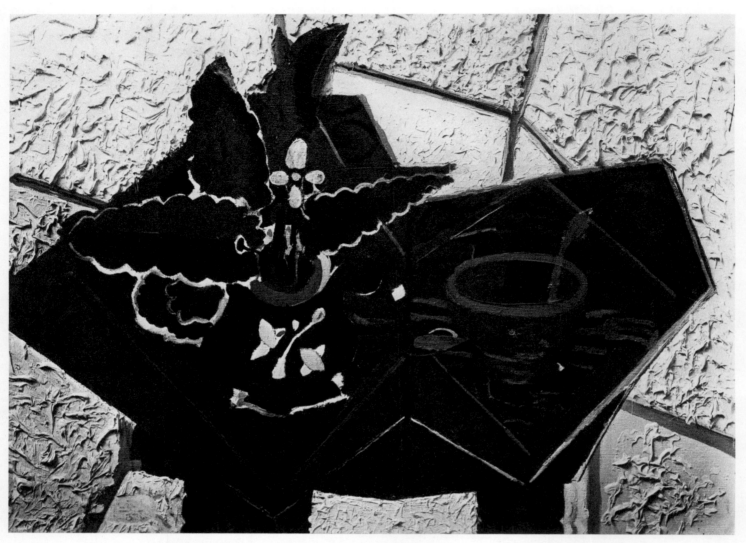

46. *The Green Tablecloth.* 1943. Oil on canvas,
18 1/8 × 24 3/8″. Private collection

He had already introduced these objects in three 1938 works. Was this a presentiment of the gravity of approaching events? We do not wish to dwell too much on symbolic interpretations. We shall simply point out that the last works to deal with this theme date from 1943 and that, during these years, the specific objects brought together by the artist as well as the overall appearance of his pictures veer toward a sense of deprivation and severity that stands in contrast to the blossoming of earlier works. The fruit and musical instruments have been replaced by toilet articles and kitchen utensils, humble tokens of everyday life.

Though absent from the decorative still lifes of 1935–36, black had begun to reassert itself in the composition of certain interiors between 1937 and 1939. Now—and especially in the arrangements including fish—it became more noticeable than ever, imparting a general feeling of bare, powerful simplification of form. In several paintings, the contrast between the smoothness of the objects and the rough surface of the background adds an almost brutal accent to the atmosphere of austerity.

During this gloomy period, however, one element did appear in a few works that was to attenuate the sense of heaviness: the window was introduced into certain pictures whose themes echoed those of previous interiors. Braque did not make use of it until 1939; up to that point, he had forced us to live in a closed world. Now a window was inserted in an attempt to open things up to a less confining space. It is a spot of bright, not brilliant light, but its restraint does not prevent it from giving the atmosphere greater fluidity. Its pale light often intensifies the familiar melancholy of the objects and actually accentuates the feeling

of solitude more than it hints at the possibility of escape.

Braque was discreet when it came to his emotions. He did not dramatize his subjects to make them consistent with the trials of the times. Using everyday items, he expressed himself in paint with a sense of proportion that takes on a quality of quiet eloquence.

ENGRAVINGS (1932–57)

At every stage of his evolution, Braque was interested in experimenting with diverse technical resources. In the course of his development we have witnessed his practice of adopting different styles of painting, of shifting from one to another, then returning to previously exploited themes and devices—all of which bears out both his integrity and the extent of his unremitting curiosity. How could he resist the medium of engraving? As it happened, he didn't, but he produced fewer works in this area (especially before 1945) than in painting. Most of what he did took the form of illustrations for books of poetry.

The year 1945 was an important one for his work in lithography. Previous to this date, he had tried his hand at the technique only on three occasions: in 1921, in 1928, and a more elaborate effort in 1932. In 1945, Fernand Mourlot published Jean Paulhan's *Braque le Patron*, illustrated with lithographic reproductions of his paintings. Braque followed the printing of the edition with great interest. This may well have provided him with the chance to discover the resources that the technique had to offer, for beginning in 1945 more and more works employing the lithographic process were to appear. Several of them were published by Mourlot, others by Maeght; but it was the latter, his new dealer, who regularly organized exhibitions of his works from 1947 on.

Braque's excursion into engraving owed little to Cubism, which is a strictly pictorial system that seeks to inject the concerns of drawing style into the problematics of a picture. This can be seen in several watercolors and woodcuts from that period.

As far as subject matter is concerned, there are, apart from the still lifes and flowers, two series: *Birds in Flight* and the lithographs and etchings executed for Hesiod's *Theogony*. Although published in 1955, the latter were begun back in 1932 and are related to the incised plasters of 1931, whose figures, unwinding like a thread of

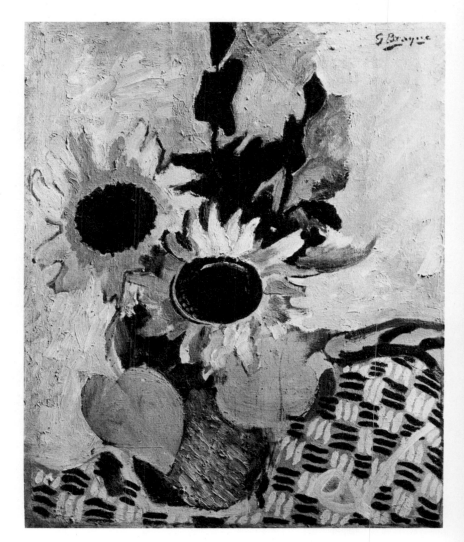

47. *Sunflowers*. 1943. Oil on canvas, 21 5/8 × 18 1/8″. Private collection

writing, belong more to the domain of graphics than to that of painting. At the time of the book's appearance, however, Braque did try to achieve the same effect in paint in a tall figure entitled *Ajax*.

Most of the engravings of still lifes or birds resemble his paintings, both in the feeling for materials and the important role played by broad bands of color. Those dealing with flowers can be traced directly to the period 1945–50, while the *Birds in Flight* echo the years 1952–56. Starting in 1957, nearly all of his lithographs took the bird as their theme.

As we enumerate the various graphic works of Braque, we should mention his *Cahier*, published in 1947 and 1948 in facsimile editions. Each page reveals a thought closely intertwined with a drawing. In effect, drawing becomes a kind of writing; and the book may be seen as a spontaneous yet refined version of some of the more highly developed aspects of his paintings and engravings. But his ideas take on particular brilliance here, as the freely executed drawings parallel texts that always invite the reader to stop and reflect.

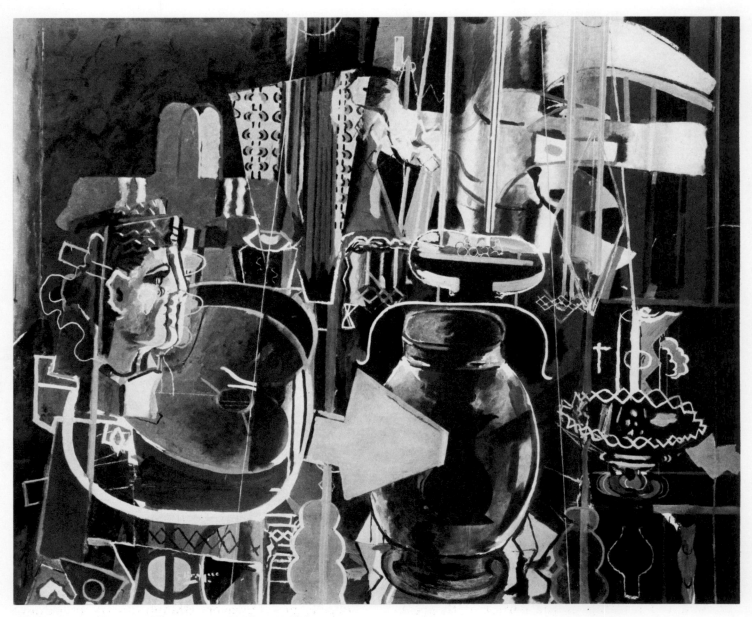

48. *The Studio (II)*. 1949. Oil on canvas, 51 5/8 × 63 3/4".
Kunstsammlung Nordrhein-Westfalen, Düsseldorf

A NEW SPACE: STILL LIFES AND BILLIARD TABLES (1942–44)

The year 1944 saw the beginning of a new theme, the billiard table, which in turn signaled a change in the artist's conception of space. Actually, this trend had already started to appear in previous works. The 1936–39 interiors with figures reveal a denseness that excludes any empty spaces. Arranged like a puzzle, they are composed of interlocking elements such as objects and decorative patterns that create a maximum of clutter. Since such overlapping tends to negate the effects of perspective, it is color that now conveys the feeling of space. Motionless as the objects themselves,

the human figures heighten the sense of haunting immobility.

In the still lifes and interiors to follow, the clutter has been thinned out, and so space, albeit still quite static, has become freer. Of particular interest is the window motif previously discussed. True, it had been utilized in preceding works, but it often filtered the daylight through gauzy curtains. Now it not only assumes an important position in the general arrangement of elements and lighting, but opens out to the sky as well. The dimensions and distribution of the various areas become altered by the light and, as a result, the more distant zones regain their value as a background relative to the whole. The air circu-

lates more freely here, but in a compact enough space to maintain a sense of stability among the elements of the composition.

Objects, too, carry more weight, a greater sense of autonomy and everyday reality, doubtless because now fewer in number and thus more loosely intertwined than in the *Guéridons* of 1930–35 or the interiors with figures of 1936–39. Their shapes are supple, and the sometimes grainy materials used to fashion them are sensuous. One gets the impression that Braque wanted to reestablish physical contact with tangible reality surrounding him. His use of the most rudimentary elements brings into play the trivial nature of the objects (washbasins, frying pans, grills), visual truthfulness (every detail can be identified), and the allure of tactile sensation (raised or rough surfaces).

At the same time, there are works whose blend of characteristics bridges the gap between the diverse approaches adopted thus far. For example, in the famous painting entitled *Patience* (1942), we see a recurrence of the clutter and general style of the interiors with figures (1936–39) and their jigsaw-puzzle effect; depth is suggested by a table placed in the kind of perspective already used for the piano in *The Duet* (1937); and the window adds a luminous transparency.

The *Billiard Tables* of 1944 mark the culmination of this series of creations which, taken separately, may seem contradictory but which acquire coherence when considered as a group. Although they clearly constitute a separate entity, they bear out once again how elements from one period crop up in another. The dominant feature is the bend in the large green expanse of the billiard cloth—the resulting surface is a development of early Cubist fragmentations and breaks in the visual plane—that allows the eye to pass from the horizontal to the vertical. Moreover, we recognize the slanted lines of the walls and cornices from the decorative still lifes of 1933–35, the supple movement from those of 1942, and the bright patch of light in the background from the windows that began to appear about 1936. Everything comes together in a space in which perspective has once again assumed the role of uniting the different parts of the painting.

AN IMPRESSIONISM OF SORTS: GARDEN CHAIRS AND FLOWERS (1943–48)

The period spanning the last years of the war and the first years of the postwar era was one during which Braque diversified his creativity, as if to reaffirm his rejection of all limitations. We have just witnessed some examples of that attitude in works which, to a large extent, still follow a certain logical development.

But there is another group of paintings that strikes us as being more autonomous. Even though they could be considered an outgrowth of the simplified still lifes that immediately preceded them, they set themselves apart by their style, spirit, and the sense of greater freedom they communicate. They depict garden chairs or vases of flowers seen close up and treated in a seemingly more spontaneous manner. In fact, a kind of improvised pointillism is employed now and then to interpret better the fragility and shifting quality of the flowers.

It is a style whose stress on sensuality and sensation tempts one to use the terms Impressionism or Fauvism. Consider, for example, how certain areas are treated as smooth surfaces, while others are applied roughly with thick impasto and granulation that catch the light. These still lifes are bathed in a brightness that obliterates projected shadow. In the case of the garden chairs, even straight lines become plied into convoluted shapes and seem to function solely as a web supporting the lightness of the other elements.

Should we see in these works the development of a kind of neo-realism, a less hermetic poetics, just at the time when younger generations of painters were leaning more and more toward purely abstract art? Couldn't Braque have been reaffirming the resources of the real world in reaction to them? In any event, his freedom tended to add a spiritual quality to reality. And let us remember that reality is not the same thing as realism. It is probably no accident that certain of his paintings echo the sun theme so dear to Van Gogh, with the obsessive force of its brilliance and energy.

Despite the fact that a painting now often depicted nothing more than an isolated subject—a chair, a bouquet of flowers, or even a single flower—at no time did Braque consider it merely an isolated venture. Not only did he eventually bring several motifs together into more complete arrangements (the *Terraces*), but he also included still lifes which, albeit more disciplined, are treated in the same manner as the others (in some of the *Billiard Tables* and occasionally in later works).

In the years that followed, and even in the final works, still lifes were painted in accordance with this approach. In many instances, Braque positioned them on elongated canvases—a format to which he periodically returned from 1919 on—or in very narrow vertical arrangements that we have also had occasion to point out. Together they represent two ways in which the artist yielded to the charm of the unexpected, as embodied in Baroque art.

THE *STUDIOS*, THE BIRDS, AND THE NIGHT (1949–56)

After the complex interiors with figures and their alternating areas of light and shadow, after the unpretentious garden chairs and radiant bouquets of flowers, we enter a realm of silence and night, of interiors where a peculiar magic prevails. In terms of the artist's evolution, one can again pick out details that trace their roots to previous works: a woman's profile; the style of certain still lifes; the device, already employed in preceding interiors, of objects accumulated to the point of clutter or even chaos; and the same way of treating all parts of the picture space with equal density. And yet, all this has become different: now thought out afresh in a new context, everything seems to exude a sense of profound mystery.

Never before had Braque penetrated so deeply into the realm of metamorphosis. Although the artist now removed objects from physical reality, he did not totally repudiate reality in the Cubist manner. Instead, objects became allusions to shapes fitted into an all-encompassing harmony, an unfolding rhythm whose successive movements again suggest a musical composition. Long parallel bands combine with or follow one another, like the propagation of waves that receive and emit color. Out of the secretive, rippling semi-darkness that harbors metamorphosis there appears a bird on the wing—a gleam of light in space, a reflection of itself—flying across the other colors that share its shifting stability, accentuating the unreal nature of their reality and the immobility of their silence.

The closed universe of the studio with its bric-a-brac of memories is invaded by birds that bring with them the alien outside world. Space and movement make their insolent presence felt, only to find themselves, in turn, falling under the spell that surrounds them. Of course, Braque had, on many occasions, demonstrated his wizardly powers of transmutation, but on a plastic level.

This time he created myths, as though wishing to give substance to the intangible. Ensconced among the *Studios* is the noble figure of an unsettling deity entitled *Night* (1951), who indeed seems to have been created expressly to haunt this abode and embody its power of nocturnal sorcery.

A ninth *Studio*, begun in 1954 and completed in 1956, was added to the existing cycle of eight paintings executed between 1949 and 1956. They constitute a group of works whose poetic loftiness is somewhat overwhelming.

EARTH AND SKY (1950–63)

At the same time as he was cooping himself up in the darkness and shuddering silence of the *Studios*, Braque continued to notice the dazzling colors of flowers and turned his attention to the rugged terrain of open fields bathed in sunlight. Starting in 1950–51, he went back to landscape painting: not solidly constructed sea-cliff scenery, but the unrelieved plenitude of broad horizons, the marriage of earth and sky running parallel along vast expanses viewed at ground level. Braque showed a marked preference for elongated formats during these years; and the landscape theme was especially well suited to it. Without any help from forms or details, the artist united sensation and feeling with the utmost simplicity.

Elsewhere, birds in flight, conjured up from the unfathomable depths of the studio, now regained their freedom of movement and space. Braque released them into the limitless sky, alone, where they took spirited wing. Simplified like some abstract force of nature, they are virtually his unique inventions. When he was commissioned to decorate the ceiling of the Etruscan Gallery of the Louvre (1952–53), it was the bird motif that he chose to utilize. Its neck outstretched, its wings fully extended, the bird breathed life into the large paintings and became light itself when treated in stained glass (St. Bernard Chapel at the Maeght Foundation in Saint-Paul-de-Vence, executed in 1962).

Like the birds, Braque's landscapes were now stripped to the barest essentials: the material and the spiritual were now joined to produce the purest possible synthesis of form, movement, and time. In the solemn tranquility of his twilight years, the artist seemed to have achieved what had always been his goal, the object of his unrelenting quest: the possibility of creating a space that

is both visual and tactile, well defined yet unbounded, one that fleshes out the forms without confining them, one that accepts and checks their movement without putting it in shackles.

Thus reduced to their essence, to their infinity, the earth and the sky captured the artist's imagination and intellect completely. When someone once objected to the fact that a form occurring in one of his paintings did not exist in nature,

Braque is said to have replied: "Well, it's there now!" No other statement defends or concludes his career more convincingly than that, nothing else better sums up its life-force.

Georges Braque died on August 31, 1963. He was given a state funeral amidst pomp and ceremony in the Cour Carrée of the Louvre, at which time a fine eulogy was delivered by André Malraux.

49. *The Plough.* 1954. Oil on canvas, 10 5/8 × 18 1/8″. Private collection

Rechercher le
commun qui n'est
pas le semblable.
C'est ainsi
que le poëte
peut dire :
Une hirondelle
poignarde le
ciel, et fait
d'une hirondelle
un poignard

Quand quelqu'un
ne fait des
idées,
c'est qu'il
s'éloigne.
de la vérité
— S'il n'en a
qu'une
c'est l'idée
fixe on
l'enferme

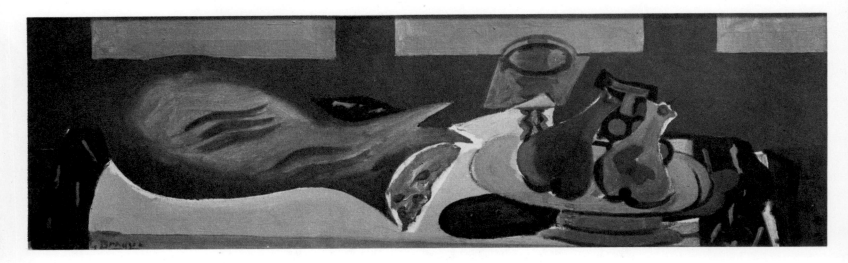

WRITINGS AND THOUGHTS OF GEORGES BRAQUE

Extract from "The Wild Men of Paris," *The Architectural Record,* May, 1910

"I couldn't portray a woman in all her natural loveliness. I haven't the skill. No one has. I must, therefore, create a new sort of beauty, the beauty that appears to me in terms of volume, of line, of mass, of weight, and through that beauty interpret my subjective impression. Nature is a mere pretext for a decorative composition, plus sentiment. It suggests emotion, and I translate that emotion into art. I want to expose the Absolute, and not merely the factitious woman."

Extracts from *Cahier de Georges Braque: 1917–1947*, Paris: Maeght, 1948

"Reality. It isn't enough to make visible what you paint. You have to render it touchable, too."

"Emotion can neither be added nor imitated. It is the seed, the work is the flowering."

"The artist should not be asked for more than he can give, nor the critic for more than he can see. Let's be satisfied to cause people to think; let's not try to convince them."

"Art is meant to disturb, science reassures.
By the grace of God, says one,
the other says: God is with us, and the third: God and my Right."

"One should not imitate what one wishes to create."

"If the painter doesn't despise painting, then he ought to be afraid to create a canvas that is worth more than he himself."

"Those who forge ahead turn their backs on the followers. This is all that the followers deserve."

"A painter doesn't endeavor to reconstitute an anecdote, rather to constitute a pictorial fact."

"There is popular art and there is art for the people, which latter was invented by intellectuals. I believe that neither Beethoven nor Bach—while being inspired through popular melodies—ever thought of establishing a hierarchy thereby."

"I would much rather put myself in unison with nature than copy it."

"Every age limits its aspirations. From which springs, along with complicity, the illusion of progress."

"Writing isn't the same as describing.
And painting isn't the same as depicting.
Verisimilitude is visual deception."

"To construct is to assemble homogeneous elements.
To build is to unite homogeneous elements."

"A vase gives form to emptiness, music to silence."

"It is a mistake to lock the unconscious in a contour and to place it within the limits of reason."

"The future is the projection of the past that has been conditioned by the present."

"Mystery glows in the bright daylight, the mysterious mixes with obscurity."

"The perpetual against eternity.
Certain people, such as the naturalist, try to stuff nature, in order to make it immortal."

"Magic is the sum of the means which kindle credulity."

"A lemon and an orange side by side cease to be a lemon and an orange and become fruit. The mathematicians follow this law; so do we."

"What is not taken away from us remains with us. This is the better part of us."

"Reasoning is a pathway for the mind and a turmoil for the soul."

"Freedom is seized but not given. For the rank and file it means the free play of habits. For us it means going beyond the permissible. Freedom is not accessible to everyone. For many it lies between the forbidden and the permitted."

Extract from an interview with Dora Vallier in *Cahiers d'Art,* October, 1954

"The subject, it's as if a fog had lifted and the objects had appeared. Naturally the object can only appear insofar as painting permits. And painting has its demands, you know . . . There's no question of starting from the object: you go toward the object. It's this path which one takes to progress toward the object that interests us. When fragmented objects appeared in my paintings toward 1909, it was for me a means of coming closest to the object, inasmuch as painting allowed me to do so. Such fragmentation enabled me to establish space and movement in space, and I could not bring in the object until I had created space . . . At that time I painted several musical instruments, first because I was surrounded by them, and then because their plasticity, their volumes belonged to the realm of the still life, as I understood it."

Extract from *Ces peintres vous parlent,* 1954

"People know nothing whatsoever about art. It's the effects that give us the cause. Those who write history by relying on the past don't realize that the past is nothing more than hypothesis. How did Cubism originate? I myself did not have that much to do with its discovery. It was an engrossing inquiry into space, just as the *papiers collés* were a way of introducing color exclusive of form.

"Generally speaking, the space of contemporary abstract artists has been reduced to two dimensions. They find it very difficult to move about in depth. In its early phases, however, abstract art did not break away from nature; it probed it all the more deeply. We see in nature what we must see in nature. To do without it means that it all becomes decorative, a quest for the symphonic."

GEORGES BRAQUE AND THE CRITICS

Guillaume Apollinaire, Preface to the catalogue for the exhibition at the Kahnweiler gallery, November, 1908.

"This is Georges Braque. He leads an admirable life. He strives passionately toward beauty and achieves it, apparently without effort.

"His compositions have the harmony and fullness we have been waiting for. His embellishments reveal tastefulness and breeding backed by instinct.

"He has become a creator by drawing from within himself the elements of the synthetic themes he depicts.

"He no longer owes anything to his surroundings. His mind has deliberately brought about the twilight of reality: witness the all-embracing plastic rebirth taking shape within as well as outside of himself.

"He expresses a beauty that is full of tenderness, and the luster of his paintings bathes our understanding with iridescence."

Jean Cassou, "Braque, Marcoussis et Juan Gris," in *Histoire de l'art contemporain*, Pt. 1, Paris: Alcan, 1935.

"[There is] nothing dry [about his compositions]: on the contrary, there is an understated luxuriance; forms that are at once powerful and discreet; a sinuous line, in no way imperious, that does nothing more than suggest and which even finds that it must often be reinforced and divided in two. Yet, all this timidity is just one more indication of a strength that knows itself, restrains itself, and takes on a refined appearance to achieve greater majesty. The colors, too, are exquisitely delicate; they are ravishing in their restraint. What more can be said about those browns and greens—so marvelously chosen, so marvelously varied—whose austere diversity is enhanced by the diversity of materials used. Here the ingenuity of the craftsman is triumphant: it brings a whole range of substances into play, from a smooth, even touch to the sophisticated mixture by which the graininess of sand is introduced into the thick paint."

Maurice Gieure, *G. Braque*, Paris: Tisné, 1956.

"All we can get out of Matisse are displays of chromatic daring. Dufy can convey nothing but his gift for subtle fancifulness. And Picasso? Nothing. Picasso cannot be done over, only plagiarized. From Braque, however, one can learn everything.

"First of all, the value of the painter's vocation as *craftsmanship*, in other words, technique. Then, the importance of the *concept* that must govern, prepare, and preside over the picture, before as well as during the act of creation. Then, the *poetics*, the spirituality incorporated into the work.

"But above all, we learn from him that an artist's personality is not some endless effort to attain ever-higher levels of extravagance, but a process of reflection, of meditation followed by a moment of fertilization, an obsession, a haunting that is slowly expressed in the work of art."

Jean Leymarie, *Braque*, Geneva: Skira, 1961.

"His evolution after the First World War no longer followed the methodical progression of the cubist and pre-cubist years. He got into the habit of working on several canvases at the same time, for months and even years, now building them up around a single conception, now branching out into conflicting styles, as the mood took him, sometimes changing pace abruptly, sometimes gradually. So his work no longer evolved through a succession of regular stages, but wound its way along an unforeseeable course like a river in spate, developing in unequal but organically connected cycles which, chronologically, often overlap. His production, moreover, now fell into two distinct categories: small-size canvases easily carried about (chiefly still lifes, a few seascapes after 1928, more recently some landscapes), fine pieces of painting, cabinet pictures in the best tradition of French craftsmanship; and vast, complex ensembles from the brush not only of an unsurpassable executant but of a creator always on the alert for new, unexplored pathways."

André Malraux, Eulogy for Georges Braque, September 3, 1963

"But our admiration is not confined to that pacified genius which visits so many masters at nightfall. It embraces too the link between this genius and the most important pictorial revolution of the century, the decisive role Braque took in destroying the imitation of objects and of pageantry. Doubtless the most penetrating characteristic of his art is that it unites with a brilliant and outspoken freedom a domination of the means of that freedom unequalled in contemporary painting. Indeed, by revealing with contagious power the freedom of painting, Braque and his companions of 1910 revealed as well that whole art of the past opposed to illusion, from our Romanesque painting to the beginning of time: patiently or furiously creating their derided works, these painters brought back to life the world's entire past . . ."

Stanislas Fumet, *Braque*, Paris: Maeght, 1965.

"Henceforth, Braque's imagination was to govern everything: it was a guiding force that saw to it that creative impetus should never lead the subject beyond its own vibrating contours. The art of Braque did not let its dynamism waste away through dreamy escapism. Dreams, no. Ideals, no. Hope, as much as one desired, but sparked within us by an ever-present allusion to the real world. This is where art—expressed in paint, but sacrificing modeling for modulation—became the seed of matchless harmonies whose power to vary themselves grew day by day through exquisite combinations of simultaneous, independent forms and colors. Cézanne's declaration—verified in the Aix master's own paintings—was confirmed: 'Form is at its most complete when color is at its most intense.' Is this not how an entire pictorial art took shape; is this not how Braque invented a new classicism?"

51. *Glass and Compotier.* 1920. Drawing. Whereabouts unknown

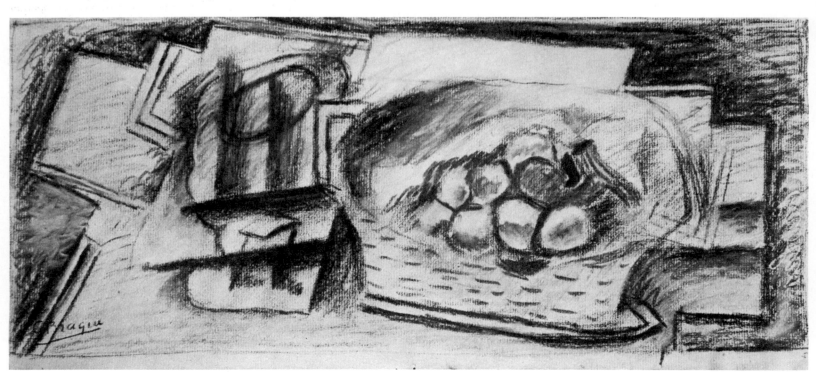

52. Georges Braque, c. 1912 53. Braque, c. 1917 54. Braque, c. 1937 55. Braque, c. 1957

BIOGRAPHICAL OUTLINE

1882 Georges Braque born on May 13 in Argenteuil, son of Charles Braque and Augustine Johanet. His father manages a house-painting business.

1890 The Braque family moves to Le Havre.

1893 Attends the *lycée* at Le Havre. Braque's preferred subjects are drawing and music, and he takes flute lessons from Gaston Dufy (brother of the painter).

1897 Attends evening classes at the École des Beaux-Arts in Le Havre.

1899 Works with his father and is then apprenticed to Roney as a painter-decorator.

1900 Continues his apprenticeship in Paris as a painter-decorator with Laberthe. He lives in Rue des Trois-Frères. Attends drawing classes under Quignolot at the Cours Municipal des Batignolles.

1901 Fulfills his military service at Le Havre.

1902 His military obligation completed, he decides to devote his energies to painting. Moves to Rue Lepic, in Montmartre, and enrolls in the Académie Humbert, where he meets Francis Picabia and Marie Laurencin. Makes frequent visits to the Louvre and the Musée du Luxembourg, as well as the Vollard and Durand-Ruel galleries.

1903 Braque spends a few months in Bonnat's course at the École des Beaux-Arts, but does not find academic training to his liking.

1904 Trips in Normandy and Brittany. Returns to Paris and sets up a studio in Rue d'Orsel.

1905 Friendship with the sculptor Manolo and the critic Maurice Raynal while vacationing at Le Havre and Honfleur. Impressed by the room of the Fauves at the Salon d'Automne.

1906 Braque enters his Fauve period. Exhibits paintings at the Salon des Indépendants. Paints with Friesz at Antwerp, then moves to L'Estaque for the winter.

1907 Sells all six paintings exhibited at the Salon des Indépendants. Spends several months in the south of France, first at La Ciotat and then at L'Estaque. Important meetings with Daniel-Henry Kahnweiler, who becomes his dealer, and Apollinaire, who in turn introduces him to Picasso just as the latter is finishing *Les Demoiselles d'Avignon*.

1908 Returns to L'Estaque. The paintings submitted to the Salon d'Automne are rejected, but Daniel-Henry Kahnweiler arranges a one-man show for Braque, with a catalogue prefaced by Guillaume Apollinaire.

1909 Picasso and Braque develop Analytical Cubism; their works are quite similar. Braque spends the summer at La Roche-Guyon and at Carrières-Saint-Denis. Two paintings accepted by the Salon des Indépendants.

1910 Moves to a studio in Rue Caulaincourt. Returns to L'Estaque in the summer.

1911 Works with Picasso at Céret and becomes friendly with the sculptor Henri Laurens.

1912 Braque is invited to Expressionist exhibitions of the Sonderbund in Cologne, as well as the second *Blauer Reiter* exhibition. Meets Italian Futurists. Beginning of the synthetic phase and the *papiers collés*. Spends the summer with Picasso and Pierre Reverdy at Sorgues, near Avignon. Marries Marcelle Lapré.

1913 Exhibits at the Armory Show in New York. Works with Picasso and Juan Gris at Céret, then travels to Sorgues.

1914–17 Braque is mobilized and receives two citations in 1915. Sustains a serious head wound and is trepanned in 1915. After a long convalescence, he is discharged but does not resume painting until 1917. He publishes "Pensées et réflexions sur la peinture" in the review *Nord-Sud* and begins work on his *Cahier*.

1918–19 Paints numerous still lifes showing everyday objects: guitars, fruit dishes, and fruit. Exhibits at the Leonce Rosenberg gallery.

1920–22 Exhibits at the Salon d'Automne and the Salon des Indépendants. First piece of sculpture, *Standing Woman*. Moves to Avenue Reille in Montparnasse. Enters his Baroque phase with the *Canephorae*.

1923–25 Designs sets and costumes for *Les Fâcheux* (music by Georges Auric), the ballet *Salade* (music by Darius Milhaud), and Diaghilev's *Zéphyre et Flore*. Moves into the house built for him by Auguste Perret at 6, Rue du Douanier.

1926–28 Exhibition at the Paul Rosenberg gallery. Begins the series of *Guéridons* and *Bathers*. Spends his summers at Dieppe.

1929–32 Has a house built at Varengeville, where he spends his summer months from then on. Executes engraved plaster panels, followed by etchings for Hesiod's *Thegony*.

1933–36 Three large-scale exhibitions: at the Kunsthalle in Basel, the Reid and Lefèvre galleries in London, and the Palais des Beaux-Arts in Brussels.

1937–39 Awarded first prize for *The Yellow Tablecloth* by the Carnegie Foundation in Pittsburgh. Series of *Painter and His Model*. Exhibitions at the Paul Rosenberg gallery, in Scandinavian countries, and in Washington.

1940–44 After a period of time in the Limousin and the Pyrenees, Braque returns to Paris for the duration of the German occupation. Works on sculptures and series of still lifes and interiors.

1945–47 Illness slows his activity for a few months. Works in lithography. Retrospectives at the Palais des Beaux-Arts in Brussels and the Stedelijk Museum in Amsterdam. Aimé Maeght becomes his dealer. Publication of his *Cahier*.

1948–51 Awarded first prize for *The Billiard Table* at the Venice Biennale, where an entire room is set aside for his works. The *Studio* series. Retrospectives in New York and Cleveland.

1952–53 Braque is commissioned to paint the ceiling of the Salle Henri II in the Louvre. Exhibitions in Bern and Zurich.

1954–56 Designs stained-glass windows for the church at Varengeville, as well as wall decoration for the Mas Bernard at Saint-Paul-de-Vence. Exhibitions in Edinburgh and at the Tate Gallery, London.

1958–62 His painting activity curbed due to illness, he draws, creates lithographs, and designs jewelry. Exhibitions in Rome. In November, 1961, retrospective show at the Louvre entitled "L'Atelier de Braque."

1963 Braque dies in Paris on August 31, leaving his last work, *The Weeding Machine*, unfinished. State funeral in the Cour Carrée of the Louvre. Buried in the cemetery at Varengeville.

COMPARATIVE ILLUSTRATIONS TO THE COLORPLATES

56. *Seated Nude.* 1907. Oil on canvas,
21 5/8 × 18 1/8″. Private collection

57. *The Port.* 1908. Oil on canvas,
31 7/8 × 31 7/8″. Art Institute of Chicago

58. Pablo Picasso. *Factory at Horta de Ebro.* 1909.
Oil on canvas, 20 7/8 × 23 5/8″. Hermitage, Leningrad

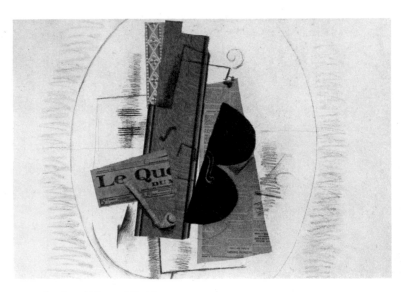

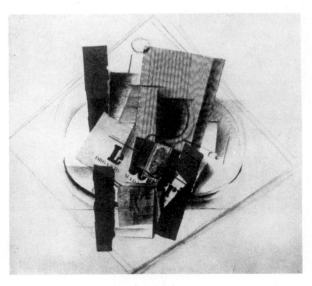

59. *Le Quotidien.* 1912–13.
Papier collé and charcoal on paper, 29 1/8 × 41 3/4″.
Musée National d'Art Moderne, Paris

60. *Le Courrier.* 1913. Gouache, charcoal,
and papier collé on wood, 20 1/8 × 22 1/2″.
Philadelphia Museum of Art. A.E. Gallatin Collection

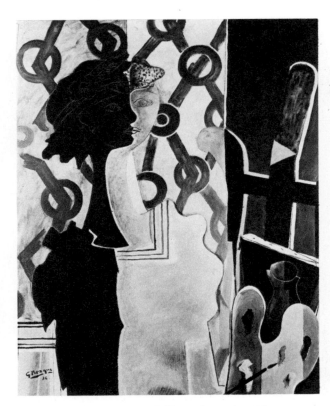

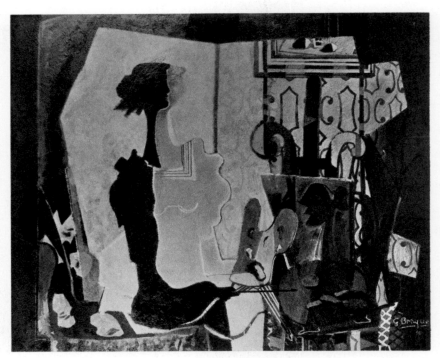

61. *Woman with an Easel (Green Screen).* 1936.
Oil on canvas, 36 1/4 × 28 3/4″.
Private collection, Chicago

62. *Woman with an Easel (Yellow Screen).* 1936.
Oil on canvas, 51 1/4 × 63 3/4″.
Private collection, Chicago

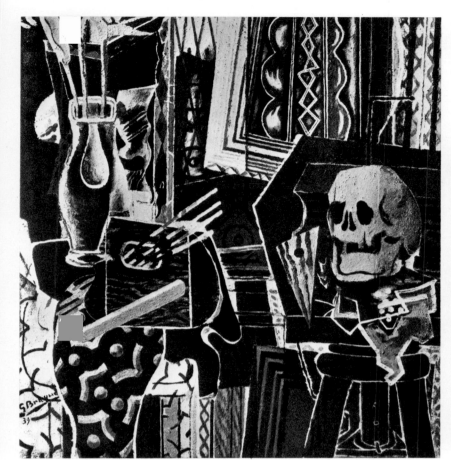

63. *Vase, Palette, and Skull.* 1939. Oil on canvas,
36 1/4 × 36 1/4″. Private collection, New York

64. *The Salon.* 1944. Oil on canvas,
47 1/4 × 58 5/8″. Musée National d'Art Moderne, Paris

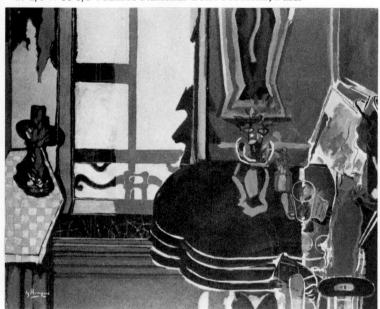

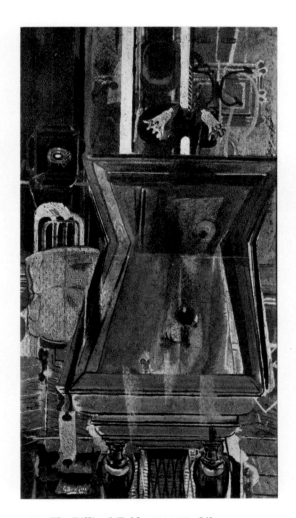

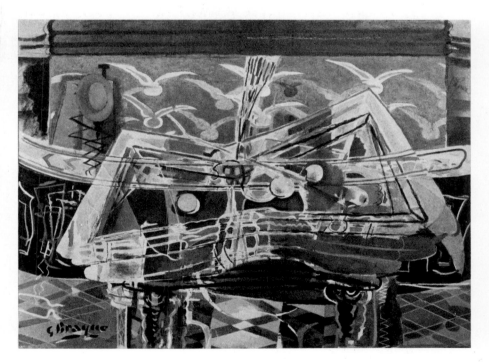

65. *The Billiard Table.* 1944–52. Oil on canvas,
76 3/4 × 38 1/4″. Private collection, Mexico

66. *The Billiard Table.* 1949. Oil on canvas,
57 1/8 × 76 3/4″. Private collection

67. *Woman at Her Toilet.* 1945.
Oil on canvas, 45 5/8 × 35″.
Private collection

69. *Reclining Woman.* 1930–52.
Oil on canvas, 28 3/4 × 70 7/8″.
Private collection

68. *Ajax.* 1949–54.
Oil on paper pasted on canvas,
70 7/8 × 28 1/4″.
Private collection

COLORPLATES

THE PORT OF ANTWERP

1906. Oil on canvas, 19 5/8 × 24"
National Gallery of Canada, Ottawa

A single room in the Salon d'Automne of 1905 created a scandal. It brought together the works of Matisse, Manguin, Derain, Vlaminck, Valtat, and Puy—all young artists anxious to make their mark by steering clear of the prescribed forms set down by their elders. The success of Impressionism had by then become an established fact, thus assuring the supremacy of color. Although they did indeed fall under its spell, the newcomers thought it possible to go a step further toward achieving greater expressiveness and more ruthless intensity. They put their belief into action and, in the process, provoked violent reaction.

Among the artists of the younger generation who visited this room were three painters from Le Havre—Dufy, Friesz, and Braque—who had come to work in Paris a few years earlier. All were deeply impressed by the brilliant displays of daring they saw there and were tempted to set out on the same path.

One of the earliest consequences of this awakening was a series of paintings executed by Braque and Friesz during their stay at Antwerp in 1906, only a short time after the exhibition at the Salon d'Automne. These early works reveal an unmistakable relationship to Impressionism, whether because they exploited its resources and effects, or because they rejected them.

The fact that the two artists occasionally painted exactly the same subject helps underscore distinguishing as well as shared characteristics. In Braque we see more of an all-pervasive suppleness; in Friesz, a sterner approach, a less flexible drawing style. The moist, luminous feeling typical of Impressionism is there; but Braque has replaced the division of color into detached brushstrokes with modulated tones that take on denseness around the ships and masts, as if to throw them into relief. It was a sign of things to come: an apparent desire to endow space with rhythm by materializing it into a more or less opaque substance that surrounds forms with a vibrant effect. This was Braque's way of reacting against the instability of divisionism while retaining a feeling of glittering brilliance.

Colorplate 2

THE LITTLE BAY AT LA CIOTAT

1907. Oil on canvas, 14 1/4 × 18 7/8"
Musée National d'Art Moderne, Paris

Leaving the soft, harmonious half-tints of Flanders and the Seine Valley behind, the artist turned to the contrasts created by the sunlight of the Mediterranean coast. It was here that a bedazzled Braque (like Derain, who was two years his elder) rediscovered the assets of Impressionism, its power of suggestion, its ability to express forms as they shift in the light. Here they fairly melt in a space that has regained fluidity and transparency. But Braque's sense of autonomy made him more expressive: like Derain or Matisse, he applied color with a touch that produced much more detached strokes than those found in Impressionist works. This was, however, only a brief interval before he embarked on other ventures that would lead to a more complete liberation.

In this painting, one senses that Braque is still careful to give the completed work the simplicity of a rough sketch, not only in deference to the freshness of immediate sensation, but also as a means of revealing the process of synthesis and retaining only what is essential to the scene.

As an echo of Impressionism that bears the stamp of experimentation, this work is remarkable for the lightness and the feeling of spontaneity that it radiates. Other Braque landscapes painted during the same period, however, are spread across the canvas in a firmer hand: their volumes are more clearly defined and molded by color. Whether dells or simplified trees, landscape volumes were starting to be arranged with architectonics in mind. We see in these other works the road leading toward the more solid structures that would soon appear.

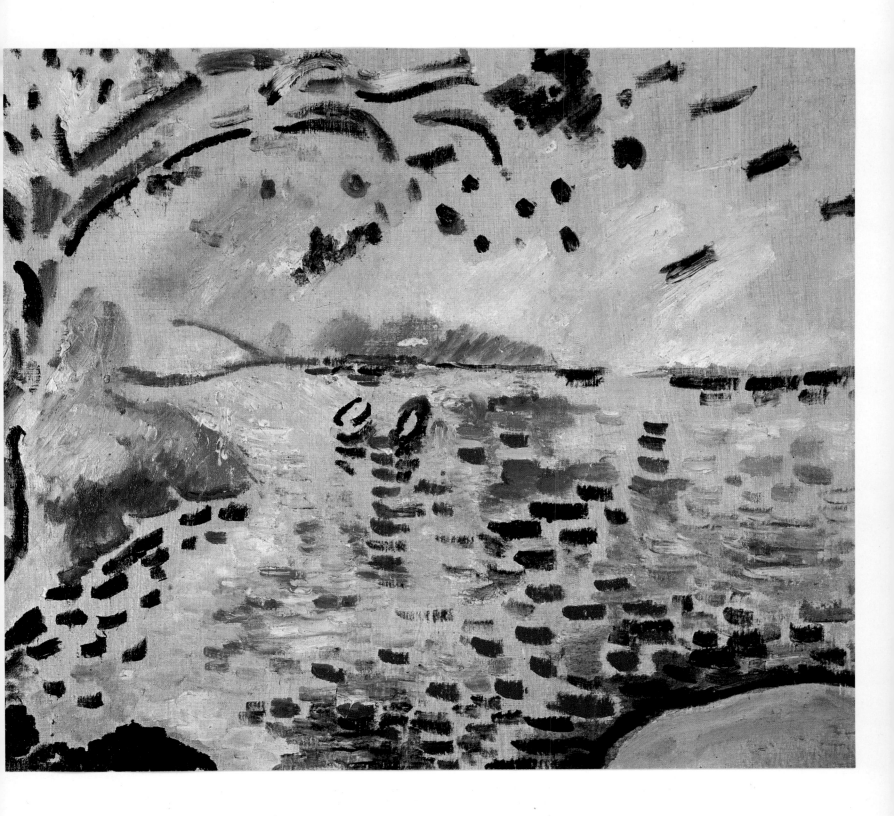

Colorplate 3

VIEW FROM THE HÔTEL MISTRAL, L'ESTAQUE

1907. Oil on canvas, 31 7/8 × 24"
Private collection, New York

With this painting, Braque made an abrupt break with what he had done before, at least with respect to the traces of Impressionistic lightness and spontaneity seen in previous efforts. Moreover, the tendency that had begun to appear in works immediately preceding it was confirmed: the emphasis was now on volume. In a steady, unhesitating fashion, he adopted a new system of representation that encompasses all aspects of the picture. Line, color, composition—everything is new; and the decisive steps taken here were to reappear in future endeavors.

This work attests to the element of permanence in Braque's development. In bringing together the components of his earliest stages of evolution, the artist demonstrated his maturity even then. For him, this meant above all the free-dom to organize the picture, not in terms of a faithful imitation of reality, but as an assertive, quasi-geometric structure expressed through a restricted, preestablished coloristic blend. Isolated touches of color have vanished: form is now rigidly circumscribed by line. The entire space is filled to the point of almost eliminating the sky.

This work thus marks a sudden awareness on the level of ideas and resources alike. In addition, it is revealing to compare it with some of the paintings executed by artists of Braque's generation, such as Raoul Dufy. Of particular interest is the work of André Derain, who also was at L'Estaque: his tree trunks, stripped bare, are rigorously delineated by bold outlines.

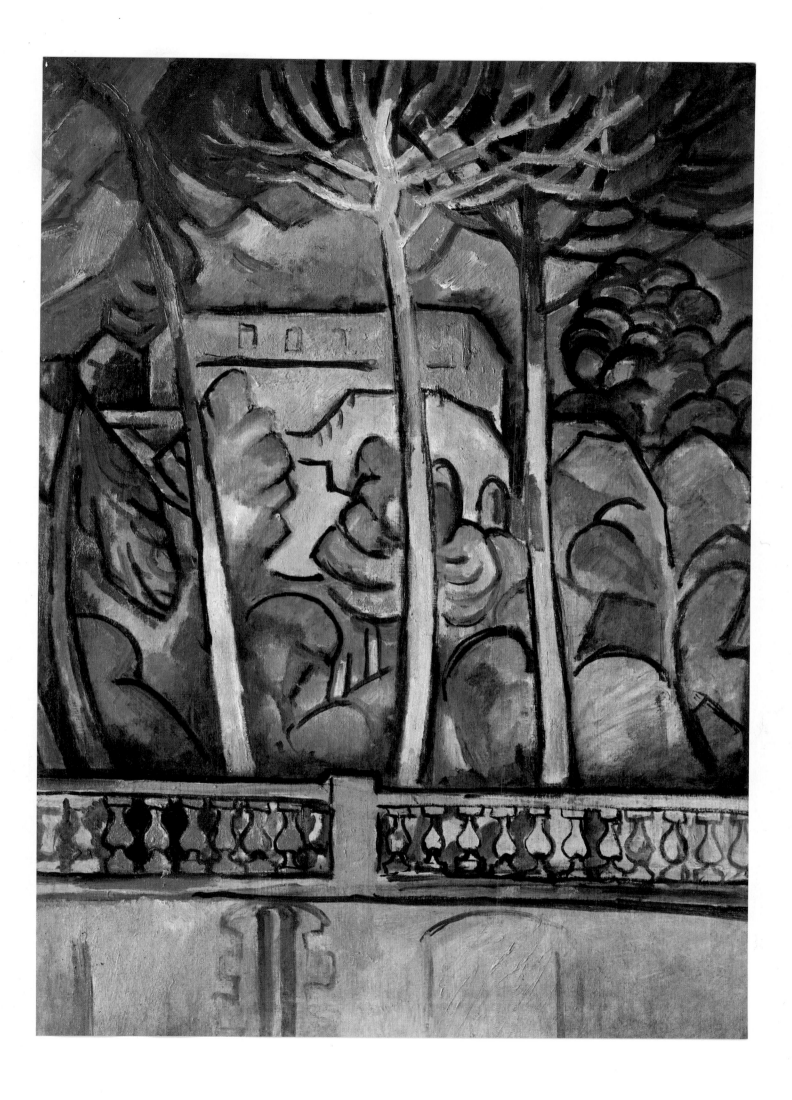

Colorplate 4

NUDE

1907–8. Oil on canvas, 55 × 40 1/8″
Private collection, Paris

The *Nude* of 1907–8 marks Braque's unequivocal commitment to a rigorously structured approach. Although contact with immediate reality was maintained through sense impression, it was now but the handmaiden to a creative process in which the intellect played an essential part. To grasp the importance of how far the artist had progressed, one need only compare this work to a nude painted a bit earlier (1907): the difference between them is enormous (see fig. 56).

The earlier work springs directly from Fauvist roots and, compared to the nude on the opposite page, has an air of realism about it. Consider the body of the woman in the 1907 version: it is treated as a total volume and is only slightly modeled by color; its mass is highlighted, albeit rather sensually, by an outline that does nothing more than delineate the contours of the body; it rests detached in a space that lacks both form and dimension.

The nude of 1907–8, if not wholly innovative, has at least been rethought in terms of a homogeneous totality. Line plays a role of paramount importance, not to define the shapes themselves, but to connect them to one another and to blend them in with the surrounding area so that the entire arrangement becomes enveloped in a single rhythm.

The former is depicted in a familiar, believable pose; the latter lacks, indeed rejects, naturalness, preferring instead to become an object whose curves, winding like arabesques, are mounted in a somewhat more rigid expanse that frames and joins in with this synthesis of movement.

Some authors have suggested that, contrary to what had been believed until recently, the subject is a reclining nude. We readily subscribe to this hypothesis. It would make the pose as well as the overall composition more plausible.

Two events may help explain the sudden shift in Braque's approach: the artist had recently seen Picasso's famous *Les Demoiselles d'Avignon*, and the Salon d'Automne of 1907 had organized a large-scale Cézanne retrospective. Both were momentous turning points in the history of art that influenced a large number of painters.

74

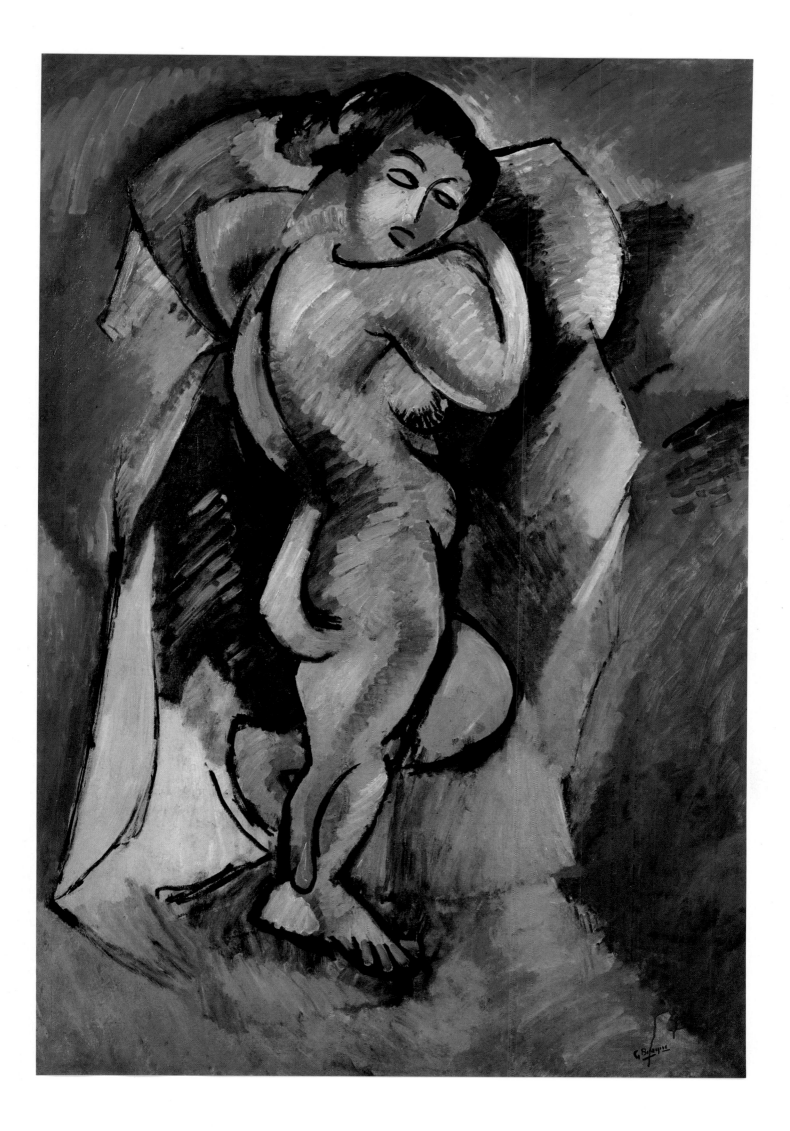

HOUSES AT L'ESTAQUE

1908. Oil on canvas, 28 3/4 × 23 5/8"
Kunstmuseum, Bern

Upon seeing these heavily congested landscapes, their trees and houses reduced to essentials, the critic Louis Vauxcelles spoke of "cubes" in the *Gil Blas* of November 14, 1908. The newly born approach was now baptized. The influence of Cézanne, which had begun to make itself felt in the *Nude* of 1907–8, was now patent: the sparing use of colors limited almost exclusively to grays, greens, and ochers; a severity that tends to purify form into an elementary geometric pattern; and above all, a way of treating each detail of the composition not as an object whose substance and function must be respected to maintain its individuality, but as a pictorial or plastic occurrence. It matters little whether the house or tree appears as it does in the real world. The goal now was to achieve a methodical volumetric arrangement that would result in an imbrication of forms and colors. The houses have no windows, the trees have no leaves: all supplementary picturesque details have been removed.

The artist's predilection for filling the entire picture surface is now obvious. Not one empty space is to be found in this serene clutter—no more sky, no more escape toward some ill-defined area in the distance. As a result, space acquires new denseness, and perspective takes on a palpable presence. Elements that would normally be situated horizontally have been spread out vertically, producing a concentrated effect distributed evenly over the entire picture surface. The painting thereby attains a high degree of unity.

The Cézannian stage of Cubism clearly reveals what set Cézanne apart from the other Impressionists, indeed, what set him against them. At this point, one might legitimately wonder whether it was Cézanne's work that opened the Cubists' eyes to a new concept, or whether it was the still-inarticulate intuitions and aspirations of the Cubists that led them to discover in the master an answer to their search for new avenues of expression.

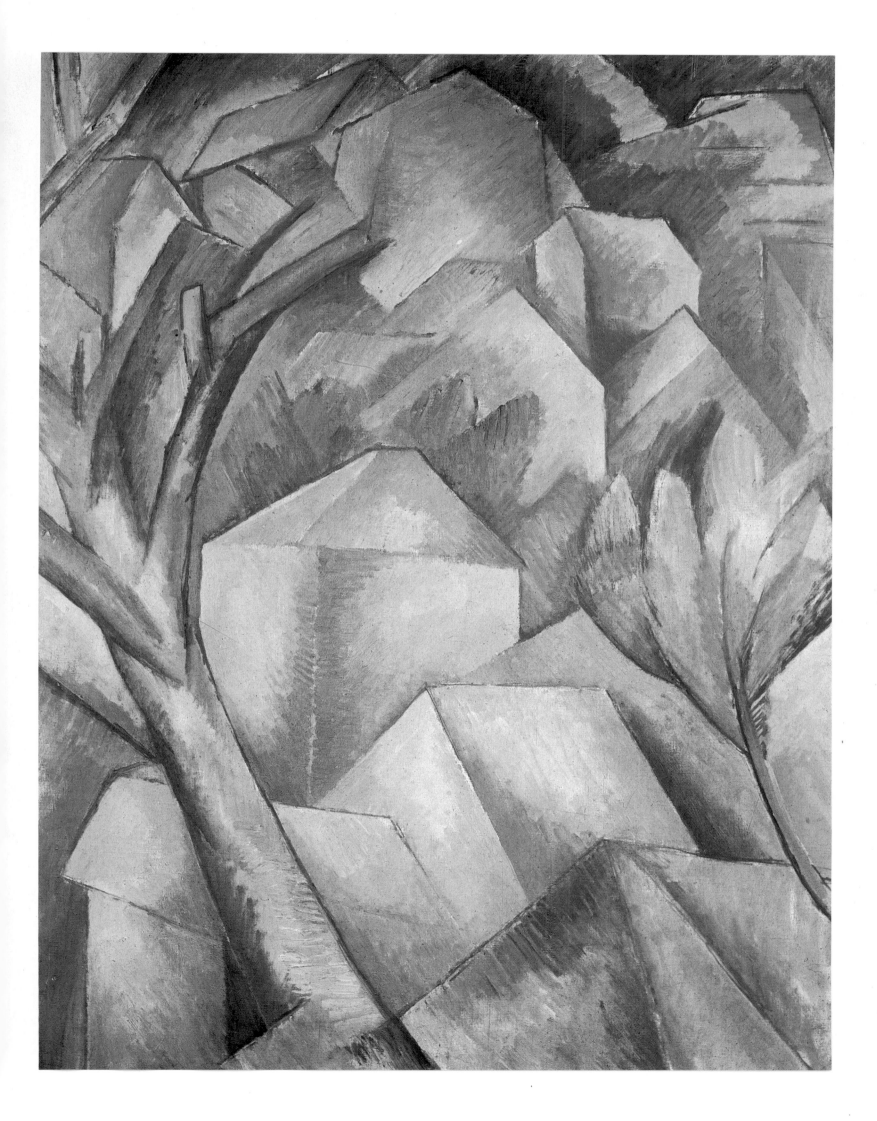

Colorplate 6

STILL LIFE WITH MUSICAL INSTRUMENTS

1908. Oil on canvas, 19 3/4 × 24"
Kunstmuseum, Basel

Since Cézanne had proposed that to study form meant a return to essentials—that is, the square and the cylinder—Cubist artists selected subjects whose constituent elements were based on the same elementary shapes. This is why, after the simplification and synthesis of the vertically aligned L'Estaque landscapes, still lifes were to take on increasing importance, becoming the preeminent Cubist theme.

The still life enabled the artist to bring pure, simple objects together into a desired arrangement. Generally speaking, they were commonplace things, the paraphernalia of everyday life. Yet, the nature of these accessories notwithstanding, there is no trace of realism in the way they are reproduced. Braque often showed a preference for musical instruments, whose greater refinement made for a less pedestrian theme.

It was after his Fauve period that Derain, in turn, tried his hand at still life. However, his compositions (usually involving household utensils) tend toward a purism with a primitivist bent, thereby sounding a rather sentimental note nowhere to be found in the works of Picasso or Braque.

The Spanish artist and Braque were brought into close contact by their common artistic quest as well as by their friendship. It is especially easy during this period to single out the things that connected as well as separated them. Picasso, in complete control of his instinctive powers, was more unyielding in his simplifications; Braque showed greater sophistication through skillful simplicity. From now on, Braque's paintings, while retaining the denseness of previous works, drew more and more in on themselves and were more tightly organized around a central grouping. Unlike the landscapes of L'Estaque, there was no longer the slightest hint that the subject might spill over beyond the frame.

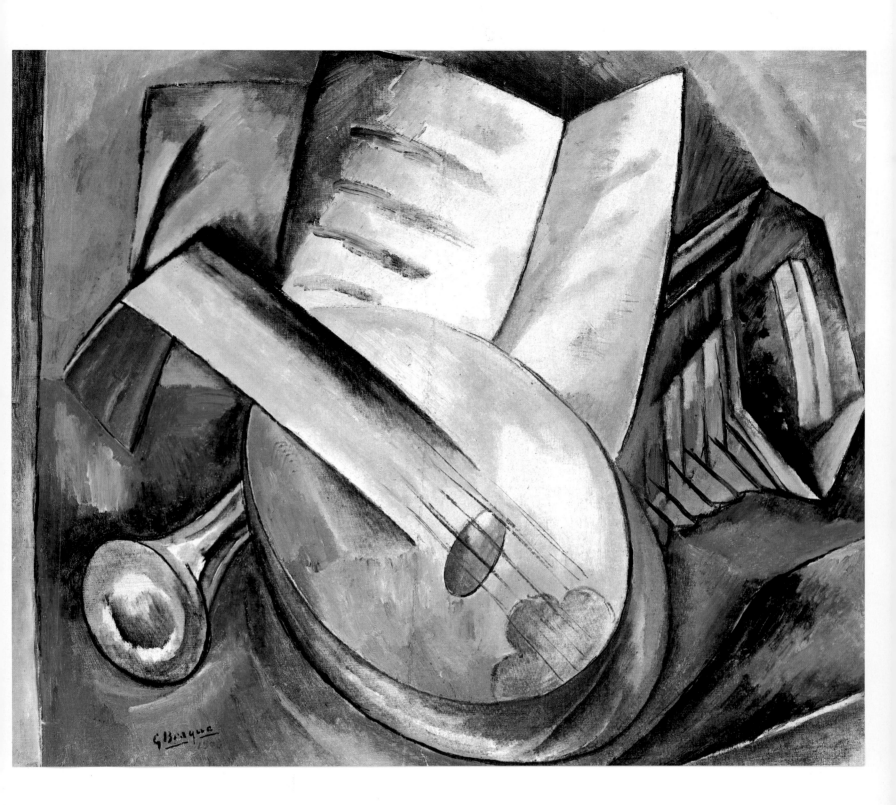

Colorplate 7

HEAD OF A WOMAN

1909. Oil on canvas, 16 1/8 × 13"
Musée d'Art Moderne de la Ville de Paris

With the exception of the portraits of family members executed in his early years, Braque showed little interest in the human figure and even less in portraiture. The figures that appear during the subsequent Cubist years are utterly anonymous, and later efforts do not accord their female models much more in the way of individuality.

There are, however, a few exceptions that give the impression that the artist did look upon his model as a specific being. Paradoxically, the earliest example of a clearly personalized face occurred during the first phase of Cézannian Cubism, when the artist was leaning toward a more abstract conception of the world. Even though this portrait of a woman is reduced to a collection of planes, the imperative of likeness has been respected and the geometrization has not supplanted the model's distinguishing features altogether.

The human subjects that Picasso was depicting about the same time are a good deal more mechanical in appearance, so much so that some

claim that traces of African art can be detected in them. In Braque's case, the surfaces of light and structure are joined together to form a reconstructed semblance of reality, thereby enhancing the believability of a volume that has been disintegrated into motionless facets. This picture was one of the final steps taken toward splitting up volumes until the resulting arrangement became increasingly difficult to decipher.

It was not until many years later that Braque broke free of the rigors of Cubism and turned toward a softer, almost classical vocabulary: only about 1928–29 do we again come across truly individualized human faces. Even then, however, the artist realized that a minimal amount of unabashed geometrization can add forcefulness to an essentially supple, dynamic representation.

Braque apparently felt that the triangle was the geometric shape best suited for constructing these faces. While it occurs as multifaceted areas in the 1909 portrait, the triangle was to assert itself even more boldly in works of 1928 and 1929.

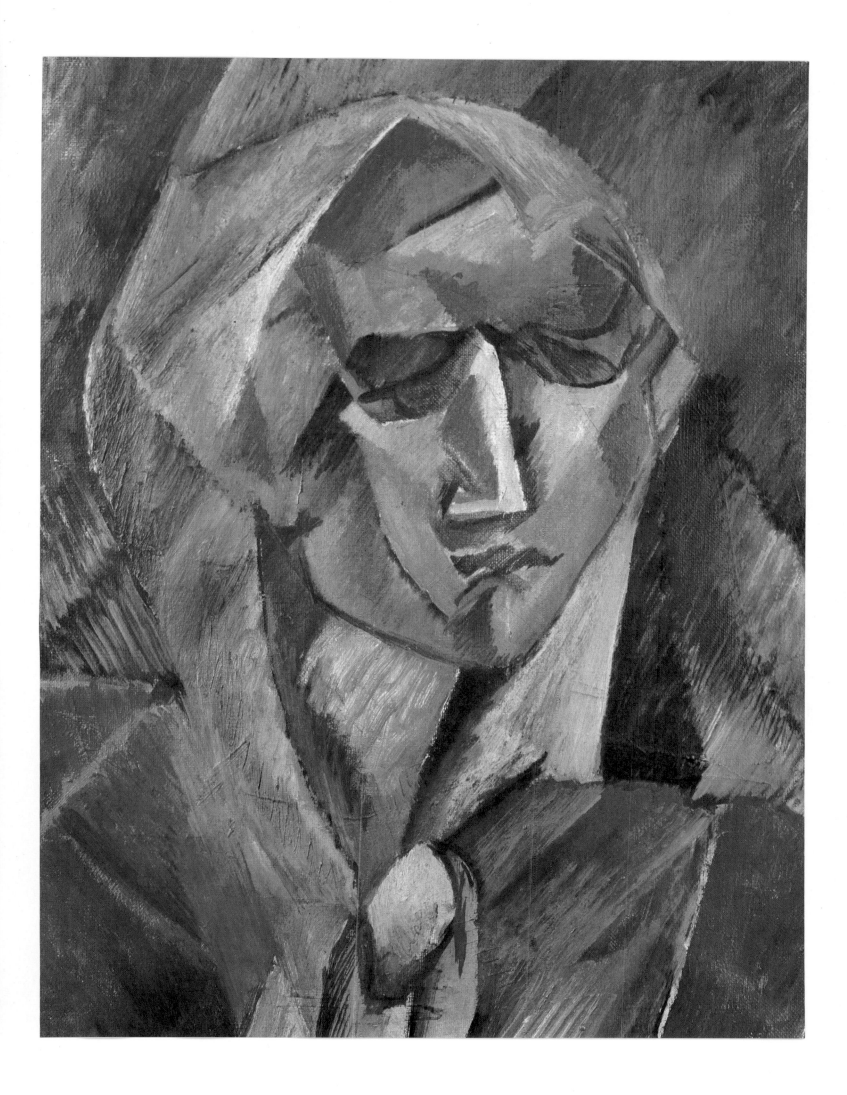

Colorplate 8

THE CHÂTEAU AT LA ROCHE-GUYON

1909. Oil on canvas, 31 7/8 × 23 5/8″
Moderna Museet, Stockholm

Although the year 1909 was rich in endeavors of many kinds, three series of paintings are especially noteworthy: the landscapes executed by Picasso at Horta de Ebro (Spain), and two groups painted by Braque at La Roche-Guyon and in Normandy. The obvious similarities among them invite interesting comparisons. They all followed in the footsteps of the preceding year's L'Estaque landscapes and pursued objectives of the same order—extreme simplification of overlapping volumes. The "climbing landscape" method yielded a static arrangement for Picasso (see fig. 58), a dynamic one for Braque, whose views of La Roche-Guyon are distinctly upward oriented but whose paintings of Normandy ports are a good deal more disordered, even chaotic. The differences within the two artists' mutual vision stemmed from the kinds of geometric shapes that each one utilized. While Picasso chose cubes and regular parallelepipeds that create a feeling of calm and immobility, Braque favored the scaling effect produced by combining triangles and shapes stretched out into pyramids. In the case of the latter's harbor scenes, the feeling of confusion arises from a tangle of diverse shapes in which curved and straight lines are crowded together in an undisciplined jumble.

This painting incorporates some of the features that were to become hallmarks of Cubism as it passed from the Cézannian phase (still visible here) to its analytical phase, of which this is actually an early example. Indeed, the artist now took what the real world had to offer and subjected it to analysis, gleaning whatever he needed in order to achieve an unambiguous demonstration of what he wanted to express.

In addition, the harbor scenes reveal an attempt to do violence to space by bringing the foreground abruptly forward, in stark contrast to what lies behind (see fig. 57). But this kind of aggressive proportion does not crop up either in the harmonious landscapes of La Roche-Guyon or even in those of Picasso. This may well be one of the earliest examples of something that would always be one of Braque's major concerns: the problematics of space.

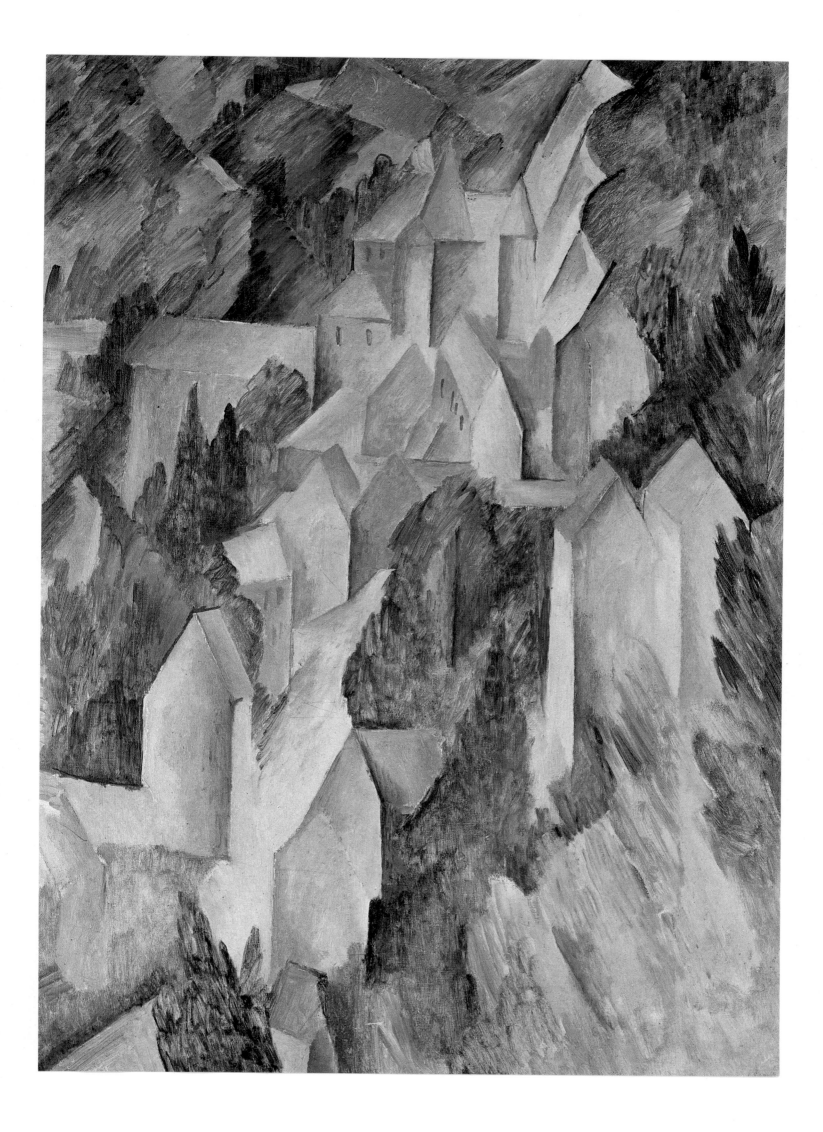

Colorplate 9

GLASS ON A TABLE

1910. Oil on canvas, 13 3/8 × 15"
Private collection, London

It was not long before Braque's still lifes began to take on a more rigorous order, a prescribed geometric pattern, even when the subject was depicted with some degree of naturalness. True, the new aesthetic found objects and pieces of fruit to be satisfying forms in themselves, but their internal relationships as well as their disposition within a totality were now subjected to the imperatives of a new discipline. The result was an architectural treatment set within an enclosed space. The merits of these objects were long appreciated and continued to play an effective role over the course of the artist's development.

Again, the influence of Cézanne is self-evident: a stable, glowing arrangement in which apples and fruit dishes have been skillfully grouped to complement one another. Braque's use of a sweeping, rigid line to indicate the edge of the table, or *guéridon*, underscores the feeling of concentration.

As in the landscapes, the vertical realignment of horizontal planes gives one the impression of a bird's-eye view. Intentional discipline notwithstanding, these compositions radiate a certain lyricism, a reserved warmth, even a kind of intense, refined sensuality that in no way smacks of vulgarity. Its sensory quality relies not on imitation of reality, but solely on the way in which the pictorial substance interacts with the movement of the shapes, softening the stiff, schematized outlines of the curves and orthogonals and endowing them with a vibration that brings all the components into harmony. In *Glass on a Table*, this effect is obtained by structuring the entire work as a variation on a spiral. Consequently, every object is thoroughly integrated into the whole without sacrificing individuality. But what counted from then on was more its meaning than its identity. In other words, the essential thing was that the fruit be more sphere than fruit, and that the glass be more a cone than a glass.

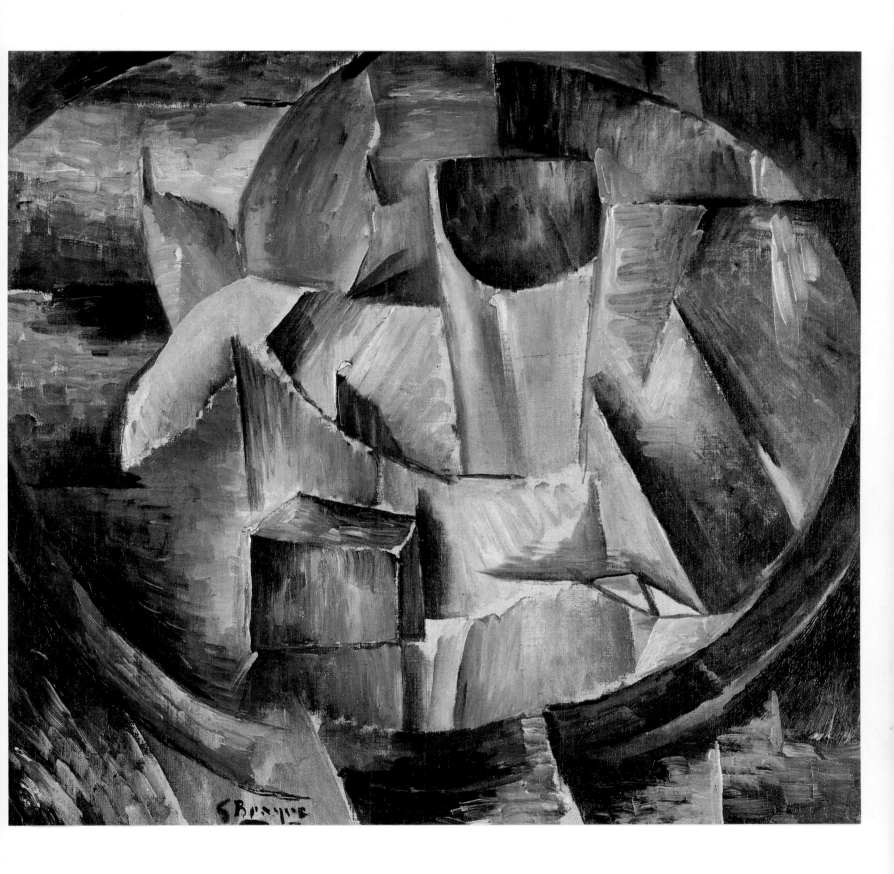

Colorplate 10

PIANO AND MANDOLA

1910. Oil on canvas, 36 1/8 × 16 7/8"
The Solomon R. Guggenheim Museum,
New York City

With *Piano and Mandola*, we stand squarely in the phase of Analytical Cubism, an approach that dissociates tangible or intangible elements of the world and then reconstitutes them while highlighting their relationships. The mysterious nature of these reconstructions inevitably gives rise to certain questions. Although we may disagree as to whether they bear any resemblance to reality, their very titles prompt us to interpret them in terms of the real world. They serve as a point of departure for an attempted reading of their signs, for a more in-depth decoding.

First of all, forms have now been bound to one another more tightly by the familiar rhythmic, vertical movement already seen in the landscapes. The linking process is brought about by means of slanted lines—richer in combinative possibilities than verticals—that add flexibility to the overall design while filling every area of the canvas with activity. It is a curious mixture of stiffness in the details and suppleness in their arrangement.

The overlapping pattern of parallel lines that makes up this rhythm imparts a trembling quality to the surfaces, which connect and complement the harmonious blendings and correspondences to be found in the warm, deeply resonant range of colors.

The objects—easily identifiable due to the precision with which certain details are rendered—as well as the titles induce us to try to grasp the musical atmosphere that the artist wishes to suggest. By means of these fleeting allusions to reality, the details stress his desire to maintain at least a minimum of contact with the real world: it is a device that appears in several other works dating from the same period.

Finally, the palpable, modulated space demonstrates how far the artist had progressed toward satisfying the demands of what he would explicitly refer to in his *Cahier* as visual space and tactile space, concepts that were always in the forefront of his concerns. The unconventional format reaffirms the vertical emphasis that was to be applied to widely diverse themes in works to come.

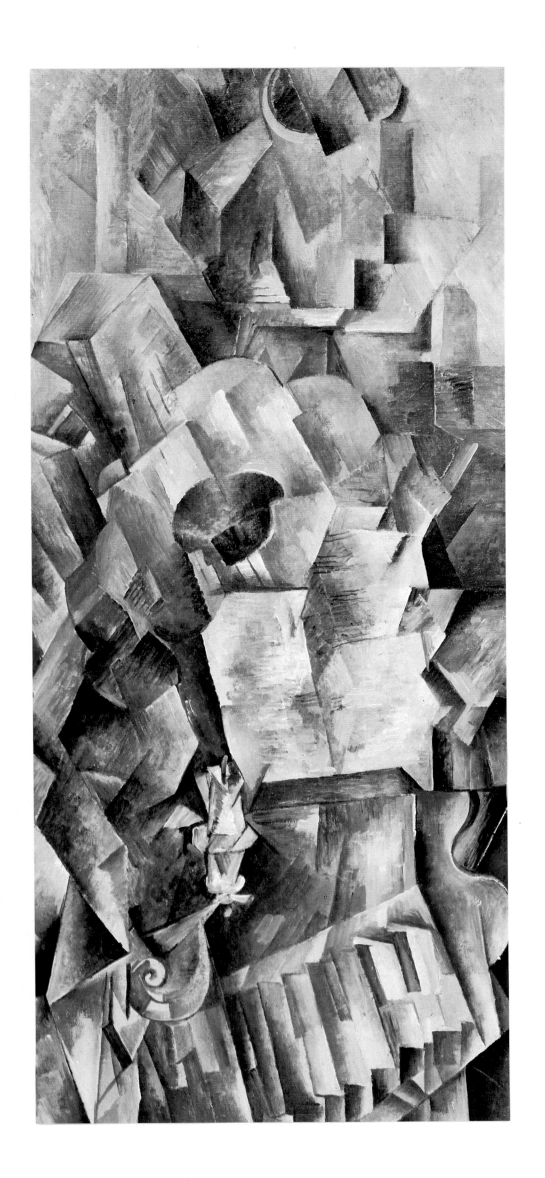

THE MANDOLA

1910. Oil on canvas, 28 3/8 × 22 7/8"
Tate Gallery, London

The importance that Braque attached to rhythm and musical sense is as pronounced in his writings as it is in many of his works. In his *Cahier* he wrote, "Echo answers echo and everything reverberates," a thought that could well serve as a commentary to *The Mandola* of 1910. The instrument, surrounded by waves, is hidden amidst vibrations of forms, colors, and rhythms, all resonating with shadow, light, and reflection that almost take on the quality of sound.

This is an exemplary exercise in Analytical Cubism, in which one begins with disintegration and arrives at reintegration. The stiffness of the flat, inert surfaces of the real instrument has given way to alternating opaque and transparent areas. The ubiquitous sense of movement is grounded in a delicate scaffolding of lines that are actually surviving traces of the original object—now but a ghost of reality undergoing transmutation—the remains of what was once a fixed structure, now a mobile one.

The reconstruction leaves no space unfilled, no point without activity. The unifying element is the centrally located disc that marks the crossroads of intersecting diagonals. Thus, the painting derives its vitality from two sorts of movement: the wavy, ascending motion that we have already encountered in earlier pictures, and the circular motion asserted even more forcefully in *Glass on a Table* of 1910 (colorplate 9).

Although the range of colors is as reserved as those in the earliest Cézanne-inspired works, it is livelier and more varied without being less austere. In other words, Braque was more in control of his own evolving awareness. Lastly, we note that the surfaces have become increasingly transparent and achieve here a degree of interpenetration that will become even more noticeable in future compositions.

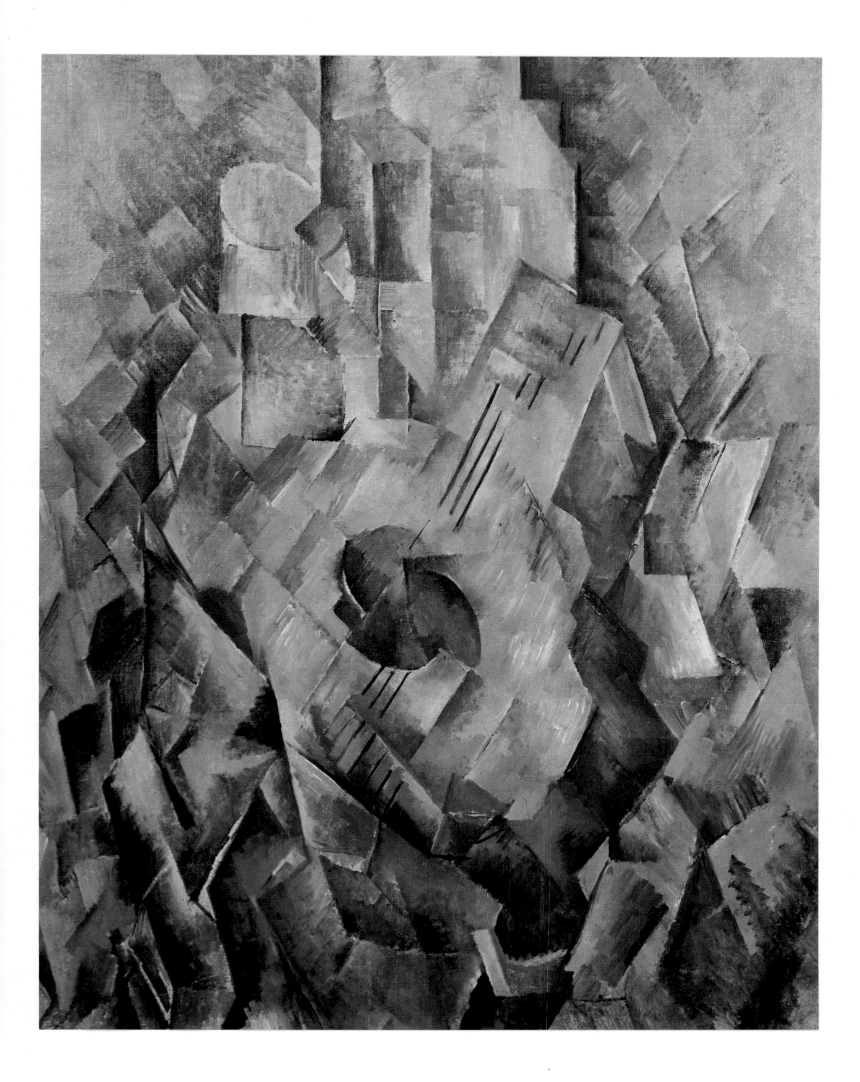

Colorplate 12

THE PORTUGUESE

1911. Oil on canvas, 46 × 31 7/8"
Kunstmuseum, Basel

The successive stages of Analytical Cubism—with its disintegration of form and an intransigence marked by growing severity—led to works that became increasingly difficult to decipher. No longer did the artist make concessions just for the sake of being agreeable. He was so anxious to avoid being led astray that he did away with anything that could be interpreted as an accessory, anything that might carry a hint of charm, whimsy, or even individuality. Braque's aggressive originality lay in an absolute neutrality of color and line. As if to underscore their acceptance of this impersonal approach, Braque and Picasso not only took to painting the same way, using the same subjects, but occasionally even left their work unsigned. This was the apogee of the hermetic phase. Human models were treated no more charitably than were objects, and, in this respect, Braque was even more unyielding than Picasso. Trying to identify one of Braque's human subjects is out of the question; whereas Picasso did manage to create actual portraits that attest to his virtuoso ability to paint a likeness without in any way compromising his approach.

The following quote from Braque's *Cahier* could serve as a defense for the hermetic phase: "Let's be satisfied to cause people to think; let's not try to convince them."

The only touch of fancifulness that the artist allowed himself was to add a readable word or an actual letter to the imbrication of colors—letters still quite mechanical and banal, to be sure, but a banality that turns into a mark of originality by making a precise gesture in an otherwise shapeless, dimensionless universe. The sense of heightened transparency adds to the unreal, shifting quality of this mass of rigidity. Could the transparency we see here—which in no way undermines the picture's stability—have been a resurgence of the sparkling quality characteristic of the Impressionist vision?

The architecture of the assembled parts has been laid bare even more conspicuously than before; and compositions based on pyramid-like shapes were to become more numerous from then on. In addition, edges of tables or *guéridons* would now root the pictorial tremors in a foundation and a framework that helped impede the scattering effect.

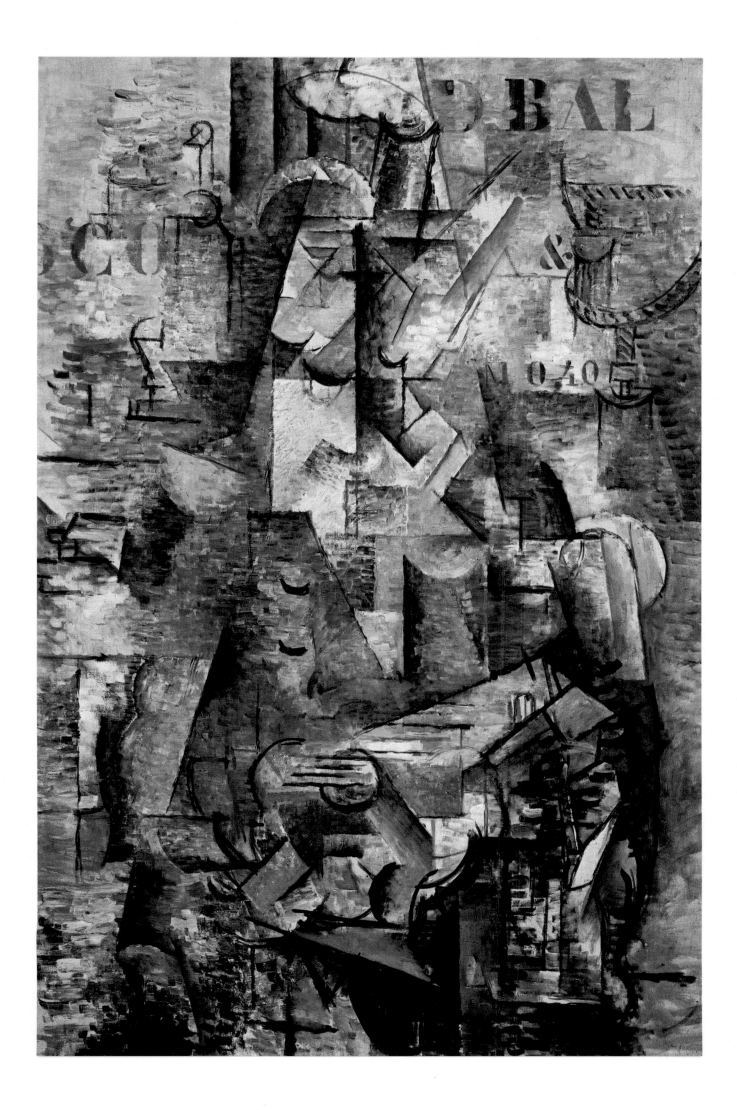

STILL LIFE WITH PLAYING CARDS

1913. Oil on canvas, 31 1/2 × 23 1/4"
Musée National d'Art Moderne, Paris

Up to this point, Analytical Cubism could be thought of as a negative endeavor: it built itself up by rejecting everything that had gone before and underwent a series of modifications that brought instability to the present and uncertainty to the future. In order to arrive at something more concrete, more constructive, the artist was led to speculate on what effects the use of new materials might have on his work. When Braque mixed unconventional substances into his paints (sawdust, sand, tobacco, iron filings), it signaled a renewed commitment to the realities of the medium and resulted in pictorial effects (granulation, for instance) that gave things a wholly new appearance. The change became even more evident when Braque, remembering what he had learned in his youthful days as a painter-decorator, began to utilize false wood-graining and false marbling techniques in portions of his paintings. As a result, reality at its most tangible, so passionately shunned beforehand, now suddenly appeared in his system of representation.

And what reality!—expertly crafted *trompe l'oeil* of the most traditional kind. Granted, this could have been the logical outgrowth of the mechanical stenciled letters that appeared in the most hermetic paintings of his Analytical Cubist phase; but this time the presence of the real world was so compelling that it entailed an entirely new way of organizing the picture. The expressive power of acquired experience was undiminished: volumes reduced in complexity set within an effective space; simplification of objects by drawing lines that do nothing more than suggest their features; and, above all, the need to integrate all the details of the picture into an ordered totality. Braque put these guidelines into force by turning his back on hermeticism in favor of paintings that could be read more easily even if he were to eliminate all details. Analytical Cubism had been a cleansing process, and his paintings emerged from it stripped bare of everything that involved respect for superfluous detail. This is an appropriate place to quote another of Braque's thoughts: "When a still life is no longer within reach, it ceases to be a still life." And henceforth a still life was no longer a collection of useful objects, but a painting.

These first steps toward reconstruction heralded the beginning of what was to be called Synthetic Cubism, which tried to bring about a reintegration of recent endeavors into an approach that would rival them in purity, but that would also be more accessible and closer to everyday life.

One might say that such a development was only logical; but it still constituted an event of great importance: reconciliation with reality without giving in to it.

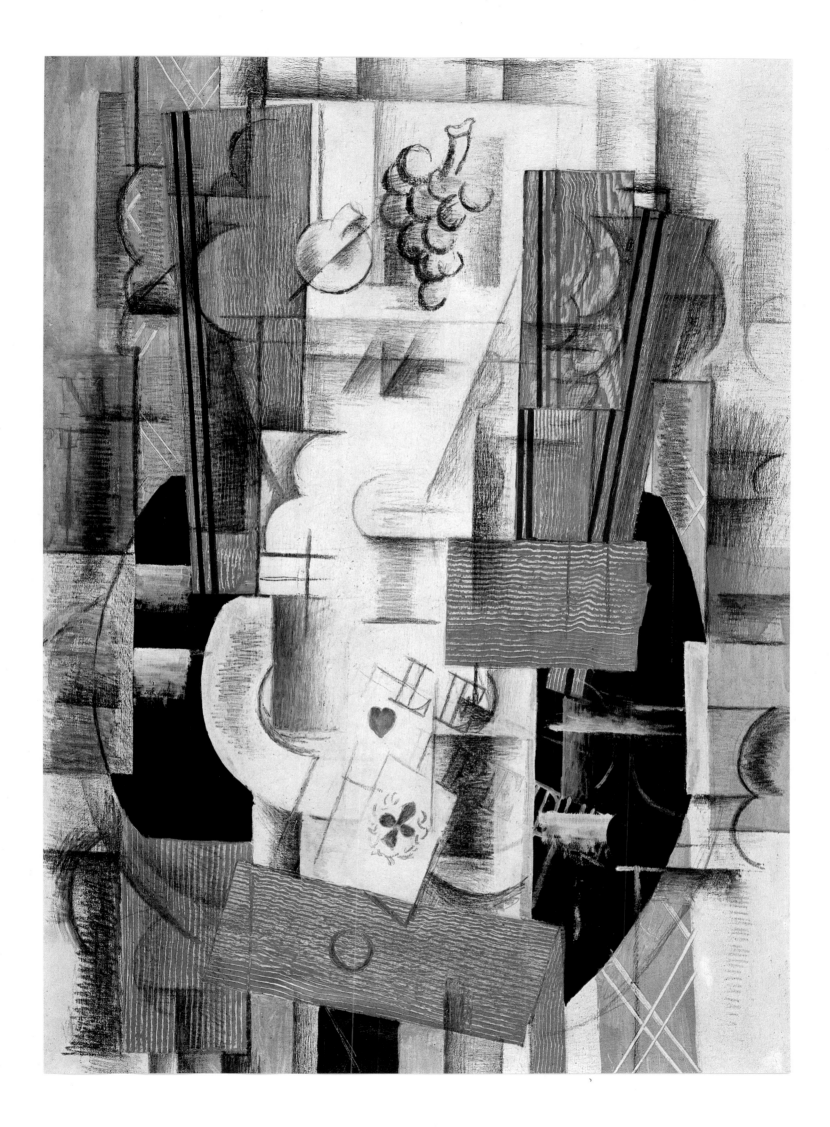

THE CLARINET

1913. Oil on canvas, 37 3/8 × 47 1/4".
Private collection, New York

With the *papiers collés*, we enter a period of constructive activity. Braque demonstrated that his change from the earlier stages of Cubism was no concession to mere expediency when he created the first *papier collé* in 1912. Pushing his new "minimal" approach to the extreme, he combined nothing but pieces of paper of different kinds—especially newspaper and wallpaper —and unified the entire arrangement by means of a very simple, clean sketch. Never had anyone achieved grandeur so dignified, or bareness so sophisticated.

If there were ever a time when one could apply the term "architectural" to the composition of a painting, the *papiers collés* provide that opportunity more than any other work. Using nothing but elementary shapes, the artist formed his static arrangements with equally modest materials that one might well dismiss as aesthetically undistinguished. The result of this unavoidably ascetic effect is a feeling of perfection, without which only unappealing banality would remain.

In this severe order of things, every element becomes a sign—whether strips of paper or the faintly sketched outlines that give them a foundation, or meaning, or even, one might say, a soul. With the collages, other seemingly forgotten factors of expression reappear, notably a feeling for materials and colors. This is a far cry indeed from Analytical Cubism, with its repudiations and determined insufficiency. Nevertheless, Braque did glean from this background an astounding command of space, once dynamic during the analytical phase, now a strange, crystallized immobility in which all suggestions of horizontality have been eliminated.

Another principle was confirmed: visual interest is concentrated toward the center of the picture, leaving a perimeter of nearly empty space. This effect is accentuated by a faint but assertive line that circumscribes the grouping, effectively obstructing any movement beyond its limit and firmly returning to the center any detail that threatens to escape.

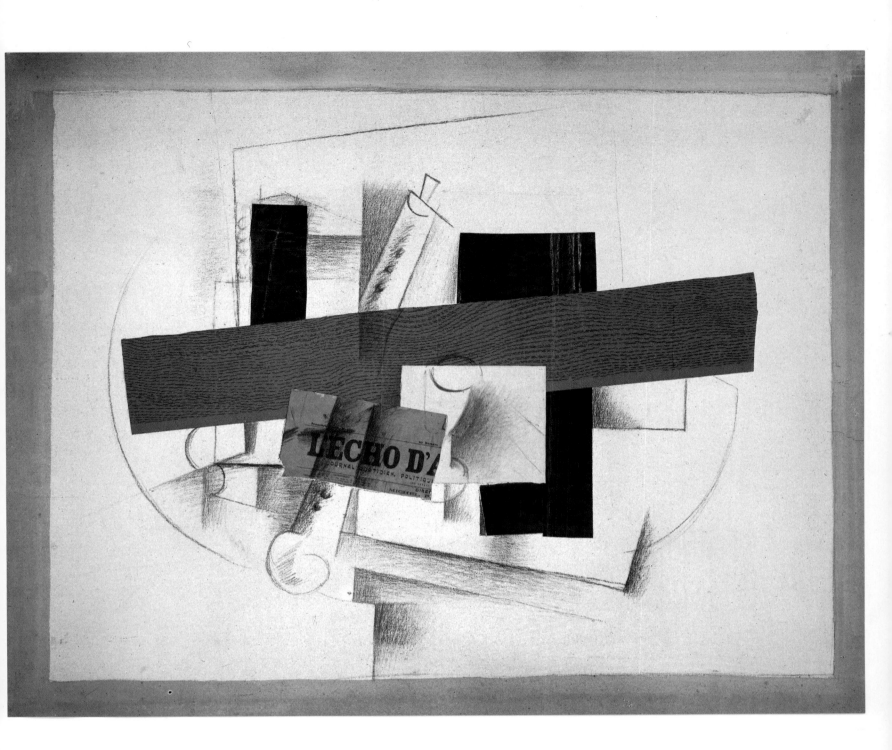

BOTTLE AND GLASS (LE VIOLON)

1913. Oil on canvas, 24 3/4 × 11 3/8"
Private collection, Basel

The interplay of elements grew more complex. Now that color had reappeared, paint claimed its rights. Each member of the triple alliance of paint, crayon, and paper became less intransigent and helped attenuate the austerity of the composition as a whole. Would it perhaps be going too far to detect in this work a note of fancifulness? Nothing remains of the scattering effect typical of Analytical Cubism's tiny, fluttering facets of light. The large, overlapping surfaces are arranged in a way that brings out their contrasts with great serenity.

Cubism had now reached a new stage by making use of diverse materials without welding them together. In fact, even when overlapped, every component maintains its autonomy. Paint keeps its characteristic impasto; the crayon draws nothing more than outlines; and paper retains its humble qualities—all contribute to a tripartite freedom that gives rise to innovative blendings of diverse substances. The purity of the *papiers collés* (see figs. 59, 60) was thus en-hanced by the dynamic infusion of contrasting elements.

In this manner, complexity reasserted itself by saturating the crystalline atmosphere of the *papiers collés*. Even though Braque came dangerously close to anecdotal or picturesque illustration, his unerring instinct steered him clear of those pitfalls. Braque gave space and silence substance, but went beyond mere allusion to the physical world.

We are obviously as much in the realm of poetry as in that of aesthetics—in an unreal world as well, for even in its most hermetic days, Cubism had never come so close to abstraction. It was Braque's way never to let himself, at any given moment, wander too far from the everyday and the commonplace: he never broke the ties that bound him to the world. And although there is an orderliness behind this apparent disorder, there is also something very tense about its tranquility.

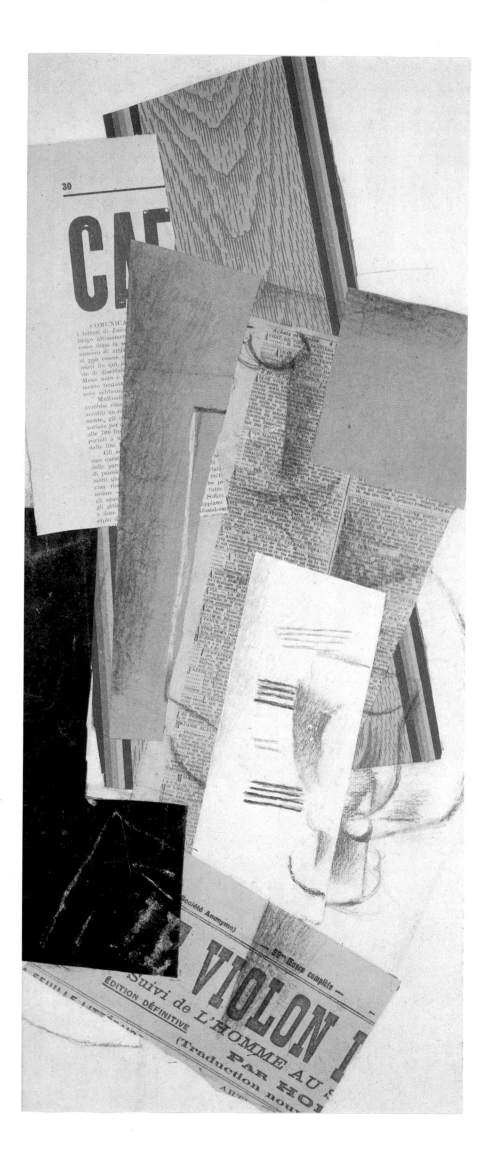

MAN WITH A GUITAR

1914. Oil on canvas, 51 1/8 × 30″
Private collection, Paris

The works produced in 1912, 1913, and 1914 took many different forms. Braque simultaneously followed what appeared to be diverse, even contradictory paths that actually complemented one another. From its earliest days, Cubism had played the gadfly and committed itself to ceaseless self-renewal; but it was still difficult to toss aside what had been gained with each new stage of development. Consequently, however promising or captivating the first ventures into Synthetic Cubism may have seemed, the preceding analytical phase was neither immediately abandoned nor completely supplanted. In fact, there would be moments of compromise for some time to come, works of transition that sought a reconciliation between analytical disintegration of form, space, and movement and a more clearly constructed, static arrangement.

Spreading over the canvas like waves, the long vertical panels in *Man with a Guitar* (1914) —also known as *Man with a Violin*—are reminiscent of the keyboard in *Piano and Mandola* of 1910 (colorplate 10). The allusion to musical instruments is likewise a throwback to previous years.

A comparison of these two paintings, executed during different periods, is revealing. The materials used here are less rudimentary (stippled or wood-grained areas); the composition is more orderly (long, well-defined strips); and the range of colors, though still unobtrusive, is somewhat more varied, more receptive to new possibilities, and, above all, less negative in character.

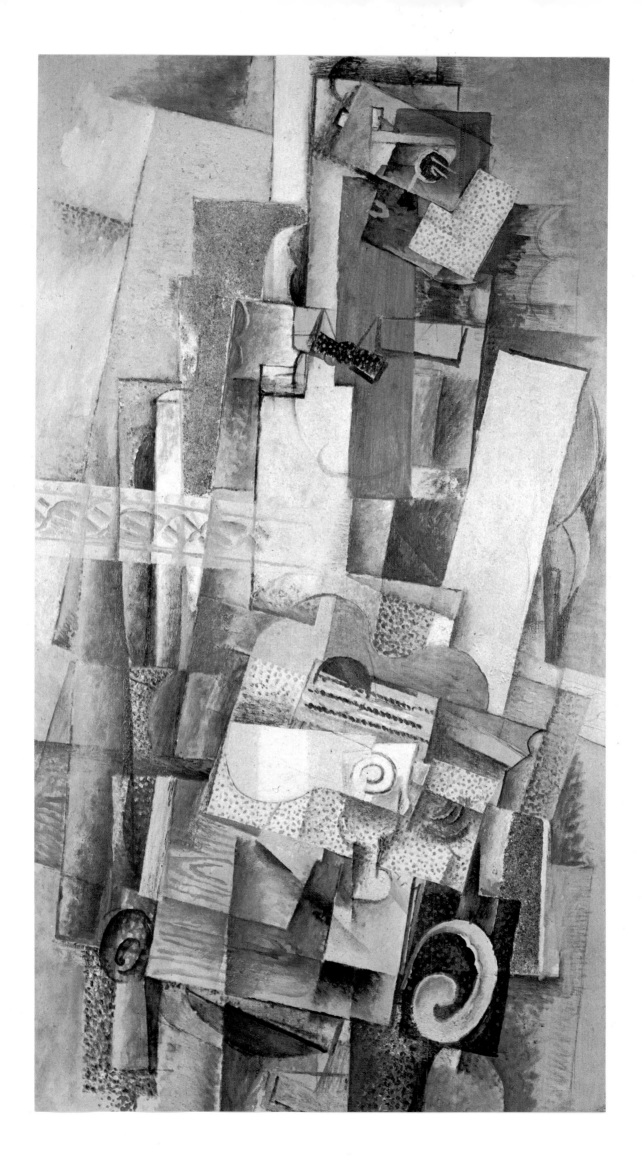

THE MUSICIAN

1917–18. Oil on canvas, 87 × 44 1/2"
Kunstmuseum, Basel

In 1914, Braque's work was suddenly interrupted by war; and it was not until 1917 that the artist, having sustained serious wounds, returned to painting. This hiatus could not have been without consequences: it was doubtless during this period that he sorted out the ideas he had acquired to that point. The works that were to emerge in the course of the following months were more solidly constructed, more assertive in structure and spirit, one might even say more architectural.

Also sometimes referred to as *Man with a Guitar, The Musician*, which hangs in the Basel Kunstmuseum, is the culmination of the synthetic phase, its most accomplished creation. The large, geometric shapes of the *papiers* have reappeared in greater numbers, this time bursting with color. Though still confined by thinly sketched outlines, color has become dominant once again. Painting had now regained its rights and powers.

In addition, the human figure has reemerged. We sense a palpable, watchful presence beneath the mechanical mask, just as we do a certain suppleness of movement behind the rigid, parallel surfaces. How can one not think of the stiff-as-skyscraper figures created by Picasso about the same time for Erik Satie's ballet *Parade*?

As one probes more deeply into this composition, it brings to mind a page from a miniature medieval manuscript: its fresh colors are kept within well-defined contours; its space, though filled almost to the point of clutter, is still quite orderly; and the stippled, checkered, and crackled textures of the wood, wall, and ground areas are applied with meticulous detail. In short, we see here a work that combines sophistication and simplicity, nature and artifice, reality and imagination. There can be no question that this painting marked a point of utmost importance: the end of what can properly be called Cubism.

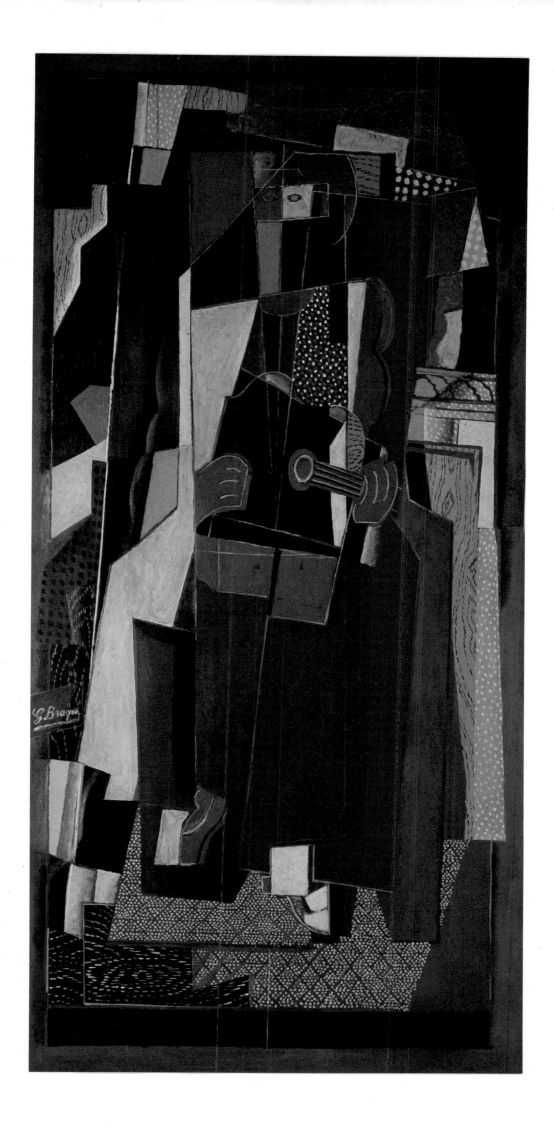

CLARINET, GUITAR, AND COMPOTIER

1918. Oil on canvas, 28 3/4 × 39 3/8"
Kunstmuseum, Basel

Synthetic Cubism did not end in decadence, and its works were not weakened by repetition. On the contrary, the final blossoming of the concept led it beyond the parameters of its own system. The severe, stark *papiers collés*, instead of wasting away completely, turned toward richer themes and more varied materials, thereby paving the way for the next phase. Although it would appear that austerity had been eliminated, the works to come were actually to profit from its lessons.

The legacy of the synthetic period consisted of objects arranged in concentrated groupings; objects reduced to simple geometric patterns; color applied in wide, uniform strokes; and a general movement toward greater flexibility and variety than had been seen in previous efforts. Even though the arrangement has grown less rigorous, even strangely unsettled in certain instances, at no time does it lose its inherent respect for discipline. This confrontation between reason and intuition produces a feeling of stern poetry, of suppressed violence ready to burst through the barriers imposed on it.

One of the first gestures against the Impressionist principle of extension had been the effort to confine the composition to the frame of the picture. We have seen that Braque, not content with one frame, occasionally added another that would become part of the painting itself. In a few of the works dating from 1917–18, he took this procedure a step further by nesting several geometric figures in one another to form a multiple framework. With the number of borders increased, any movement beyond the picture is made impossible. This rather tyrannical solution adds great elegance to the whole and harks back to the purity of the *papiers collés*.

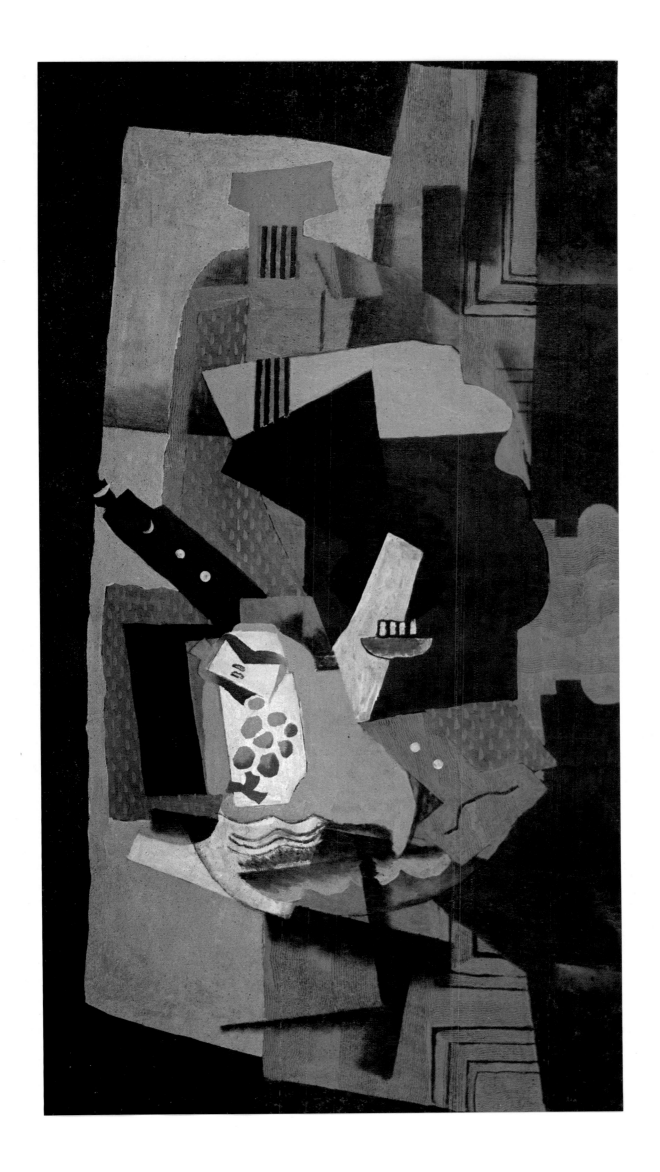

Colorplate 20

CAFÉ-BAR

1919. Oil on canvas, 63 × 32 1/4"
Kunstmuseum, Basel

The explosive moment had arrived. Forms were set free to clash in an upheaval that affected both realistic representation and the Cubist system developed in the course of the artist's previous phases. An unruliness has taken over the painting with unexpected zest; and despite traces of past endeavors, the old unbending restraints have now fallen by the wayside.

The legs of the pedestal table step merrily across the floor tiles; the overlapping objects seem to have difficulty keeping their balance on the tabletop, itself set awkwardly askew; and the arrangement is crowned with letters ("Café-Bar") that seem to be dancing a kind of sarabande. Braque, however, is no humorist: he does not joke with art, and this explosion is not merely a game intended to draw smiles. For some time now, one could sense Braque's need to escape toward greater freedom, toward a more lyrical vitality, toward a source of inspiration more closely related to Baroque art. Indeed, this com-position comes closer to suggesting chaos than order.

As is always the case with Braque, residual elements assure a sense of continuity from one stage to the next. In several pictures, the familiar pyramidal construction crops up, albeit utilized in a less severe manner; and the texture is varied, not by means of unconventional materials, but by such painted effects as stippling and shading. His loyalty to objects—fruit dishes, musical instruments, pipes—takes on a more tangible, more familiar quality. By providing such points of comparison, this permanence in the midst of change enables us to weigh the importance of different stages of the artist's evolution and appreciate them for what they are: not passing fancies or mere appendages, but signs of a fundamentally new language. Although the overall appearance of this work is still rather austere, a closer examination of its details reveals a more relaxed, more animated outlook.

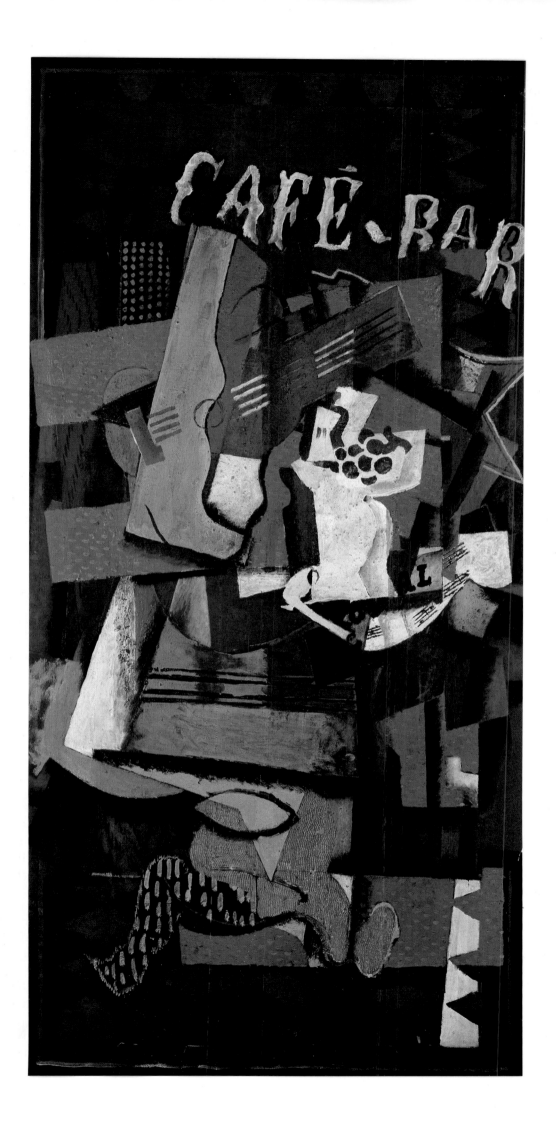

GUITAR AND SHEET MUSIC

c. 1919. Oil on canvas, 28 3/8 × 36 5/8"
Private collection, New York

Here we see Braque intrigued by a freer, more thorough application of a softer approach. The lines now constitute a true script; orthogonals, fewer in number, have loosened under the random impulses of the artist's hand, which no longer seeks to vie with the mechanical perfection of a musical instrument. Surfaces are full of life and often modeled. Reason has given way to intuition. Now at last each object loses its independence in order to contribute to a sense of totality, a resonance that gently brings the entire arrangement to life. Every line, every bit of paint shares in a hushed reverberation that more than ever prompts one to draw an analogy to music. Not one surface is inert, not one form is rigid,

not one line expresses geometric dryness. Even the opaqueness of the substances is dynamic and hints at restless undercurrents.

Braque the theoretician has abandoned his theories to better serve his feelings: his regained freedom has sometimes been interpreted as a surrender to carelessness. By nature too exacting to indulge in this sort of laxity, the artist held his senses under a tight rein. Although dignity and elegance do prevail in this series of paintings, their profound human feeling can be detected more easily than in previous works. For this reason, they signal the next step in Braque's emotive evolution: he now entered a new phase of his artistic career.

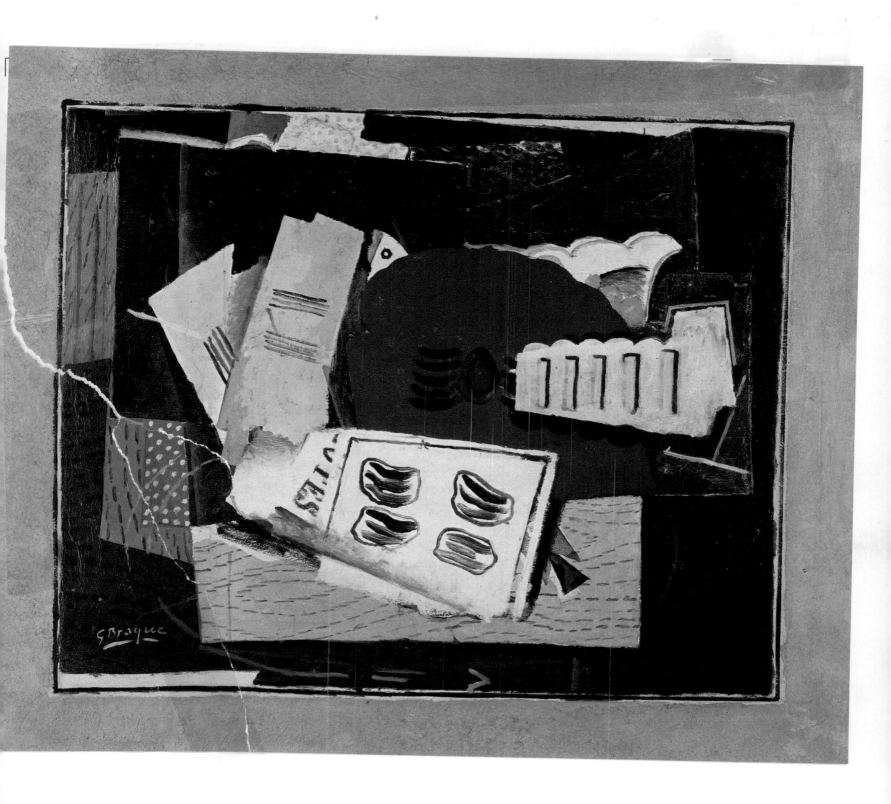

Colorplate 22

CANEPHORAE

1922. Oil and sand on canvas,
71 1/4 × 28 3/4″ each
Musée National d'Art Moderne, Paris

The Baroque impulses that could already be seen in the still lifes painted about 1920 began to appear more frequently. Sensuality was now freely accorded its place in Braque's work. The stiff lines of fruit dishes and bottles found themselves blended with, even replaced by, the supple roundness of fruit. In 1922, this new vitality blossomed into large-scale decorative paintings that depict female nudes carrying baskets of fruit. Their somewhat massive, monumental fullness invests them with a sense of calm, majestic elegance that recalls the caryatids of ancient Greece. This impression is confirmed by the fact that the artist himself entitled them *Canephorae,* or "offering bearers," and thereby clearly revealed their source of inspiration.

In 1924, several other works were added to the series, and their poses constitute a less hieratic variation on the theme. The female nude reappeared in a cycle of works depicting bathers (1925–26): although no longer reminiscent of antiquity in either subject or title, they are no less indicative of an unequivocal, unruffled paganism that, without the slightest hint of perversity, displays the human body like a piece of luscious fruit. The outstanding characteristic of this phase was the balance achieved between classical intention and Baroque spirit, resulting in a feeling of abundance bursting with both forcefulness and tranquility.

Braque's treatment of this theme in drawings reaffirms the sense of calm and attests to the artist's concern for evoking the vibrancy of life through authenticity of form as well as suppleness of drawing style.

It is interesting to note that Picasso also found himself drawn to the nude around the same time; if nothing else, the artists' efforts are similar in the fullness of their forms and an absence of provocativeness.

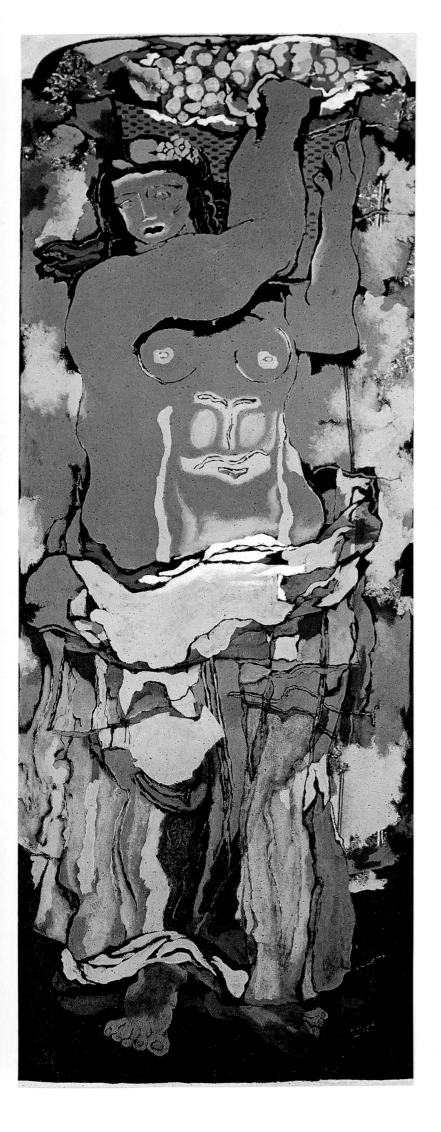
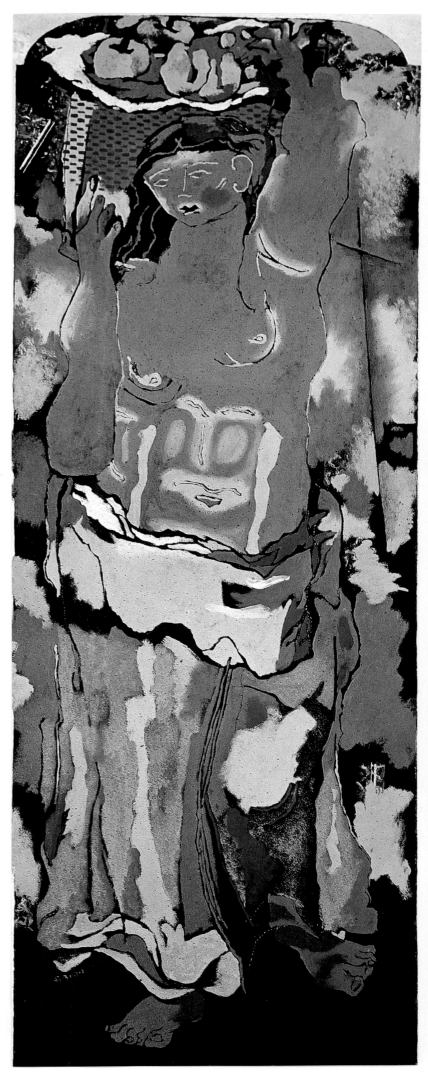

Colorplate 23

VASE OF TULIPS

1927. Oil on canvas, 21 5/8 × 15 3/4"
Statens Museum for Kunst, Copenhagen

The fruit of 1921 and the female nudes of 1922 were followed by the flowers of 1924–27. To be more precise, all three themes were explored along parallel paths, but the flowers were the last theme and were immediately recognized as nearly perfect examples of their kind. Without resorting to halfway solutions, without any hint of hesitancy, they reflect a sureness, a vitality that emanates both cheerfulness and sobriety. The exuberance of their forms and colors endows them with an intensity and a sparkle that avoid flashiness.

Flowers, fruit, women—all of their matured riches were now being harvested. They breathe a healthy, open sensuality: we can almost taste the fruit and smell the flowers. One is led to believe that this was the period during which Braque wrote: "It isn't enough to make visible what you paint. You have to render it touchable, too."

The sheer physical sensations of material existence we see here signal a heightened aware-ness of reality; never before in Braque's work had they achieved this degree of intensity. It might appear that we have reached the very antithesis of Cubism. Actually, this radiance could never have been brought under control without the artist's analytical, then synthetic journey through the rigors of Cubist discipline. By the time he reached this stage, matter had lost its coldness; drawing, its stiffness; surfaces, their flatness. All the elements of the painting were now united into a cohesive, somewhat austere brilliance that removed it from mere imitation of the physical world and brought its realism closer to deliberate, thoughtful, plastic construction.

For several years prior to 1927, Braque gave free rein to this spirit of equilibrium which, except for two or three interruptions from the past in the form of mantelpieces or *guéridons*, remained undisturbed by any conflicting en-deavors.

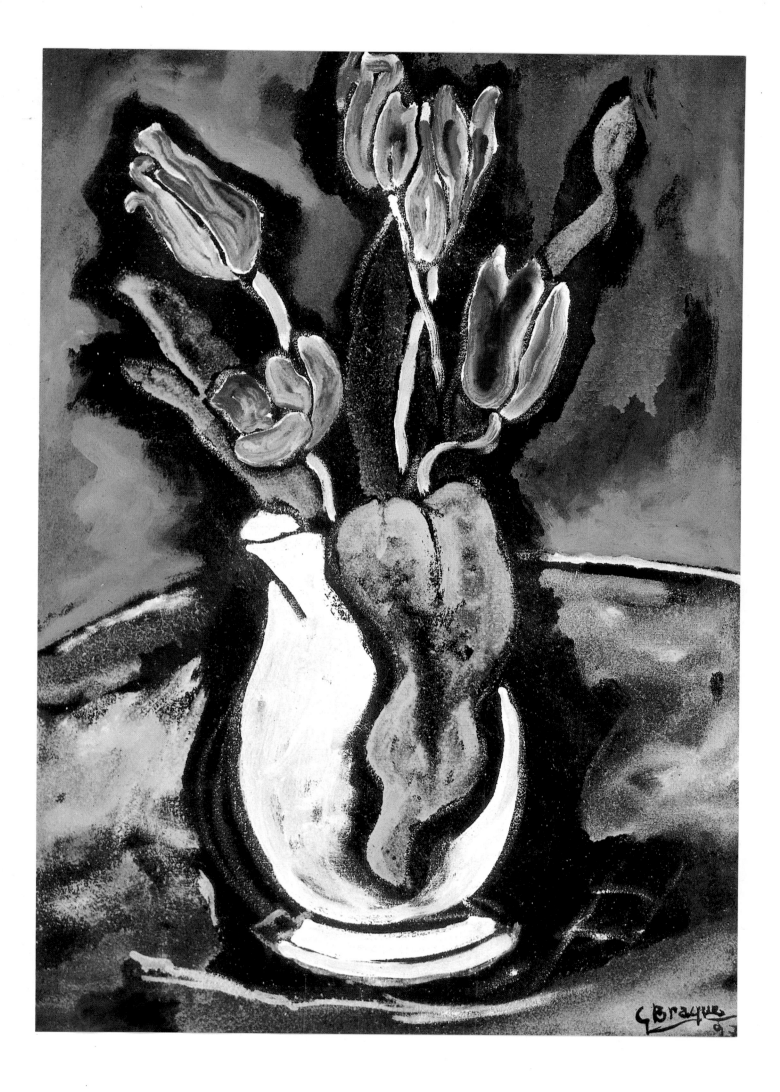

Colorplate 24

THE GUÉRIDON

1929. Oil on canvas, 57 × 44 7/8"
The Phillips Collection, Washington, D.C.

Braque had for some time neglected the theme of the mantelpiece or pedestal table laden with objects. When he returned to it in 1927, he brought along the distortion and geometric structures that had been the hallmarks of Cubism. The limits of this hiatus can be pinpointed quite accurately. In 1921, when the artist found himself beginning to yield to the temptation of the Baroque without yet fully abandoning Synthetic Cubism, he painted a mantelpiece piled up with assorted objects. Then, in a 1923 painting, he treated the same theme in much the same spirit. A good deal later, in 1927–28, he executed a virtual replica of the 1923 work. The intervening years had witnessed the outpouring of nudes and "Baroque" still lifes that we have just examined.

The theme of the pedestal table met the same fate as that of the mantelpiece. Although the *guéridon* in *Café-Bar* of 1919 (colorplate 20) was followed by another in 1921, nothing resembling this motif appeared until 1928.

We now enter a period whose alternating or conflicting tendencies were even more widespread than in previous phases. "Visual space separates objects from one another. Tactile space separates us from objects." One must always bear in mind Braque's definition of space; and it is especially relevant here. In *The Guéridon* of 1929 we see an interesting example of that idea in the way the artist filled different portions of the canvas. The congested central zone is surrounded by a lighter or darker perimeter that pushes the walls back to form a separate area; and a third area is formed by the legs of the table, which bear down forcefully on the floor. Even though each of these three areas corresponds to a specific distance and tactile sensation, their combination in no way detracts from the unity of the painting.

In order to grasp the sense of serene orderliness that pervades this work in spite of its dynamic flavor, one need only compare it to the pedestal table in *Café-Bar* (1919). In the latter, we see a nearly explosive turbulence that seemed strangely violent at the time; whereas the 1929 work, notwithstanding its numerous oblique lines, bears witness to the artist's continuing search for the more static appearance presaged by the *Mantelpieces* of 1923 and 1927–28. These paintings, therefore, are highly significant in that they reveal both the conflicts and the consistencies of Braque's development during the years 1920–30.

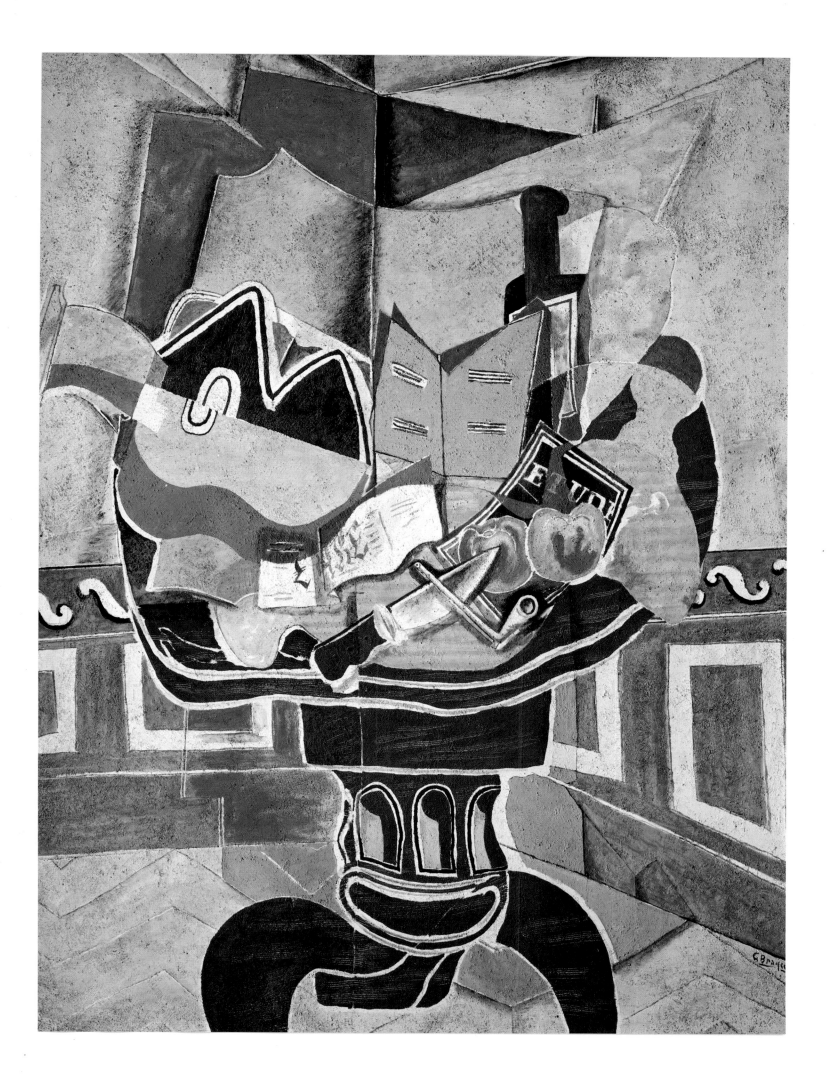

THE GRAY TABLE

1930. Oil on canvas, 57 1/8 × 30"
Private collection, United States

Spatial concerns always played a key role in Braque's work and led him to adopt approaches that put him in a position to undermine tradition. Thus, he avoided falling into the trap of expediency offered by imitative representation of reality and its conventional system of photographic perspective.

One of the ways he restricted himself was to utilize oddly shaped formats that forced him to confine the subject to the given boundaries. This explains his choosing vertically elongated canvases even for horizontal themes, which meant that the objects had to be arranged so as to overlap along a frontal plane of vision instead of being distributed along several grounds receding into the distance. If we look back to the Cézannian landscapes painted at L'Estaque during 1907–8, we see that this procedure asserted itself at a very early point in Braque's career. Every stage of the artist's development reveals an unending desire to resolve such problems by means of strictly personal solutions. After all, he was not unaware of the achievements of Far Eastern artists in this field. Although he could well have allowed himself to be influenced by

them, no trace of their efforts is to be found in his work.

To bring off this verticality, he, like many other artists, occasionally made use of a bird's-eye-view perspective. However, he often chose not to employ this expedient and instead offered arrangements that made no effort to look "realistic." All the elements of the composition would be placed on the same visual plane and at the same distance from the observer, which gave the upward movement a high degree of unity.

As a way of accentuating this deliberately vertical effect, Braque generally avoided anything that might have created the impression of distance between objects, even when he would model their surfaces. One feels that he was more concerned with visual planes than with volumes. In this manner, he remained closer to a purely two-dimensional, pictorial world than if he had resorted to the subterfuge of suggesting the depth of a third dimension. These tall panels, therefore, often led Braque to do away with the concept of distance, even in those paintings where shading is used so as not to exclude relief altogether.

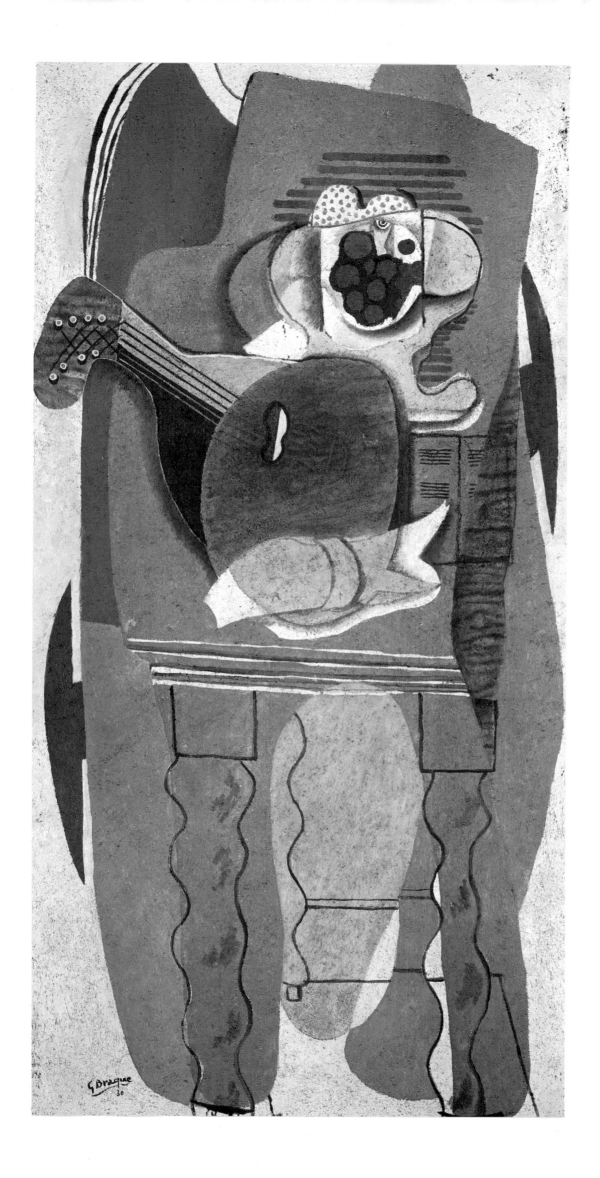

THE BOTTLE OF MARC

1930. Oil on canvas, 51 1/8 × 29 1/8"
Private collection, New York

Although Braque's diverse approaches may sometimes appear to be in reaction against one another, they do not reflect inconsistencies in the artist's outlook. Several of his paintings attest to the ease with which he attained a degree of synthesis that undoubtedly stemmed from a desire to unify.

In *The Bottle of Marc* (1930), we again see the kind of large vertical areas that had been used to orchestrate *The Musician* of 1917–18 (colorplate 17); objects collected atop *guéridons*; surfaces enlivened by stippling; the sensual brushstrokes of the fruit; open books or pages of music; and even the vibrant sensuousness of the still lifes dating from the period we have just discussed. Despite the diversity of Braque's pictorial vocabulary at this point, his coherent medleys of 1929–30 manage to blend various forms—rigid or supple, linear or wavy, flat or modeled—with consummate skill. What seems different about these compositions is not so much his masterful ability to reconcile heterogeneous elements as a spirit of refined, balanced logic that was to blossom in a few years' time with serene loveliness.

Braque ventured beyond particular methods toward more agreeable juxtapositions. For all their daring, his distortions are not cartoons: they bespeak a freedom of movement, a controlled ease that is less concerned with depicting a piece of fruit or a mandolin than with following the intricacies of their winding shapes. At the same time, the object, though still a pretext for creativity, ensures by its very presence a continuing obedience to the imperatives of realistic representation.

Here again we should like to emphasize how Braque was able simultaneously to pursue different paths that recall the past as well as presage the future. True, *The Bottle of Marc* is largely made up of elements derived from previous works. However, other compositions—the simple, almost realistic fruit and flower arrangements—were very much an enterprise of the present moment, signaling the preliminary stage of the unified, so-called decorative still lifes that would prove to be one of the high points of Braque's art.

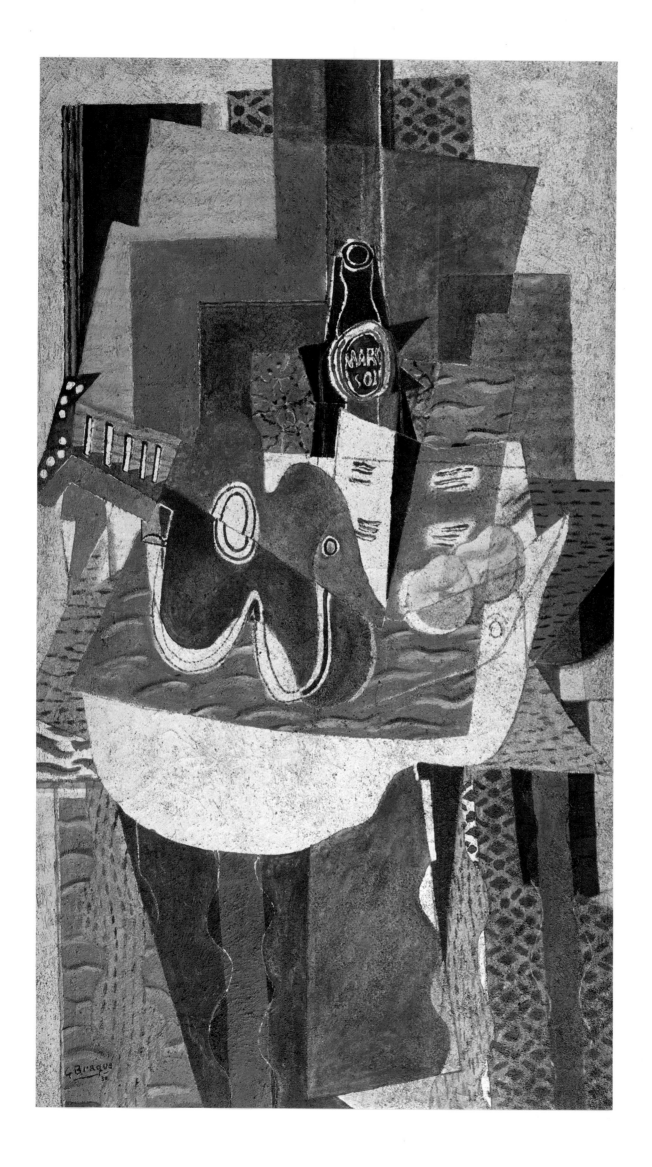

Colorplate 27

THE THREE BOATS

1929. Oil on canvas, 9 1/2 × 13 3/4″
Private collection, Stockholm

Now we are confronted with the most striking inconsistency of all. Braque had utilized the landscape for his first bold excursions into Fauvism, and then in his earliest Cubist endeavors. However, with the exception of two works in 1910–11, he dropped the landscape theme altogether and did not return to it until 1928. By that time, he was further along the road of artistic liberation, including a rejection of the rigors of Cubism.

In 1923, Braque had designed sets for *Les Fâcheux* (Ballet Russe) and in 1924 *Salade* (Soirées de Paris); in 1925, he had worked on the sets for *Zéphyre et Flore*, again for the Ballet Russe. It is difficult to believe that his contact with the theater had nothing to do with his movement toward this new concept of space. The way the volumes are arranged in the foreground, their massive proportions, the way they are spread out to the right and left—everything contributes to a theatricality that stands in contrast to what we have seen in paintings dealing with other themes.

As Braque interprets it, nature, though still quite realistic, has been stripped of all superfluous details and reduced to its formal essentials, not for the sake of achieving a Cubist-inspired geometric construction, but to create an impression that can reach out to the senses.

The artist's contact with the sea (at least since his move to Varengeville in 1929) certainly had something to do with all this, and one gets the feeling that he now wished to break out of the rooms that sequester his still lifes. Could his renewed contact with nature have brought with it a rediscovery of the real world? And did it result in an attempt to reconcile artistic technique with the landscape's physical characteristics, as seen in stippled areas to suggest sand and sleek expanses for the sky and sea?

This minimal realism, however, led not to *trompe l'oeil*, but to purification. The simplified forms and colors come closer to a unified, emblematic system of representation than either the cerebral complexity so familiar to us from Braque's previous work, or the accuracy of photographic perspective.

In any event, and whatever the meaning of this first cycle of landscapes, they constituted yet another point of departure. Similar concepts were to crop up in subsequent years and eventually lead to a new version of the landscape, somewhat different in spirit, that the artist formulated toward the end of his life.

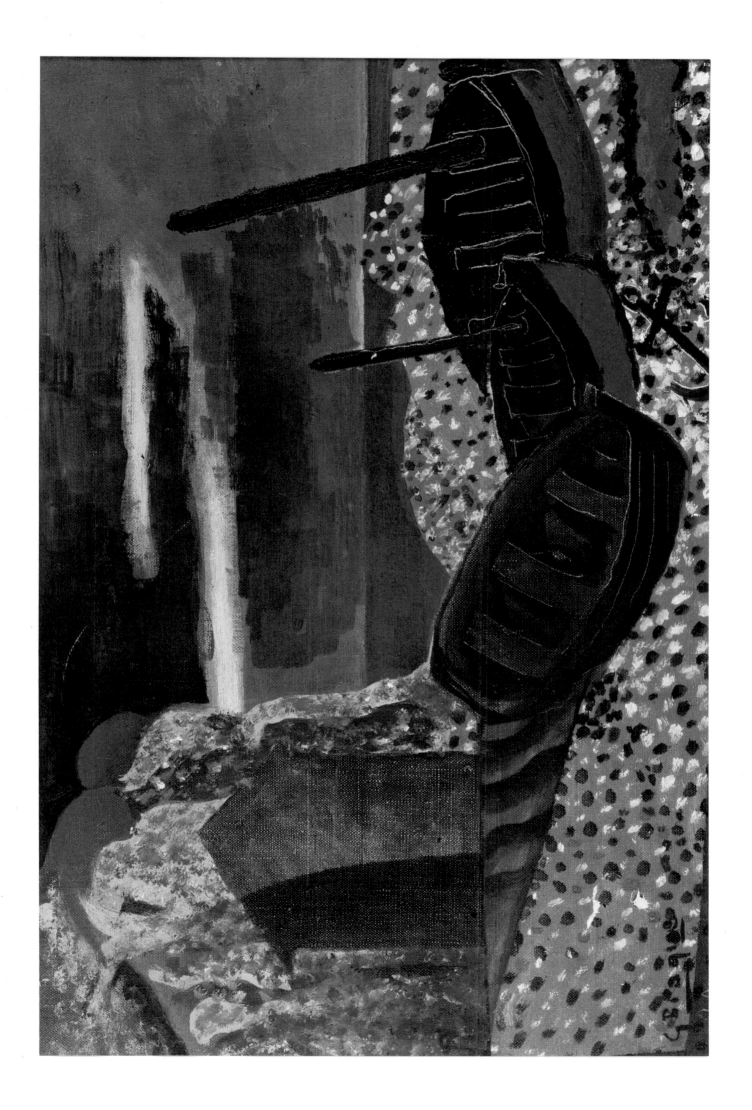

Colorplate 28

NUDE RECLINING ON A GUÉRIDON

1931. Oil on canvas, 9 1/2 × 16 1/8″
Private collection

There was another theme which, at every new stage of Braque's development, seemed destined to serve as a catalyst for innovation. About 1930, the human figure came again to the fore and bore out the artist's commitment to self-renewal and his willingness to explore untapped resources. These nudes, stretched out on the beach, were not made to conform to the kind of realism just seen in the landscapes. Instead, they reflect a restlessness that points to his persistent ties to Picasso and the curious reciprocity between the two painters. Picasso's female nudes, including their various manifestations since 1925, reveal numerous similarities to Braque's bathers in the mechanical distortion of their bodies and the aggressiveness of their shapes.

Even though 1914 marked the end of their collaboration, their individual paths often ran parallel to each other. We saw this first in the transition from Analytical to Synthetic Cubism, then in the return to a more realistic approach—especially in the plump female nudes of Braque's

Canephorae—which signaled both artists' receptiveness to themes drawn from antiquity and its belief that the human body should be openly displayed.

This gesticulating, almost cartoon-like drawing style reflected not only a search for a new way of approaching the relationship between movement, form, and color, but a deliberate attempt to steer clear of the realism that had characterized the recent landscapes. The picture has been reduced to a collection of large expanses painted with broad layers of color. Both form and color have undergone extreme simplification and find themselves enveloped in sinuous, undulating curves that follow the rhythm of the pose. The end product is a bizarre-looking marionette fitted together with highly flexible joints.

In a way, this anti-realism is a kind of anti-Cubism as well, a new yearning for the Baroque spirit that had already appeared during Braque's career and which would continue to assert itself in the years to come.

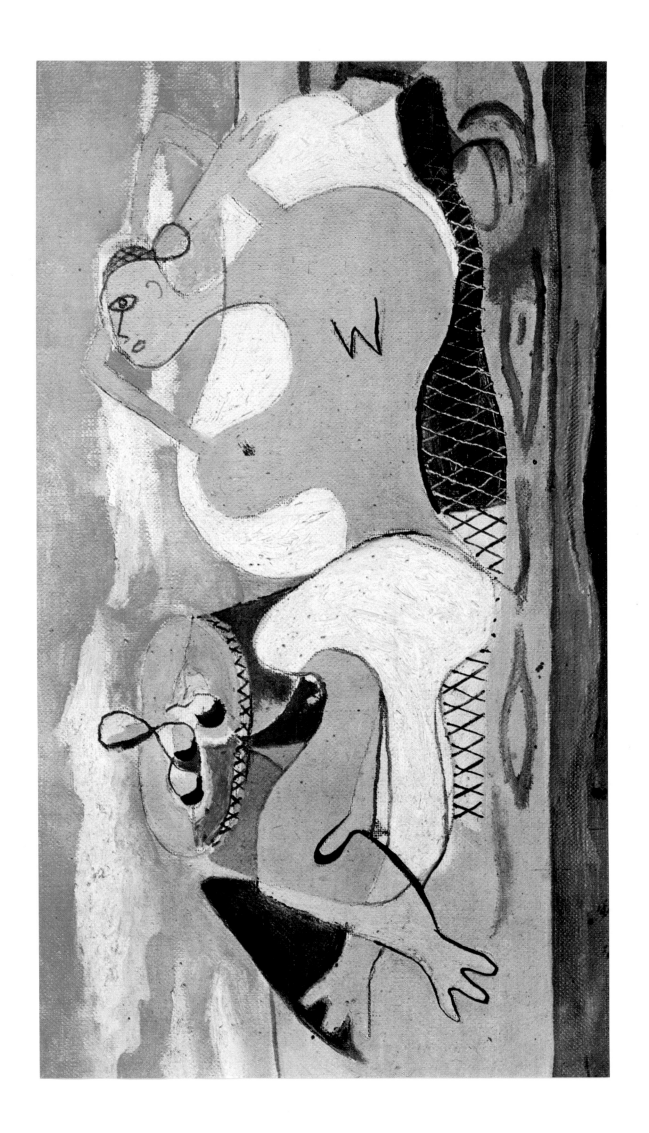

Colorplate 29

BROWN STILL LIFE

1932. Oil on canvas, 51 1/8 × 76 3/4"
Musée National d'Art Moderne, Paris

The still lifes that followed the nudes could truly be called their offspring, for they utilized the same approach with even greater confidence and freedom. From now on, large expanses of color were spared the necessity of suggesting objects or persons: all that remained was the stark fullness of oblong shapes. Their naked simplicity makes it easier to see their gracefulness, leaving them with no other justification but their own interrelationships. An idealized conception of this type enables the outlines of the forms to be wrapped in a cloak of intangibility without robbing them of their autonomy.

The real and the unreal overlap to create a poetry in which preciosity, curiously enough, remains rather muted. Although different materials are employed here, one is reminded of the purity of the *papiers collés*, perhaps because, in both cases, Braque successfully dissociated line and color as a way of maintaining each element's brilliance and expressive power. As Braque once wrote: "Shape and color can't be exchanged. But there is simultaneity." Never before had this principle found a more exacting application or achieved a more successful outcome.

The elegance of drawing and the refinement of painting complement each other without sacrificing individuality; they are closely interrelated, but there is no loss of identity. Reduced to their essentials, they both profit from the required suppression of all superfluous detail; and yet their simplification gives no hint of insufficiency or constraint.

This duality, in which color and line are in agreement and in opposition, is accentuated even more strongly by the technique adopted by the artist. Color is obtained by applying paint in the usual way, whereas the lines are threadlike incisions cut into the layer of paint, recalling the engraved black plaster panels that Braque executed about this time.

In terms of its overall effect, drawing here takes on the appearance of writing or graffiti akin to expressive symbolism. Color, for its part, endows an unreal space with tangibility. The twofold interdependence of mind and senses results in exceptional unity where there might have been only dissonance.

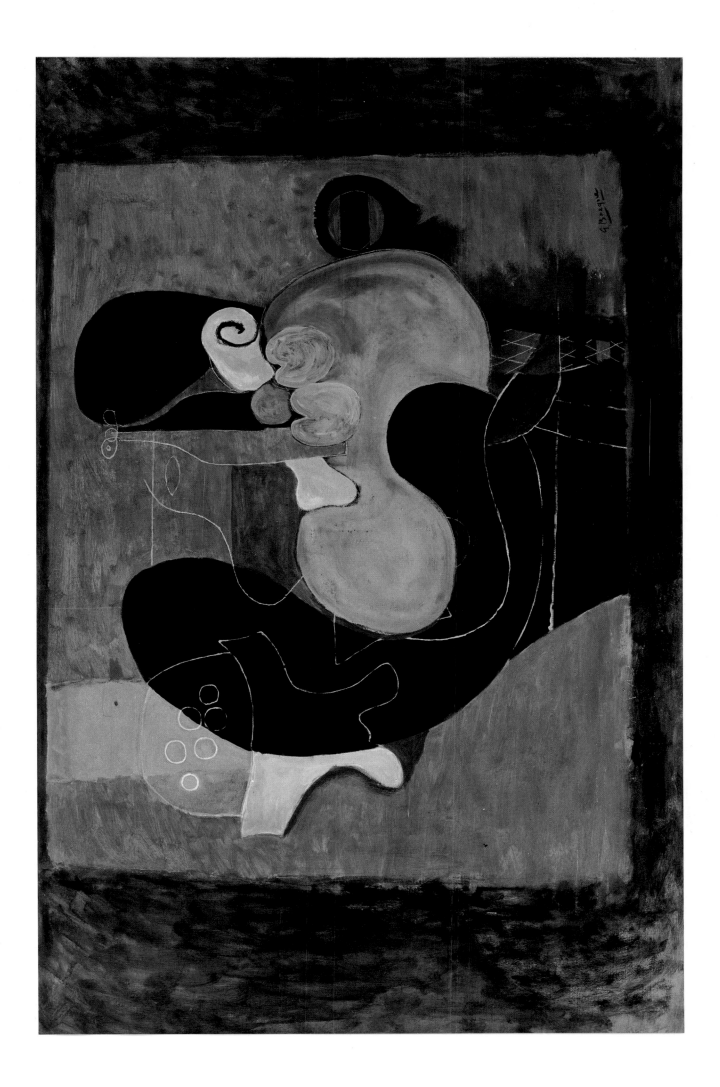

STILL LIFE WITH GUITAR

1935. Oil on canvas, 31 7/8 × 45 3/4"
Private collection

The still life continued to be Braque's preferred theme. It had by now shed some of its austerity. Objects, though still undulating, allowed themselves to be fitted into the contours drawn for them. Suppleness of line was retained—in fact, its sinuousness was accentuated—but it was no longer content to serve as a mere diagram for form. Whether delineating or decorating the object, line became sensation rather than abstraction.

The material quality of objects began to show itself once more; the objects themselves were more numerous and were depicted in a less static, seemingly more spontaneous arrangement. An air of vibrancy prevails, a sort of elasticity between the objects and the atmosphere that surrounds them. The top of the table, or *guéridon*, has been set upright along a vertical plane of vision, thereby framing the assorted objects that rest upon it. However, unlike the still lifes of 1920–30, the tabletop is not set far away from the wall that serves as background. The volumes are still simple, but their elegance is less severe than in previous works: even decorative elements have been allowed into the picture.

One feels that Braque was now totally at ease when it came to combining the orthogonals of the painting's perimeter and the central area, which is usually composed of curved lines. So well integrated are the components of this prescribed order that it seems completely natural and, indeed, could easily go unnoticed. Even when the objects are very few in number, the way they are arranged underscores the feeling of concentration or accumulation.

Given the diversity of approaches that were being exploited at this time, Braque seems to be in the process of drawing up an inventory of his resources, of summing up in a few paintings all the means at his disposal: an inventory of forms, that is, objects (bottles, fruit dishes, mandolins, fruit); of pictorial techniques, whether the medium is brushed on, scraped on with thick impasto, or applied as a fine colored line; of compositions that set objects apart or bring them together; and of rhythms, static or dynamic.

From these collected energies would emerge, fully blossomed, a new and brilliant phase of his art.

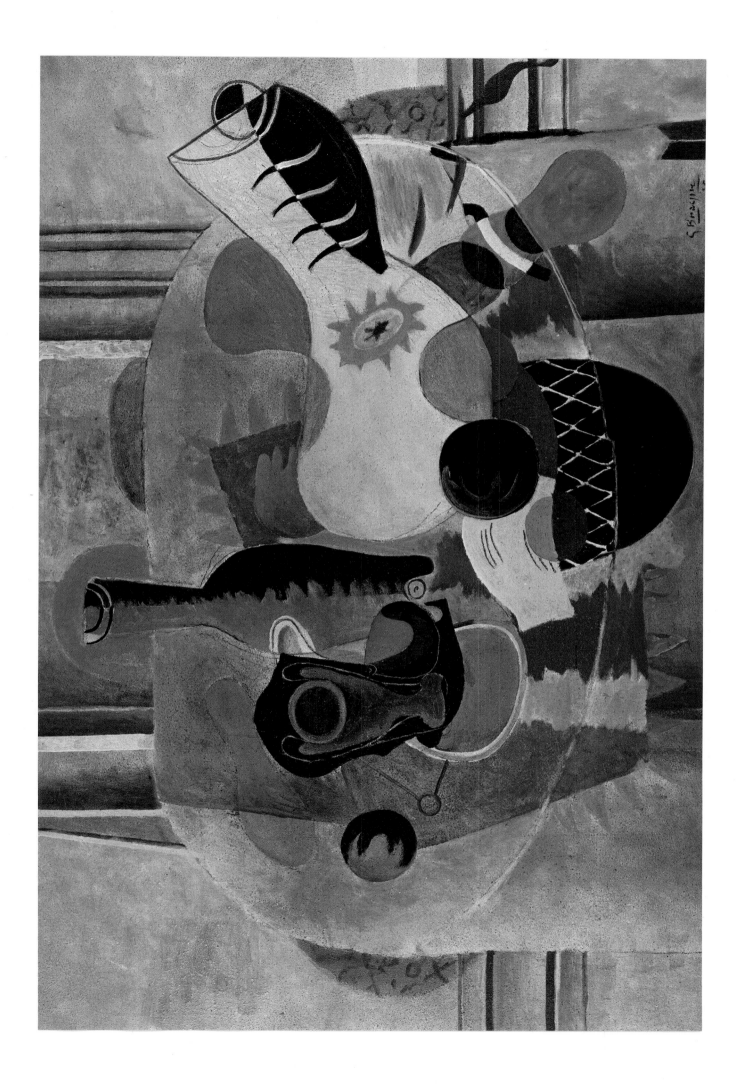

THE PURPLE TABLECLOTH

1936. Oil on canvas, 38 1/4 × 51 1/8"
Private collection, New York

Braque's art reached one of its zeniths with the so-called decorative still lifes of 1935–36, works of serene grandeur whose sophistication, though quite elaborate, did not lead to overrefinement. It was one of the paintings in this series, *The Yellow Tablecloth*, that won the first prize of the Carnegie Foundation in 1937.

Like a bouquet of radiant blossoms, each of these still lifes is a totality in which Braque demonstrates his command of all the problems he had chosen to deal with. This was especially true of his ability to arrange the components of the painting so that the observer could be made to perceive the distance he referred to as visual or tactile space. Probably his most effective device was to blend pictorial elements by alternating quiet areas with busier ones: the motionless tabletop is nestled between a modulated, unstable area of objects crowded together and the walls in the distance. All the elements follow different rhythms, but the artist has managed to bring them into harmony.

The earlier works had proved to be but the preparatory steps leading to this crowning achievement; all the different combinations Braque had worked on over the preceding years were brought together in these marvelous amalgams. We see again perspective effects in the lines of the walls and in the isolated central area propped up by a scaffolding of vertical, horizontal, and oblique lines of the cornices and paneling. There is the familiar tabletop that encircles objects made up of intricately connected curved lines; the vase vertically divided into areas of light and shadow; the simulated wood and false marble; the undulating mandolins; and lines that change color as they travel from one area to another.

The still lifes of 1933–34, among others, paved the way for this work. They are highly structured exercises in rigorous interdependence of pictorial areas, in which the tabletop surrounds objects whose inverted curves join the background to the central grouping. Everything that had been only tentative in nature now obtained the certitude of perfection.

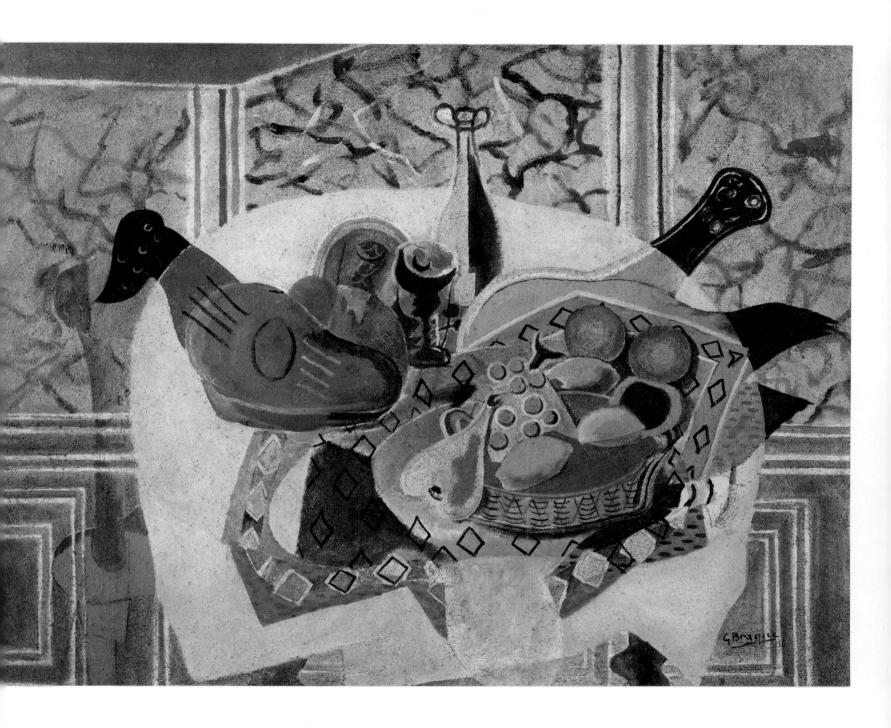

Colorplate 32

STILL LIFE WITH MUSIC SCROLL

1936–38. Oil on canvas, 44 7/8 × 57 1/2"
Private collection, Chicago

Whenever his evolution reached a point of perfection, Braque would delight in shuffling the cards now and then and in sowing at least what appeared to be the seeds of disorder. Although the objects seem to be thrown together at random, they actually are overlapped to produce a carefully designed eruption. First of all, we see the customary unity created by a coloristic theme —in this case, luminous ochers and fiery reds toned down with browns. Then there are the intertwined white outlines that delineate the forms by traveling from one object to the next, before being surrounded themselves by the sinuous contours of the pedestal table.

The lines are developed like a musical theme: wavy or angular, now densely packed, now scurrying about, shifting from one kind of movement to another in so unaffected a manner that everything seems completely natural and spontaneous.

The fruit dish, decanter, glass, and pear are drawn in a particular way that distinguishes them from the other objects. The light outline that circumscribes these shapes throws them into relief: they stand out from the group, but are not cut off from it. They function as stable elements in a composition that fairly bursts with radiant energy. Though one may not notice them at first, they are the components that impart a sense of equilibrium to the entire arrangement; they are the source of its dynamism. They constitute a crowded nucleus whose pulsation— now amplified, now softened to more sedate rhythms—finally reaches the large, glowing, uninhibited expanses that fill the painting's perimeter, or the lower part of the table, that oasis of serenity decorated with floral designs. A kind of tranquility flows from this turbulent expansion: even the mandolin adds a note of calm, its contours contrasting with those of its boldly assertive neighbor, the fruit dish.

It had been a long time since Braque began to think of painting in terms of a self-contained object that gave no hint of extension beyond its limits. Now his work had reached the point where it was impossible to add or remove anything without destroying its unity.

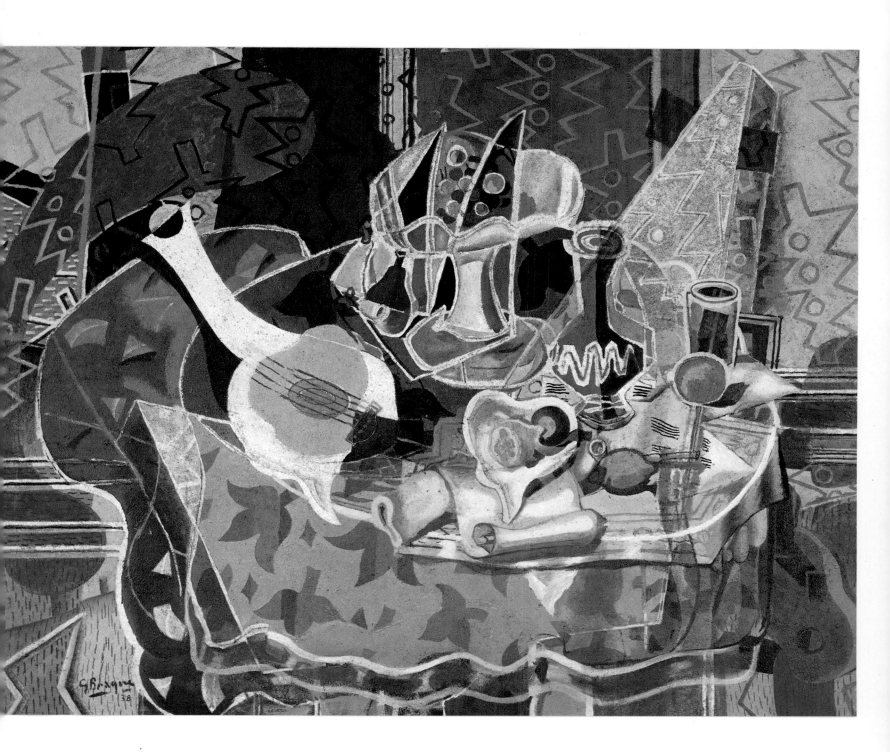

THE DUET

1937. Oil on canvas. 51 1/8 × 63"
Musée National d'Art Moderne, Paris

The human figure reemerged in 1936, not isolated as in previous works, but placed in an interior, living in a room, doing things that suggest the private world of everyday activity.

All the works in this cycle evoke the peacefulness of watchful solitude, of meditation within some hushed dwelling sheltered from the flow of the outside world. But the feeling of emptiness is offset by flat mural surfaces that languidly throb with a covering of decorative patterns. The very denseness of this environment imbues the entire picture with a kind of haunting tension. One might think that Braque's involvement with this theme could have taken him back to the sort of anecdotal genre painting held in disrepute by artists, especially since the age of Impressionism. But he avoided that pitfall. Not one of his works attempts to relate a story. Instead, his goal was to create a pictorial statement that happened to take life as its point of departure.

The course of this creative enterprise can be followed quite accurately, and a comparative study of several works dating from this period demonstrates that Braque left little to spur-of-the-moment improvisation. We have selected three paintings (two from 1936, one from 1937) to illustrate the various stages of this evolution. *Woman with an Easel (Green Screen)* (see fig. 61) could be considered the prototype whose principal motifs are reproduced quite faithfully in the other two works. In all three there is the same profile, the same juxtaposition of two faces, the same hairstyle and bodice neckline, even the same triple lighting effect at the neck and wavy outline of the torso. Although what we believe to be the first version is more harsh, more assertive than the other two, it already included all the elements that would be utilized later with greater flexibility. The canvas is divided into almost equal vertical sections, each playing a specific role: the left one is reserved for the figure and backlighting; the middle, for direct illumination; and the right one for still-life objects and their *chiaroscuro* highlights. The same kind of vertical separation occurs in *Woman with an Easel (Yellow Screen)* (see fig. 62), but there is now a large centrally located line that Braque had already used in *The Guéridon* of 1929 (colorplate 24) to suggest the feeling of distance between the background and the objects in the foreground.

All of the aforementioned features were duplicated in *The Duet* of 1937, including the way the arm and hand are positioned to hold the brush and palette (here, a page of music). Comparing the paintings enables us not only to trace a creative evolution to its ultimate statement, but to understand better the air of self-assurance that flows from it.

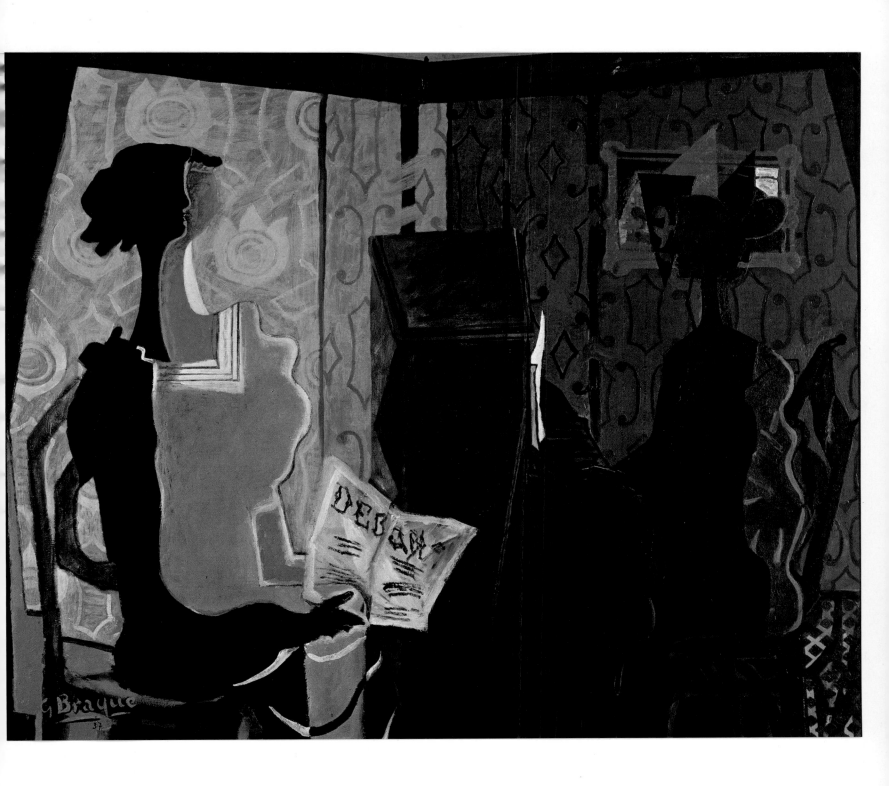

Colorplate 34

THE PAINTER AND HIS MODEL

1939. Oil on canvas, 51 1/8 × 69 1/4″
Private collection

Although Braque continued to experiment with the theme of interior with figures, with their faces depicted as a front view–profile combination, the fundamental aesthetic and intellectual ideas of the theme lost none of their expressive forcefulness over the years. Their mysterious power is undiminished, to the degree that each of the paintings affords a myriad of possible interpretations. Certainly, these works could hardly be considered transpositions of the real world: the figures look more like elements grouped in some abstract arrangement, and the setting that frames the silent confrontation is frozen in time and space. Fixed as monuments, the images convey the feeling of an unchanging present moment as shut off from the past as it is closed to the future.

We see here a somewhat freer version of the tripartite spatial division that we pointed out in colorplate 33: the supple contours of a woman depicted as a dual form, the still life with its geometrically shaped cutouts, the phantom reality of simulated wood, the alternation of window and wall, shadow and light. Even though the triple vertical separation appears to be less severe here than in previous works, it still respects the sense of equilibrium that assigns diverse elements to their proper place. For example, the angular silhouettes of the painter and his easel serve as a counterpoint to the sinuous folds of the woman's body. Likewise, *The Studio* of 1939 (colorplate 36) reveals intricately winding curves counterbalanced by the rigid shapes of the still life that fills the right side of the painting. In addition, the window and panels in the middle part contribute to a new, more flexible concept of space.

While examining these works, one discovers similarities among them involving not only figures and objects, but their light, silence, rhythm, surface, volume, and flat and modeled areas—all of which produce a curious sense of simultaneity that makes every element count, whether it is figure, object, or decorative motif, and whether it is considered individually or in terms of its relationship to the whole.

134

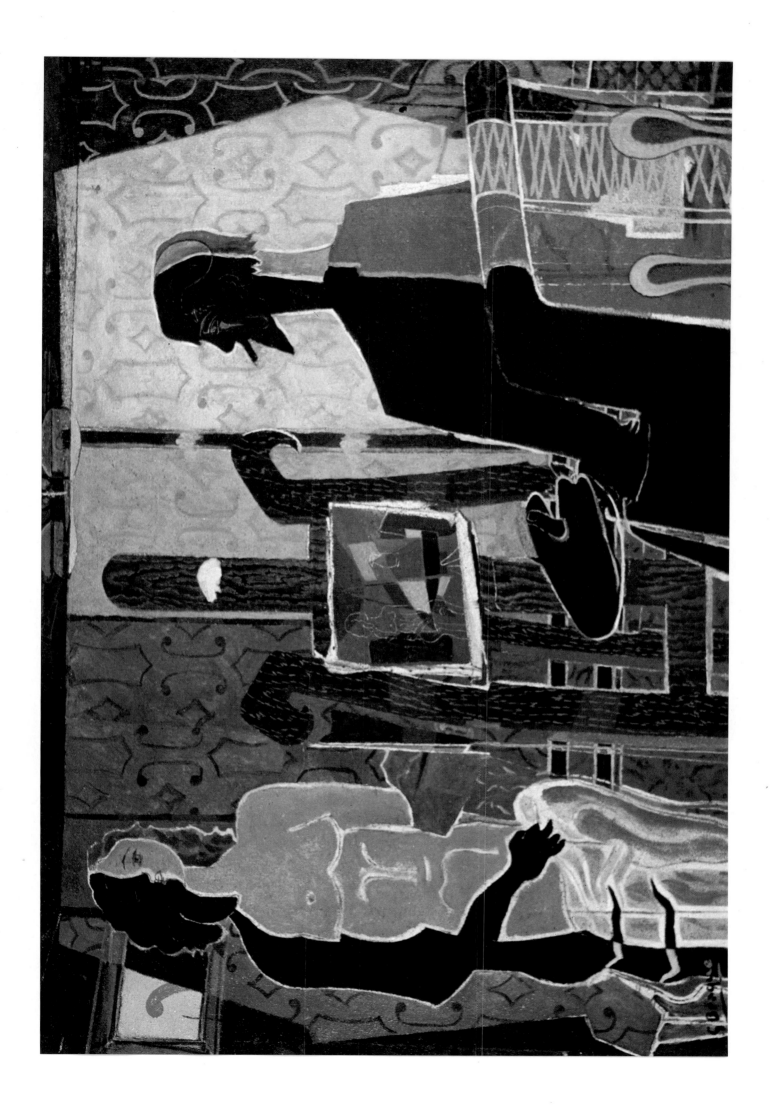

THE GUÉRIDON

1938. Oil on canvas, 42 1/8 × 34 1/4"
Private collection

In keeping with his tendency to shift from one aesthetic pole to another, Braque created transparent still lifes whose less oppressive atmosphere contrasts with the opaque feeling that pervades his interiors with figures. Although these works do not equal the "decorative" still lifes of 1935–36, something of those magisterial compositions survives in the orderly disorder of the objects, in their appealing distortion. The relaxed atmosphere of 1935–36 now borders on breeziness, and everything seems more natural than ever before.

Even if the objects are generally isolated from one another, they appear to be connected by the winding outline of their contours or by some decorative element. In place of the severe elegance of mandolins, the artist evokes the unstable shapes of plants.

The tops of both the table and, to an even greater extent, the *guéridon* submit to the principle of verticality: they are stretched out toward the top of the painting and framed by the moldings of the background wall.

Of course, all of this calls to mind previous works, but nowhere do we detect the monotony of imitations weakened through repetition. What distinguishes these from preceding still lifes is, above all, the lightness and liveliness that are produced by the denseness of the materials and the instability of the forms. The objects, the fruit—everything is transparent; instead of merely circumscribing immobile tables, the tablecloths seem to lift them into flight; the flowers and leaves spread out like wings. Straight lines and intricate curves intermingle without losing their individuality.

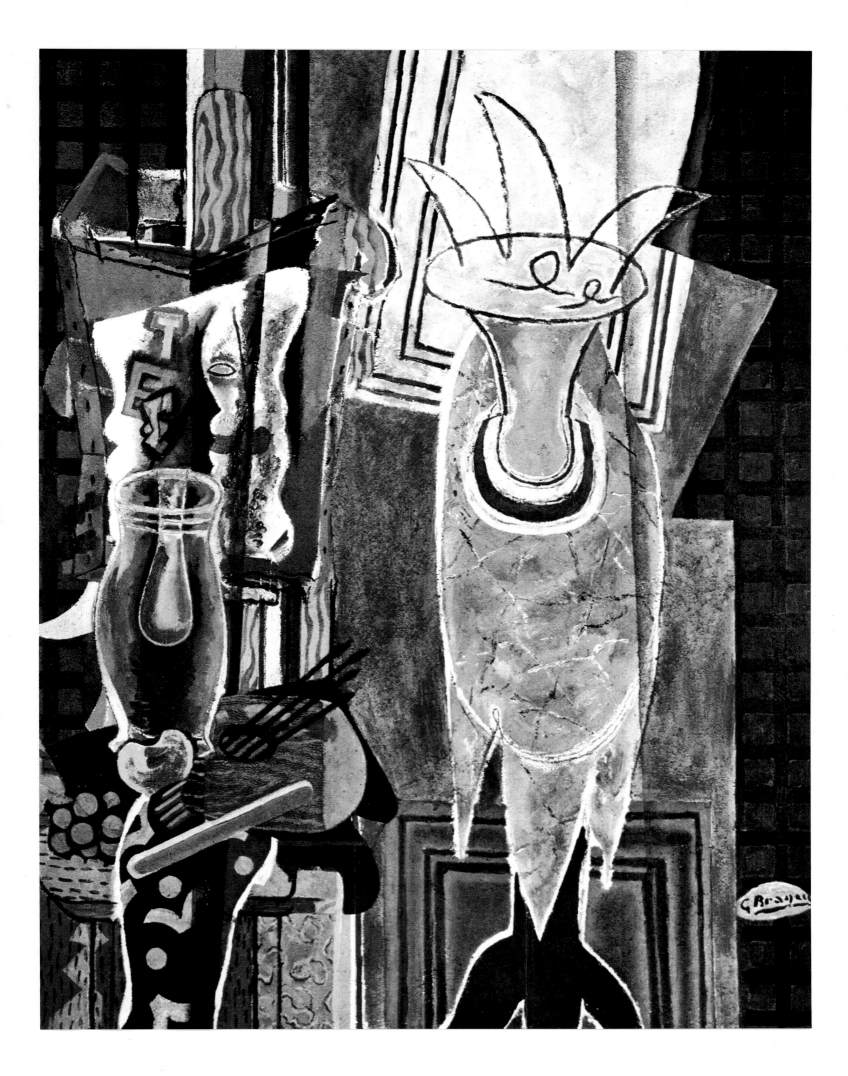

Colorplate 36

THE STUDIO

1939. Oil on canvas, 40 1/2 × 57 1/2''
Private collection, New York

Braque explored the structural potential of objects, seized the opportunities provided by transparency of material and interdependence of form, and either depersonalized or particularized his themes. Thus he had at his disposal an extremely varied stock of plastic terms. His ability to suggest things without having to describe them enabled him to express their essence. Now fully aware of the extent and diversity of his vocabulary, he tried to utilize all of its resources at once.

Angular, false wood-grained slabs, curving vases, and the decorative arabesques of fabrics are combined more freely than ever before. All of the shapes interact and overlap to form a richly suggestive state of disorder.

The paintings of this period bring to mind our dreams, those old attics, cluttered with assorted memories, that open out to the poetry of the imagination. One could again point out the division of the canvas into vertical sections, compare the static and dynamic elements, take stock of the different materials, and above all marvel at that magical space, at once near and far away with no breaks in between.

The cluttered look notwithstanding, Braque manages to reduce everything to its essentials by stripping each detail bare: one feels as if he is revealing the blueprint, one might even say the skeleton, of his arrangements. Then, as if to underscore the solemnity of what might otherwise be taken for a mere game, he adds something new—a skull, seemingly placed at random among the other objects—that looms out with a strangely authoritative presence (see fig. 63). It had already been and would continue to be the thematic focus of compositions with meaningful titles such as *Vanitas* or *Hamlet*. The fact that the artist would place the death's head amidst increasingly disparate objects in no way diminishes the striking impression it makes on the observer. If anything, it adds an uncharacteristic note of commentary while avoiding dramatization. All the same, certain of Braque's subjects at this time were not unaffected by the political situation and the threat of war.

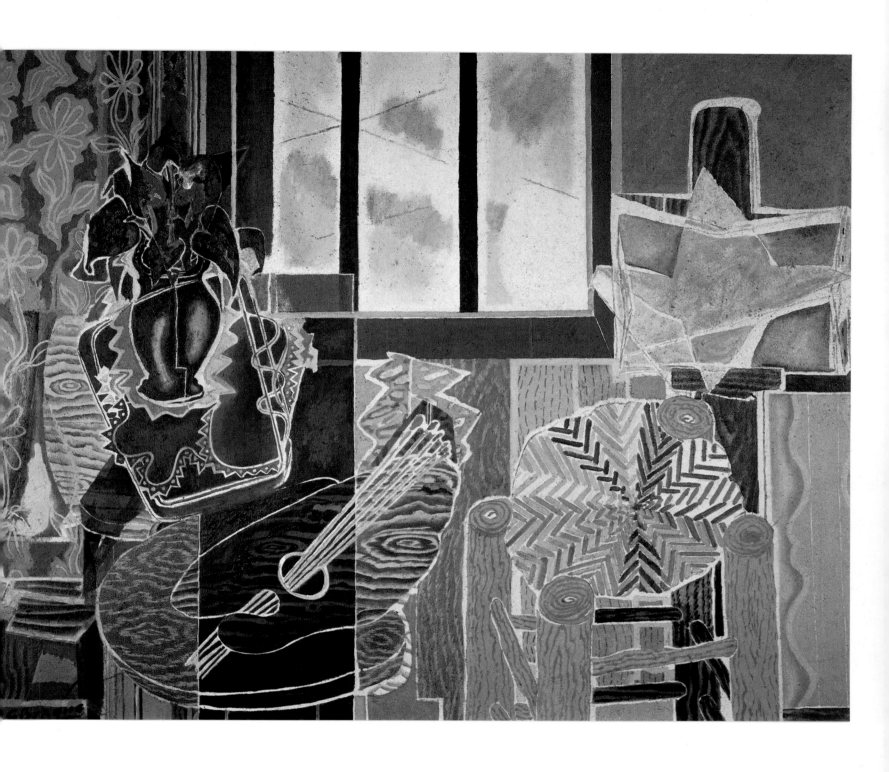

BLACK FISH

1942. Oil on canvas, 13 × 21 5/8"
Musée National d'Art Moderne, Paris

The cares and deprivations of war spread an atmosphere of austerity and frugality; and Braque likewise tried to simplify his art. The most telling evidence of this lies in the fact that his still lifes, for the most part, underwent a change in tone. The yearning for purity emerged once again, as it had in the *papiers collés* of 1912–13 and the still lifes of 1931–32. The fish theme proved to be particularly well suited for this exercise in stripping the subject of all superfluous details. The shapes combine to form a severely geometric arrangement utterly devoid of fancifulness. The colors are simple: black now plays a key role. The smooth substance of the still life proper stands out against the granular background, whose relief contributes a touch of liveliness.

The same feeling of austerity, albeit rendered with greater suppleness, can be seen in other still lifes that include vases or fruit. The outlines unwind their curves in controlled freedom; and the fish, though drawn more severely, lose none of their elegance.

These works are the antithesis of the previous "studio" paintings; here the air has taken on a strange sort of clarity. Their rediscovered simplicity and lucidity join forces with a striking impression of solidity. One feels that what appears to be effortless is actually the fruit of complete mastery acquired through long years of experience. Indeed, how else could he have combined large, unmodeled areas, using virtually no perspective, and still have managed to avoid being dull? On the contrary, the result is a curiously suggestive representation of space.

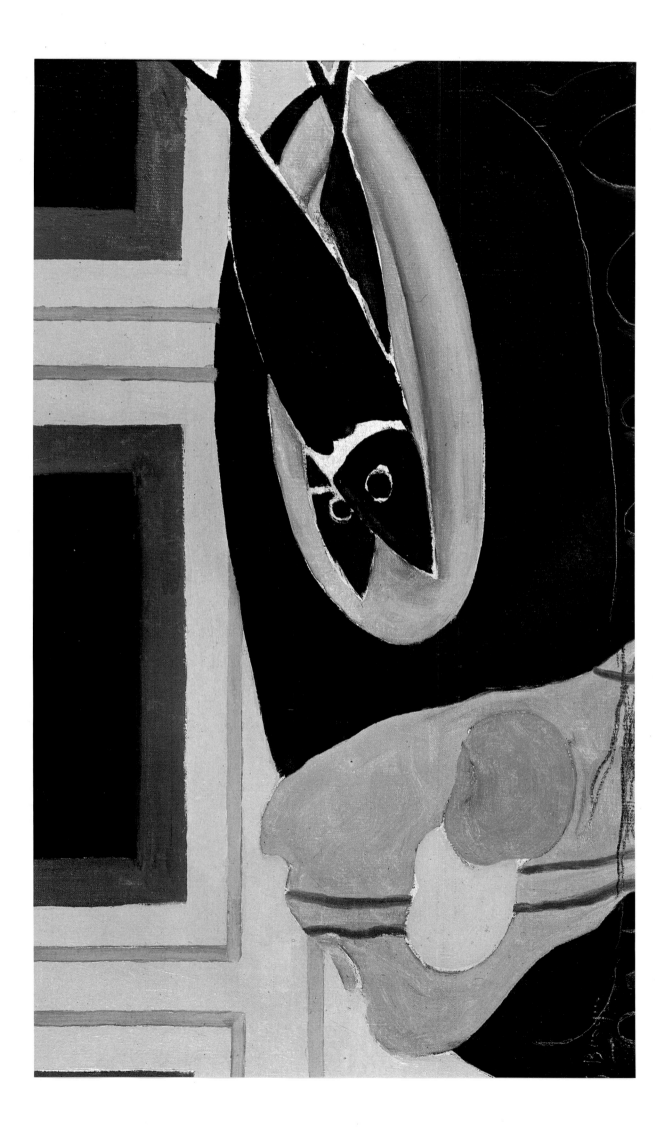

Colorplate 38

THE BLUE WASHBASIN

1942. Oil on canvas, 23 5/8 × 31 1/2"
Private collection, New York

The fish theme was but one way of paring things down to their essentials. Braque's return to simplicity meant that everyday objects now took on the value of specimens or symbols. Washbasin, pitcher, coal scuttle, stove—all became prototypes, and their arrangement in the picture underscores their new function. Each heavily outlined object is set well apart from the others, which gives the drawing the crafted appearance of a template for lettering on signs.

The rehabilitation of these humble objects would soon serve as a source of inspiration for young artists and lead to what was later to be called miserabilism. Braque might seem to be a precursor in this respect, but that would be attributing to his accomplishments a part they really did not play. For one thing, Braque apparently did not intend to invest his works with social meaning, even during that era; moreover, the young artists who founded miserabilism neither claimed him as their forebear nor turned to his works as models. In addition, miserabilism focused on the mediocrity of commonplace objects, whereas they received from Braque the same degree of dignity he would give a mandolin.

Following as they did the refined, often highly complex elegance of the preceding years, these new still lifes were a forceful statement of expressive vigor in which every object maintains its autonomy. This is a reality whose harsh candor glorifies the ordinary.

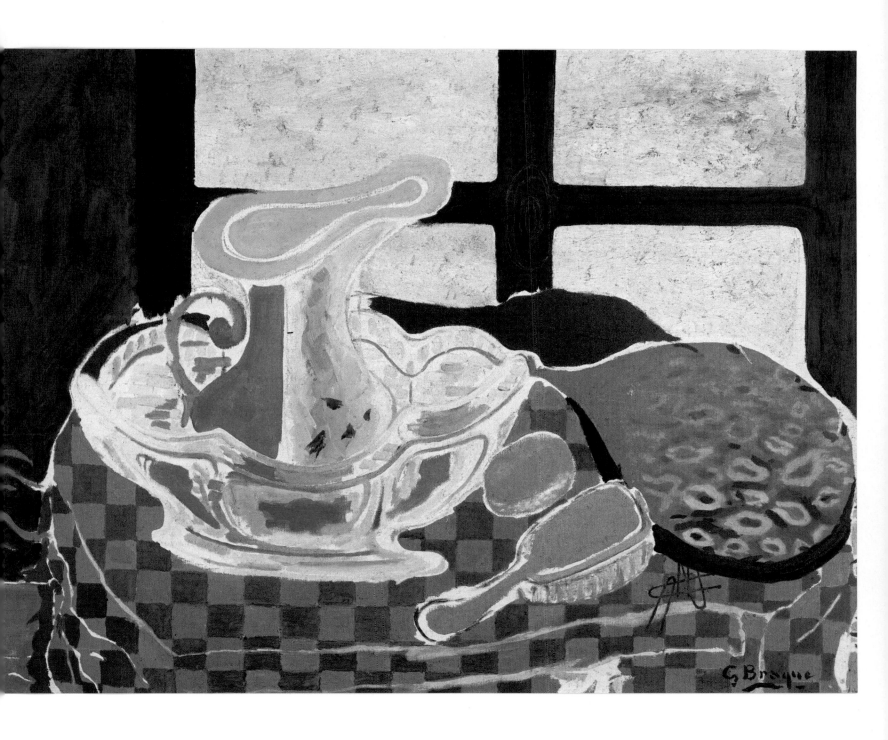

INTERIOR WITH PALETTE

1942. Oil on canvas, 57 1/8 × 77 1/8"
Private collection, Houston

It is impossible to narrow the war years down to one or two specific series of paintings. On the contrary, by diversifying his works, Braque apparently seized this moment—which was for most Frenchmen a kind of uneasy break—to ponder his recent efforts and see what he could draw from them, now that he was in a state of isolation not entirely of his own choosing. His withdrawal imparted a sense of brooding solitude and meditation to all the works of this period, albeit in various ways.

This explains the artist's return to static, silent interiors, to solitary objects waiting in their deserted studios for something to happen. Frugal in both form and color, these tranquil, unpretentious still lifes convey a feeling of seemingly placid mystery.

Outside—the war; inside—life, a purified air bubble, life sheltered in its immobile permanence, turning its back on drama and disorder. The performers have gone to act out their play elsewhere, away from a familiar setting, that refuge which, lacking violent action, survived the era by following the dictates of harsh simplicity.

In *Interior with Palette* (1942), the severe orthogonals of the dark background frame the curving lines of the central scene, across which is superimposed a double volute or horn (an allusion to the artist's easel, if one examines other paintings dating from around the same time). In this manner, the effects produced by substance and design join forces to create a unified realm of total solitude.

No longer does the artist utilize the cheerful colors from the days of his brilliant still lifes. Black, now a key element, adds powerful accents that bring out the more transparent areas of the light and the objects.

The Salon of 1944 (see fig. 64) provides a striking illustration of the conflict or accord between opaqueness and transparency. Here black gives the pedestal table a compelling presence that contrasts with the brilliant light filtering through a window half-shaded by a curtain. While it contrasts with it, at the same time it blends in with it to add an indomitable stability to the pile of objects on the right.

Here Braque states his confidence in order, without bombast or sentimentality.

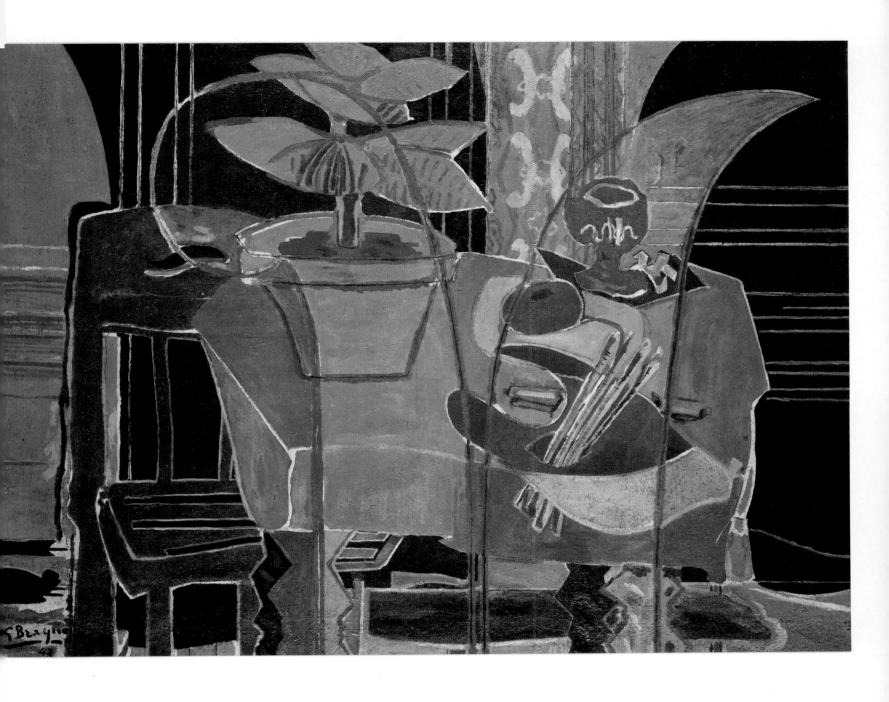

Colorplate 40

THE BILLIARD TABLE

1944. Oil on canvas, 51 1/8 × 76 3/8"
Musée National d'Art Moderne, Paris

It was through the billiard table theme that Braque demonstrated in a most meticulous way the diverse approaches he used to interpret truth. What is truth? That would make a lovely subject for an essay, for truth has many faces. Most of Braque's works reveal truth's diversity, and he was fully aware of the role that art plays in the process: "In creative art there is no effect without distortion of truth." Since the billiard table provides the mind as well as the senses with a multiple view of reality, it is a piece of furniture that lends itself particularly well to the search for truth. Its structure, conceived strictly in terms of its function, never deviates from a basic geometric shape. When made part of an interior, it constitutes a vast monochromatic area, a plane surface that greets the observer with many points of view. In order to use it, one must continually go around it, lean over it, in other words, observe it from every angle imaginable. What horizontal surface could be better suited for vertical realignment? True, we did say it was an inert, empty surface. But when put to use, it becomes crisscrossed with cues, like so many rigid flashes of lightning, or streaked with mov-

ing balls as they roll their pure colors along broken paths. The other features that can be spotted from previous works also stem from the quest for truthfulness: the silhouetted scrolls of the easel, already noted in a preceding interior; the great vertical fold that abruptly severs the composition into two parts (one less cluttered, gloomier in tone; the other, full of objects, light, clarity).

Another painting from the years 1944–52 depicts a billiard table viewed frontally and lengthwise, its surface clearly marked by a horizontal rift that underscores the verticality of the arrangement (see fig. 65). These two works show how Braque simplified his combinations of surfaces by juxtaposing simultaneous points of view. Now more than ever, they were used to express that tactile space so crucial to his approach.

In a third *Billiard Table* (1949), we see something quite different from the agile serenity of the two earlier versions (see fig. 66). It is an exercise in boisterous contrasts that add to its space a burst of movement resembling an explosion.

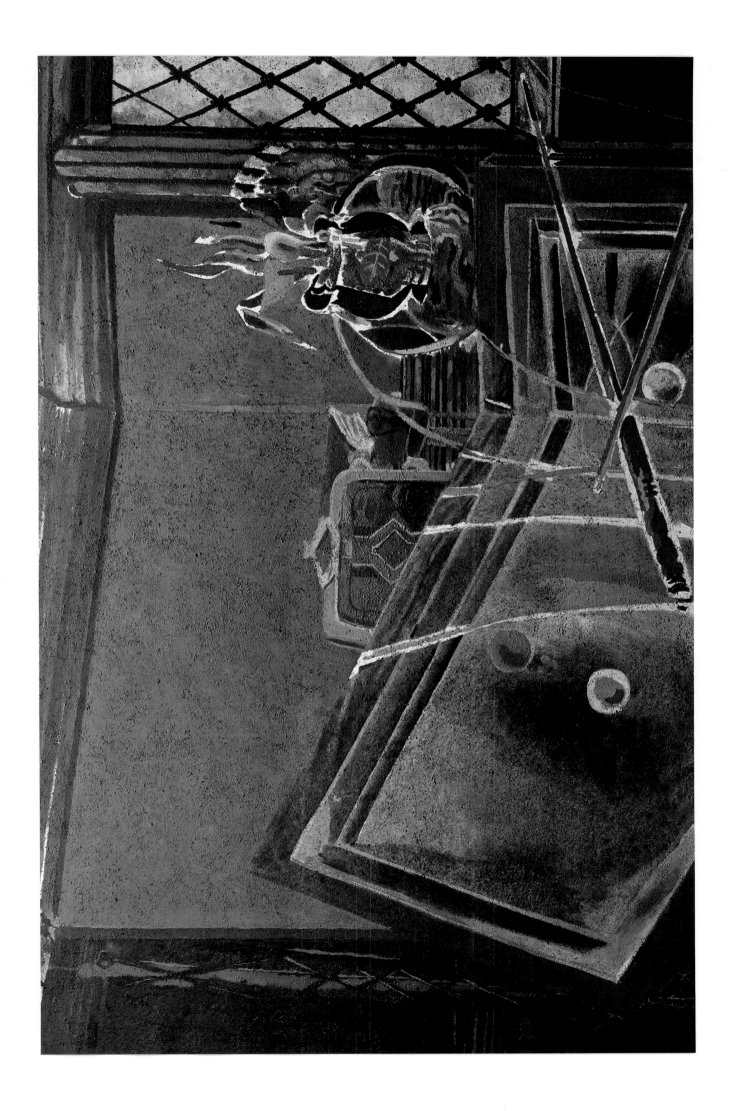

Colorplate 41

WOMAN WITH A BOOK

1945. Oil on canvas, 50 3/8 × 37 3/4"
Private collection, Paris

The theme of interior with figures first reappeared with *Patience* (1942); then in a noticeably modified version entitled *Woman at Her Toilet* (1945), which retains the face drawn as a combination front view and profile (see fig. 67); and in *Woman with a Book* (1945), which respects the division into vertical sections but does so with greater flexibility. These works show how Braque developed the rhythms of his paintings into an organized disorder that soon reached its climax in the *Studios*.

Patience (already discussed in the introduction) occupies an especially significant place in this evolution. It not only marked the final chapter of the preceding period, but paved the way for the works to come. As it might facilitate our reading of future paintings, *Patience* deserves special attention.

The outlined figure is crowned with a dual face—its shadowy profile is complemented by a lighter front view—a twofold perspective that takes the surface of the face and throws it into relief. The head, in turn, is propped up on an arm, likewise illuminated, which also accentuates the verticality of the subject.

The oblique lines of the table, the way its angle of perspective shifts the eye from two dimensions into three, add something different to the architecture of the picture. Everything else revolves around this centrally located object: the curving back of the chair fills the space next to the woman with vitality; the vertical elements of the background or the furniture legs come alive with parallel brushstrokes or a wavy, semi-circular motion that looks like vibrating light.

Thus, as one scans the painting, the different parts respond to one another in a way that alternates light and shadow around a central motif. The resulting space is not "realistic," nor is it metaphysical. It is an essentially pictorial space created by colors and their interaction. The poetic atmosphere of this work is not of an intellectual order: it arises from the conflict or harmony between the specific objects and the fact that they are jumbled together. The feeling of transparency and disorder that is characteristic of works of this period can be explained by the way color acts on the objects and becomes part of the drawing.

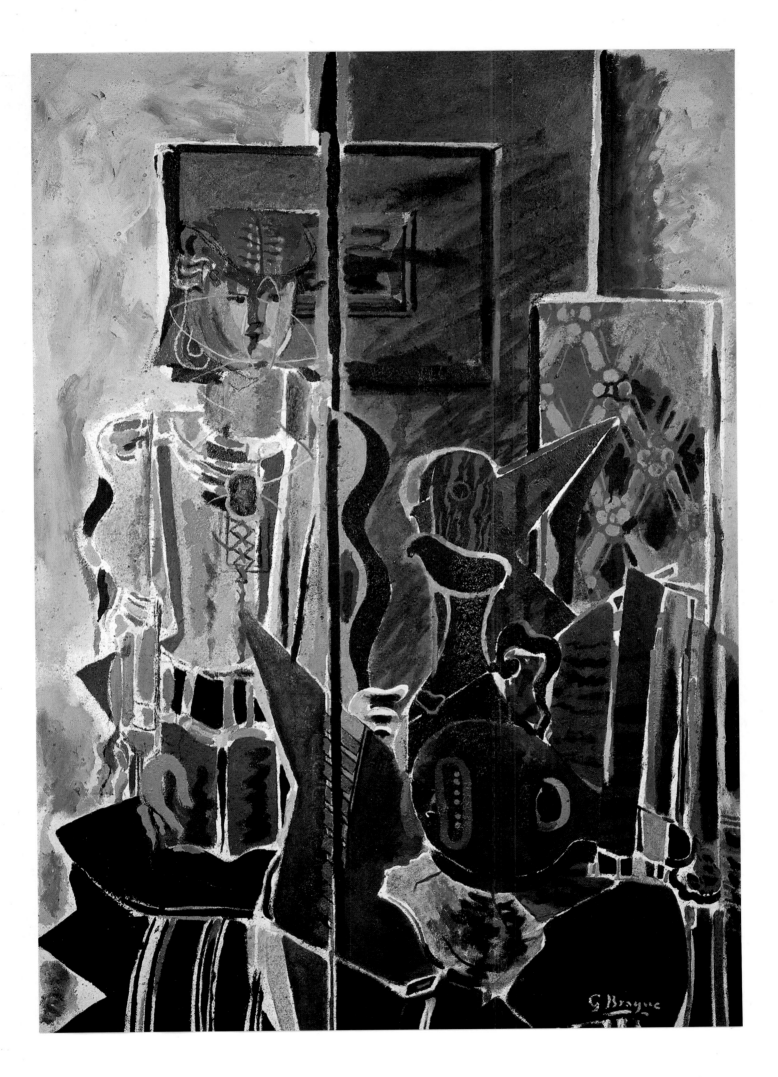

Colorplate 42

THE PACKING CASE

1947. Oil on canvas, 36 1/4 × 36 1/4"
Private collection, London

The war was over. As the nightmare faded into memory, the minds of men turned to liberating endeavors. Young painters boldly ventured into abstract art, a movement that would soon experience an astonishing spurt of growth. Its intellectual pleasures hardly came as a surprise to Braque, who had for some time been exploring this approach—so much so that, as far as he was concerned, it seemed more innovative to renew a closer contact with a real world whose resources he had not had enough time to tap fully.

Once again, flowers provided a theme in keeping with this unreservedly sensual approach. The artist occasionally incorporated them into complex arrangements and blended their relaxed naturalness with other motifs (fish, round tables, simulated wood).

This should not be interpreted as a return to Impressionism: the use of juxtaposed or superimposed colors to set light in motion was not the rule here. The works in this series, generally speaking, could be thought of as more closely related to Fauvism. Consider their zest, their unrestrained arrangement, the free and easy touch that recalls the emotion of Van Gogh—a comparison that is all the more justified in that several of his paintings include the sun theme.

With this hymn to nature, Braque removed himself farther than ever before from prescribed aesthetic approaches. He is like a poet who loves plants flowing with sap; his sole desire is to express their aroma, their fragility, their elegance. He surveys a living world and physically perceives its pulsations. By working with these elements, it would seem that he did not intend to reconstruct another reality with the same materials. Instead, he displayed his talent for spontaneous expression that could forget what it had learned.

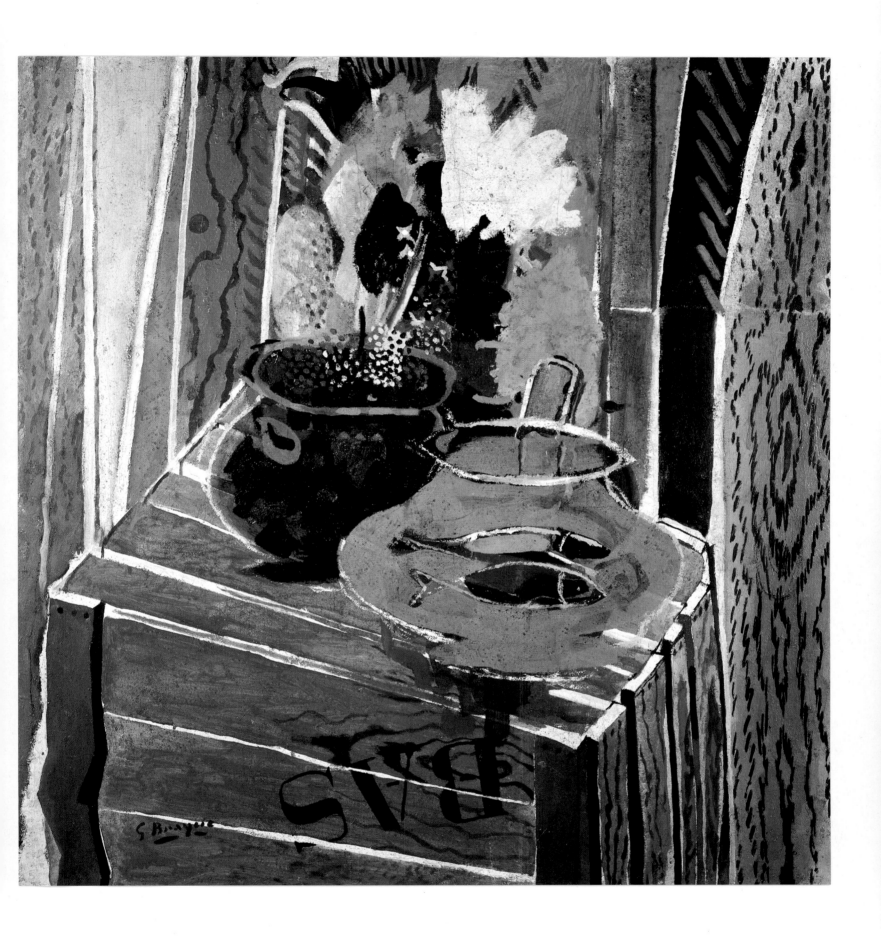

Colorplate 43

THE CHAIR

1948. Oil on canvas, 24 × 19 5/8"
Musée National d'Art Moderne, Paris

Braque's view of nature in terms of trembling flowers took in objects as well. Pedestal tables and garden chairs were wound into intricate shapes that resemble flower stems or tree branches, and the background areas are given a rich, rugged covering of oily color applied with a thick impasto. These works breathe a sense of reserved gladness. Although there can be no question that they profit from the lessons of previous works, they have a less severe, less methodical feeling about them.

Even if reason still holds sway over the ordering and positioning of the objects, at least it does so with the aid of the senses. Witness the light spreading over the canvas, the way the medium is utilized, the vibrant brushstrokes, and the graceful design that has the suppleness of a dancer.

Of course, Braque remained true to the principles that had for so long guided his development. Again we see, for instance, his use of verticality, either by realigning horizontal visual planes or by superimposing objects to create a tiered arrangement. He continued to distribute the components of the painting to large, distinct sections that vary in their degree of clutter. He also tried to minimize the third dimension (that is, depth) by doing away with conventional perspective as much as possible. Nor did he neglect the effects to be derived from transparency. Yet, for all this alchemy of substance and space, Braque achieved a naturalness that gives no hint whatever of intellectual effort.

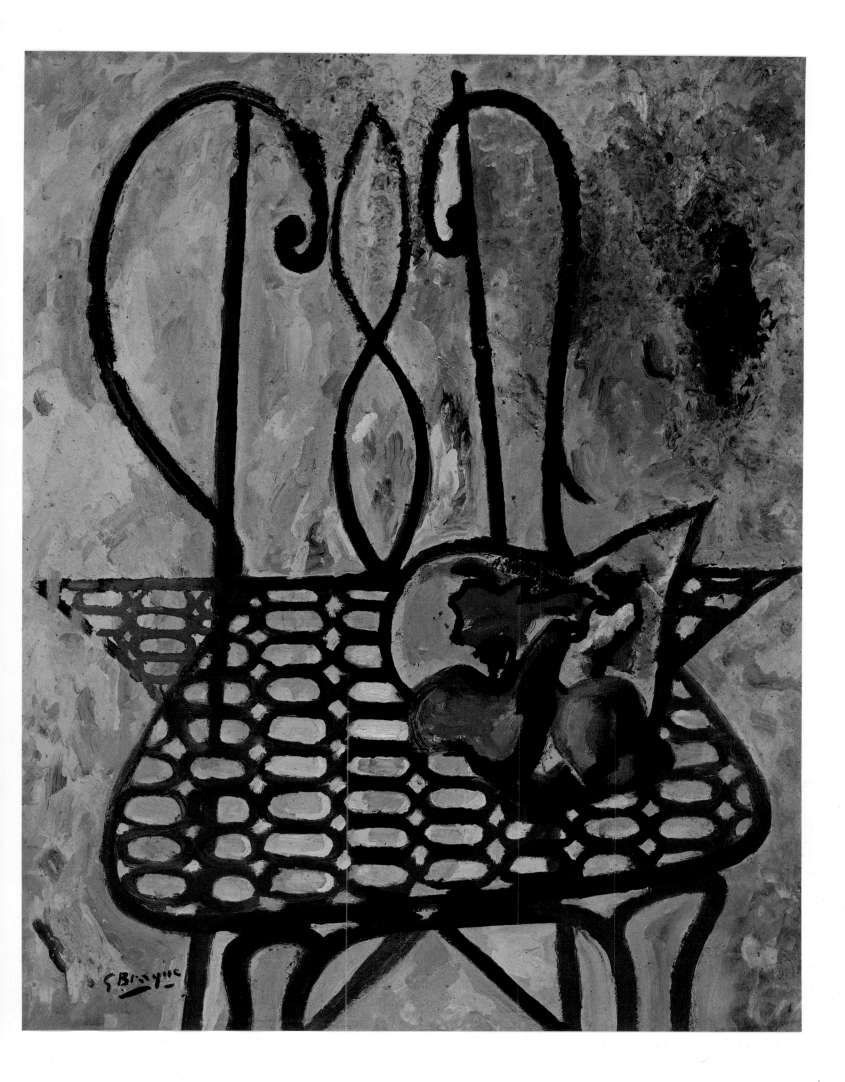

THE WINDOW SHADE

1954–61. Oil on canvas, 63 3/4 × 28 3/8″
Private collection, Paris

Braque continued to show interest in still lifes right up to his death. For one thing, they provided him with moments of relaxation: these simple statements of life as it is directly perceived proved that the prestigious charms of the intellect had not caused him to wander too far from the real world. In addition, they enabled him to add a touch of believability to the distorted, highly elaborate works created during the more refined periods of his evolution.

Consequently, we see him returning periodically to this point of reference. It is especially interesting that he often used the theme in unusual formats that were much greater in width than height. Spreading out pieces of fruit over the length of a canvas tends to lighten the overall tone of the picture, whereas the pyramidal structures of vertical compositions call for a concentrated arrangement of objects. *The Window Shade* is a telling example of this procedure:

the breezy, animated flower motif contrasts with the rigorous geometry of the background.

These spontaneous little panels are virtuoso exercises that seem to have been executed for no other reason than to set down a certain relationship between form, substance, and color. They were to become more numerous, as if to counterbalance the tension present in the last series of studios, birds, and open fields. One is reminded of the decorative panels into which the artists of the great periods of traditional French painting—the seventeenth and eighteenth centuries—put so much skill and sophistication. The poetic sensuality of these "minor" works has made them masterpieces in their own right. Braque, too, had the ability to create works that were light and serious, ordered and spontaneous, and improvised with a naturalness that still respected the chosen guidelines.

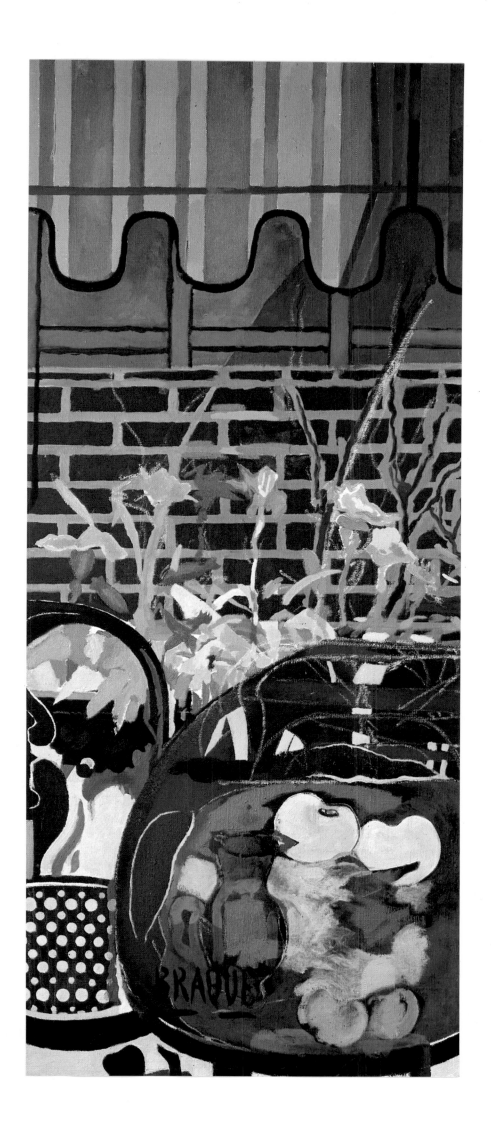

Colorplate 45

THE STUDIO (V)

1949. Oil on canvas, 56 3/4 × 68 7/8"
Private collection, Basel

The *Studio* series—that strange, cluttered hodge-podge of surviving memories, the odds and ends of an old craftsman who knows the living value of what his hands and mind have created—embodies the glimmer and shadow of memory. Air no longer circulates here: it has become matter almost as dense as that of the accumulated objects.

In Egyptian tombs there are chambers, filled with symbolic objects, that lead to the sanctuary and bear the same stamp of vanished time. One feels as if a door has just been opened slightly, leaving a crack through which a bird, blinded by the night, slips into this temple of silence. In the same way, the archaeologist, intimidated by his own arrogant boldness, holds his impulsive enthusiasm in check so that his unexpected intrusion might not disturb the orderliness of the disorder.

In the studio, as in the alchemist's cavern, the very substance of objects is altered, and they are readied for the ultimate transmutation: to be changed back into something that is more rhythm than form, to be blended together into a cohesive unit.

The bird frozen in silent flight ends up immobilizing what it had hoped to resuscitate—a closed world, the repository of an artist's entire life, a jumble of object-symbols that turns into a silent trap. Without the bird, this peculiar, haunting solitude would not be so palpable or physically perceptible, nor would the union of material and spiritual be so irrevocable.

To achieve this effect, Braque does not resort to a symbolic language reserved for a select few: we are not expected to guess the metaphysical meaning of the objects. Using nothing more than what he, as a painter, has at his disposal, Braque creates a magical world all his own. He crystallizes space. It is as if he had taken a sheet of plate glass and set it in front of the painting, between the spectacle and the spectator. Although the observer can see it, he cannot touch it, he cannot interfere with its unfolding mystery.

Here, the large vertical areas of light that Braque so readily employs become narrow strips painted entirely in half-tints. When joined together, they silently work their way across the canvas like a reverberating echo.

156

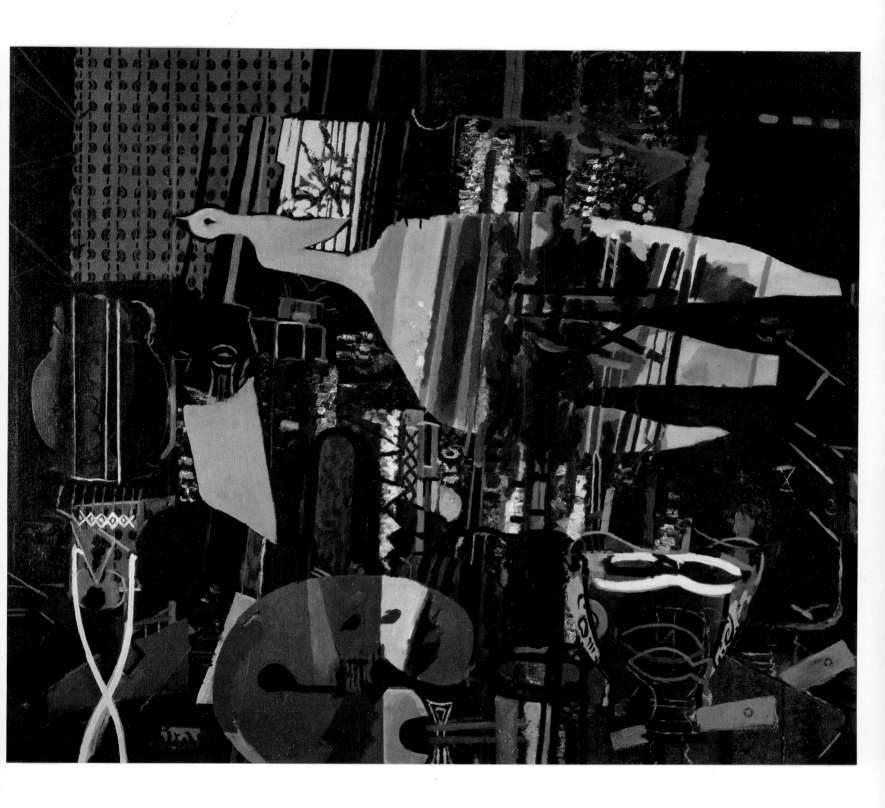

Colorplate 46

NIGHT

1951. Oil on canvas, 63 3/4 × 28 3/4"
Collection Maeght, Paris

The fresh, radiant vitality of flowers was but one of Braque's sources of inspiration (and may even have been an escape mechanism). However, we must not forget that this gateway to freedom did not mean that its counterpart—the solemn meditations of the dreamer—disappeared from view. Ghosts rise up from the past. The specter of night offers a gloomy reply to the luminous still lifes. Shadows within shadows, the apparition looms out at us to haunt and be haunted; it is a presence at once unequivocal and contradictory, well-defined in form but disembodied in substance, a product of Cubism's successive mutations and its interaction with the mythic world of antiquity. Its pose stiffens and its gaze becomes fixed in the warm, dank wind.

Curiously enough, these ventures into the realm of the fantastic reveal the artist's concern for accents of realism that help him express the intangible. The trembling movement that brings the surfaces to life is like a throbbing from within—the antithesis of the superficial sensory approach of Impressionism.

In 1952, he returned to one of the reclining female figures that he had begun about 1930 and subjected it to the same process (see fig. 69). Peaceful monochromatic areas were fragmented into wavy movements; forms were jostled about and interwoven; substance became an intermediate state, neither completely solid, nor completely fluid, nor completely transparent—a changing world standing at the frontiers of nothingness.

Braque had, on several occasions, already yielded to the temptation of suggesting mysterious forms that lie somewhere between fact and fiction: witness the incised plasters and the illustrations for Hesiod's *Theogony*. Their form and spirit are both echoed in a mythological figure entitled *Ajax* (see fig. 68), whose wandering lines reflect the tortuous paths of intuitive thought.

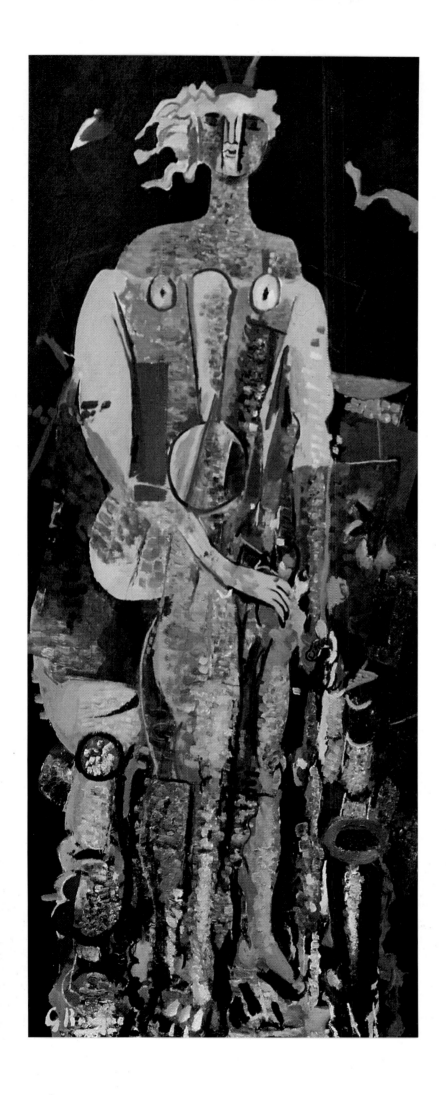

Colorplate 47

CEILING IN THE LOUVRE

1952–53. Oil on canvas, 11′ 4 5/8″ × 16′ 5 1/4″
Etruscan Gallery, The Louvre, Paris

Now that he had reached the summit of knowledge, Braque dared to take on the sky itself. Although space had always been his prime concern, he had worked with it only as it related to objects. But space itself—amorphous, infinite—had yet to be explored. Faced with the challenge of the absolute, Braque had the courage to stick to a simple approach.

First of all, in order to supply dimension where there was none, to give shape to shapeless space, something concrete had to be brought into this abstract domain. The bird that had already been used in the *Studios* to disrupt those gateways to nothingness now soared into a world not yet expressed. The bird and the sky are the twofold materialization of contradictory statements: echoless silence and motionless movement.

Here more than anywhere else, we must let ourselves fall under the spell if we are to understand the state of tranquility that Braque had now achieved, and which blossoms on the ceiling of the Etruscan Gallery in the Louvre.

However, his command of time and space was often not quite so peaceful: the seeming calm did not preclude a sense of enduring drama. It might have been in reference to this series of paintings that Braque wrote: "The poet may say: A swallow is stabbing the sky, and makes a dagger of a swallow." Braque's birds lend drama to a sky that would be a vacuum without them; and yet there is nothing overblown about these austere fragments of infinity.

THE WEEDING MACHINE

1961–63. Oil on canvas, 47 1/4 × 69 1/4″
Musée National d'Art Moderne, Paris

One cycle of concluding works followed another: after the introverted studios and the infinite sky, Braque turned to a third variation on the themes of silence and solitude—landscapes viewed from ground level. Earth and sky meet head on, and anything not involved in their union is of secondary importance. Here, matter is primitive, light is harsh, and there is nothing in between.

Having followed the path of intellectual and technical sophistication, Braque went back to basic instincts. One cannot help thinking of the lofty vision of Van Gogh during his last years. Both artists found themselves face-to-face, alone, with the unfathomable infinity of earth and sky meeting to form something that is at once symbol and reality.

One is tempted to compare their works, not only with respect to subject matter, but also technique, format, and spirit. Yet they are as contradictory as they are analogous: on the one hand, the fervent emotion of Van Gogh, on the other, the calm fulfillment of Braque.

BIBLIOGRAPHY

WRITINGS BY GEORGES BRAQUE

"Pensées et réflexions sur la peinture," in *Nord-Sud*, no. 10, December, 1917.

Cahier de Georges Braque: 1917–1947, Paris: Maeght, 1948; with supplement, 1949–55, Paris: Maeght, 1956.

MAJOR WORKS ILLUSTRATED BY GEORGES BRAQUE

1945 Paulhan, J., *Braque le Patron*; two editions, one color lithograph for the cover, one color lithograph for the frontispiece; Paris: Mourlot.

1947 Braque, G., *Cahier de Georges Braque: 1916–1947*; deluxe edition: one color lithograph for the cover, one color lithograph for the title page, one lithograph for the preface; standard edition: one color lithograph for the cover; Paris: Mourlot.

1949 Char, R., *Le Soleil des eaux*; four etchings, one of which (frontispiece) is in color; Paris: Matarasso.

1950 Milarépa, *Chants*; five etchings and ten etched initials; Paris: Maeght.

Ponge, F., *Les Cinq Sapates*; five etchings; Paris: Georges Braque.

Reverdy, P., *Une Aventure méthodique*; one color lithograph (frontispiece), twenty-seven lithographs in black and white, and twelve colored lithographs after paintings by Braque; Paris: Maeght.

1955 Hesiod, *Théogonie*; one color lithograph for the cover (varnished by the artist), one color lithograph for the frontispiece, one etching for the first page of text, one etching for the colophon; published simultaneously with sixteen etchings without marginal notes; Paris: Maeght.

Paulhan, J., *Les Paroles transparentes;* four separate lithographs, ten lithographs in text (in blue); Paris: Les Bibliophiles de l'Union Française.

1959 Benoit, P. A., *Braque et le Divin manifesté;* Alès: P. A. Benoit.

Elgar, F., *Résurrection de l'oiseau*; three color lithographs, including a frontispiece, and three monochromatic lithographs in the text; Paris: Maeght.

Verdet, A., *Georges Braque le solitaire;* one color engraving; Paris: XXᵉ Siècle.

1960 Benoit, P. A., *Invisible visible*; one cardboard print in blue; Alès: P. A. Benoit.

Pindar, *Le Ruisseau de blé;* one cardboard print; Alès: P. A. Benoit.

Reverdy, P., *La Liberté des mers*; nine color lithographs, thirty-four monochromatic lithographs in text; Paris: Maeght.

Ribemont-Dessaigne, G., *La Nuit, la faim*; set of engravings; Paris: Maeght.

Suzuki, D. T. and Herrigel, E., *Le Tir à l'arc*; one etching for the cover, two woodcuts, eight color lithographs; Paris: Louis Broder.

1962 Apollinaire, G., *Si je mourais là-bas;* original woodcuts; Paris: Louis Broder.

Saint John Perse, *L'Ordre des oiseaux;* etchings; Paris: Au Vent d'Arles.

1963 Char, R., *Lettera Amorosa*; color lithographs; Geneva: E. Engelberts.

Ponge, F., *Braque lithographe*; two color lithographs; Monte Carlo: André Sauret.

CATALOGUES

Isarlov, G., *Georges Braque*, Paris: José Corti, 1932 (the first attempt to catalogue Braque's works between 1906 and 1929).

The *Catalogue de l'oeuvre de Braque* is being prepared for publication through the Galerie Maeght in Paris, as drawn up by Mme Nicole de Romilly. Six volumes, covering the years 1917–57, have already appeared.

MONOGRAPHS

Bissière, R., *Georges Braque*, Les Maîtres du Cubisme, Paris: L'Effort Moderne, 1920.

Raynal, M., *Georges Braque,* Rome: Valori Plastici, 1924.

Einstein, C., *Georges Braque*, Paris: Éditions des Chroniques du Jour, 1934.

Gallatin, A. E., *Georges Braque*, New York: Wittenborn, 1943.

Fumet, S., *Braque*, Couleurs des Maîtres, Paris: Braun, 1945.

Ponge, F., *Braque le Réconciliateur*, Les Trésors de la Peinture Française, Geneva: Skira, 1946.

Paulhan, J., *Braque le Patron*, Geneva: Éditions des Trois Collines, 1947.

Cooper, D., *Braque: Paintings 1909–1947*, London: Lindsay Drummond, 1948.

Grenier, J., *Braque: Peintures 1909–1947*, Paris: Éditions du Chêne, 1948.

Hope, H. R., *Georges Braque*, New York: Museum of Modern Art, 1949.

Lejard, A., *Braque,* Paris: Hazan, 1949.

Reverdy, P., *Une Aventure méthodique*, Paris: Mourlot, 1949.

Ponge, F., *Braque: Dessins*, Paris: Braun, 1950.

Buchheim, L. G., *Georges Braque: Das graphische Werk*, Feldafing: Buchheim Verlag, 1951.

Fumet, S., *Sculptures de Georges Braque*, Paris: Jacques Damase, 1951.

Seuphor, M., *Braque, graveur*, Paris: Berggruen, 1953.

Laufer, F., *Braque*, Bern: Alfred Sherz Verlag, 1954.

Gieure, M., *Georges Braque: Dessins*, Paris: Éditions des Deux Monde, 1955.

Cassou, J., *Braque*, Paris: Flammarion, 1956.

Gieure, M., *G. Braque*, Paris: Tisné, 1956.

Verdet, A., *Georges Braque*, Geneva: Kister, 1956 (pictures by R. Hauert).

Elgar, F., *Braque*, Petite Encyclopédie de l'Art, Paris: Hazan, 1958.

Heron, P., *Braque*, London: Faber and Faber, 1958.

Richardson, J., *Georges Braque*, London: Penguin Books, 1959; Milan: Silvana Editoriale, 1961; Paris: Bibliothèque des Arts, 1962.

Russell, J., *Georges Braque*, New York and London: Phaidon, 1959.

Verdet, A., *Georges Braque le solitaire*, Paris: Hazan, 1959.

Zervos, C., *Georges Braque: Nouvelles sculptures et plaques gravées*, Paris: Morancé, 1960.

Engelberts, E. and Hofmann, W., *L'Oeuvre graphique de Georges Braque*, Lausanne: Guilde du Livre, 1961; Eng. ed., *Georges Braque: His Graphic Work*, New York: Harry N. Abrams, 1961.

Leymarie, J., *Braque*, Geneva: Skira, 1961.

Vallier, D., *Braque: La Peinture et nous*, Basel: Phoebus Verlag, 1962.

Brion, M., *Georges Braque*, Paris: Somogy, 1963.

Damase, J., *Georges Braque*, Deventer: Ysel Press, 1963; London: Blandford Press, 1963.

Mourlot, F., *Braque, lithographe*, with preface by F. Ponge, Monte Carlo: Sauret, 1963.

Fumet, S., *Braque*, Paris: Maeght, 1965.

Antal, K., *Braque*, Budapest: Corvina Kiad'o, 1966.

Apollonio, U. and Martin, A., *Georges Braque*, Chefs-d'oeuvre des Grands Peintres, Paris: Hachette, 1966.

Mullins, E., *The Art of Georges Braque*, London: Thames and Hudson, 1968; New York: Harry N. Abrams, 1968.

Vinca-Masini, L., *Georges Braque*, Florence: Sansoni, 1969.

Cogniat, R., *Braque*, Paris: Flammarion, 1970.

Pouillon, N., *Braque*, Paris: Le Musée Personnel, 1970.

Ponge, F., Descargues, P., and Malraux, A., *G. Braque*, Paris: Draeger, 1971; Eng. ed., New York: Harry N. Abrams, 1971.

Cooper, D., *Braque: The Great Years* (catalogue of the 1972 Chicago exhibition).

Valsecchi, M. and Carra, M., *L'Oeuvre complet de Braque, 1908–1929*, Paris: Flammarion, 1973.

PHOTOGRAPHIC CREDITS

The author and publisher wish to thank the museums and private collectors for permitting the reproductions of works of art in their collections. Photographs have been supplied by the owners or custodians of the works except for the following, whose courtesy is gratefully acknowledged: Bulloz, Paris; Galerie Louise Leiris, Paris; Galerie Maeght, Paris; Giraudon, Paris; Hinz, Basel; Routhier, Paris; and Service de documentation photographique de la Réunion des Musées Nationaux, Paris.